The Case of the Disappearing Gauguin

The Case of the Disappearing Gauguin

A Study of Authenticity and the Art Market

Stephanie A. Brown

ROWMAN & LITTLEFIELD
Lanham • Boulder • New York • London

Published by Rowman & Littlefield
An imprint of The Rowman & Littlefield Publishing Group, Inc.
4501 Forbes Boulevard, Suite 200, Lanham, Maryland 20706
www.rowman.com

86-90 Paul Street, London EC2A 4NE

British Library Cataloguing in Publication Information Available

Library of Congress Cataloging-in-Publication Data
Names: Brown, Stephanie (Stephanie A.), author.
Title: The case of the disappearing Gauguin : a study of authenticity and
 the art market / by Stephanie Brown.
Description: Lanham : Rowman & Littlefield, [2024] | Includes
 bibliographical references and index. | Summary: "Authentic or forged?
 Follow the journey of a painting that may (or may not) be the work of
 Paul Gauguin as it travels around the world over the course of a
 century. Explore the networks and relationships that help determine
 authenticity in the art world"— Provided by publisher.
Identifiers: LCCN 2024004425 | ISBN 9781538173107 (cloth) | ISBN
 9781538173121 (paperback) | ISBN 9781538173114 (ebook)
Subjects: LCSH: Gauguin, Paul, 1848-1903—Authorship. |
 Painting—Expertising. | Painting—Economic aspects.
Classification: LCC ND553.G27 B74 2024 | DDC 759.4—dc23/eng/20240501
LC record available at https://lccn.loc.gov/2024004425

♾️™ The paper used in this publication meets the minimum requirements of American
National Standard for Information Sciences—Permanence of Paper for Printed Library
Materials, ANSI/NISO Z39.48-1992.

For RFB, CSM, and LMS.
Thank you.

~

Contents

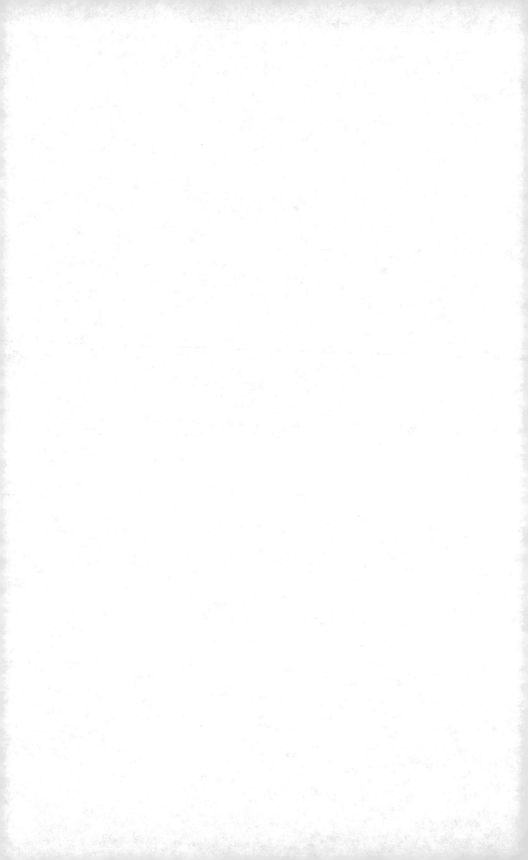

~

Introduction

Gold Rush heiress Eila Haggin McKee in 1929 bought a painting by the noted French artist Paul Gauguin called *Flowers and Fruit*. French celebrities and art experts coveted the painting; MoMA's director, Alfred Barr, may have considered it for the fledgling museum's first exhibition. Today, it hangs in a disused staff office in the Haggin Museum in Stockton, California, no longer attributed to the artist.

Flowers and Fruit first appeared on the art market in 1923. Established auctioneers and respected experts sold it twice in six years through Paris's Hôtel Drouot. Then, the painting traveled through that network of dealers to New York, where Eila bought it. It remained in her family for a decade before it traveled to Stockton, California, where it joined the collection of the Haggin Museum. The museum's Gauguin was a source of pride; locals brought their out-of-town visitors to see it. Staff highlighted the painting when auction houses around the world sold other Gauguins at newsworthy prices.

Decades passed.

In Paris, the dealers and experts who made up the art market did not know where the painting was. They labeled it lost: one of the hundreds, thousands, of European artworks lost to the upheavals of the twentieth century.

The painting resurfaced in the art world in 2018, almost a century after the painting first came under the auctioneer's hammer. The Gauguin Committee of the Wildenstein Plattner Institute examined it and "determined that this work would not be included" in the Institute's *catalogue raisonné*.[1]

Fig I.1. Receipt, Clapp and Graham, December 31, 1929. *Source:* Haggin Museum, Stockton, California

And so it remains hidden away in the back of the museum, awaiting the next chapter in its biography.

Flowers and Fruit is an ordinary still life. On a table covered in a yellow cloth we see two vases filled with pink roses and greenery. A scattering of apples painted in greens, reds, and yellows sits around them, and a nasturtium blossom and petal. Blue wallpaper patterned in stripes and abstract flowers form the backdrop. The cylindrical, footed vase on the left is dark pink, almost mauve, and has a matte finish. The vase on the right is deep blue and expands voluptuously from a narrow base into facets that reflect the light of a long-ago room. The eight pieces of fruit on the table vary in shape and color from pale green through an almost olive color, yellows through oranges to reds. Some are stem side up; some show the uneven bumps of the calyx. All are wobbly and imperfect. The roses in both vases are shades of pink. They are full-blown, just moments from dropping their first petals. Some of the leaves framing the roses have detailed veins; others merely suggest the shape of a leaf. The surface on which the fruit and flowers sit is painted in

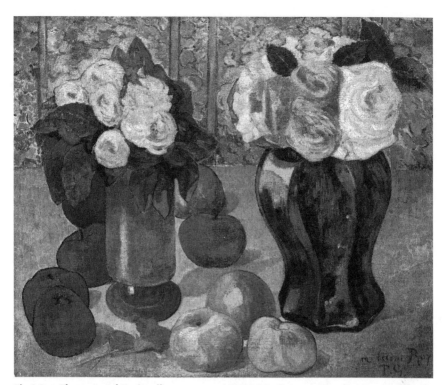

Fig I.2. *Flowers and Fruit*, oil on canvas, 1939.34.3. *Source:* Haggin Museum, Stockton, California

short strokes of a deep late-summer yellow ochre; the blue wallpaper varies from cornflower to lilac. In the lower right corner of the painting someone has written: "à l'ami Roy [to the friend Roy] / P. G."

On a windy January day in 2016, I saw *Flowers and Fruit* for the first time. I had driven up from the Bay Area that morning to meet with staff at the Haggin Museum. The red-brick museum sat at the center of Victory Park, in the center of a neighborhood of 1920s bungalows. Canada geese guarded the small lake while palm trees whispered. Neighbors walked their dogs while teenagers kicked around a soccer ball. Staff at the museum had hired me to research and write about their permanent paintings collection. Most of the paintings in the collection were nineteenth-century American landscapes and French academic paintings, collected by two generations of the Haggins, a family made wealthy by real estate and mining. There were large canvases by Bierstadt and his contemporaries showing expansive North American landscapes, and drawing-room-sized paintings of rosy-cheeked French peasants at work in the countryside. *Flowers and Fruit* was one of only

five Impressionist works in the collection. The other Impressionist paintings hanging alongside it were by less controversial artists: a Renoir pastel of two ladies, a Childe Hassam street scene, a William Merritt Chase portrait, and a scene in London's Hyde Park by Giuseppe de Nittis. Each of them was an unsurprising example of the artist's work, just as Bierstadt's *Looking up the Yosemite Valley* was typical of his catalog. Something was different about the Gauguin.

One mystery: the subject was not typical for Gauguin. Best known as the leader of the Post-Impressionist movement who spent his final years in Tahiti, still lifes make up only about 15 percent of his paintings.[2] Gauguin had begun his professional life as a stockbroker. He had come to painting when he was in his late thirties, and it had cost him his comfortable living as well as his family. Gauguin's early paintings were unsurprising Impressionist landscapes, interiors, still lifes, and portraits. Camille Pissarro invited Gauguin out to his rented country house to paint for a couple of summers, and Gauguin learned from him about the use of color and form. Gauguin also admired Paul Cézanne's work and owned several of his still lifes. Gauguin's still lifes from the early 1880s demonstrate his engagement with Pissarro and Cézanne. Most of those paintings are in private collections or in internationally known museums. On May 16, 2023, an 1885 Gauguin still life of peonies and a mandolin, long exhibited at the Musée d'Orsay, sold for over ten million dollars at Sotheby's.[3]

Flowers and Fruit did not look like those paintings from early in Gauguin's career. The greens were greener, the yellows more ochre. The composition was simpler. The 1885 still life included a multitude of details: an ornamented vase, a woven trivet, a painted porcelain bowl, a patterned tablecloth, a framed painting. *Flowers and Fruit* contained only a few elements. There was no sense of a middle-class interior. There was no paraphernalia of family life or bourgeois status. There were flowers, in vases, with some apples, on a table, with a wallpaper background. Nor did it resemble Gauguin's still lifes from Brittany with their firm contextual connection to place. His 1894 *Flowers and a Bowl of Fruit on a Table* includes in the background the red-tasseled mantlepiece scarf of Marie-Jeanne Gloanec's Pont-Aven inn as well as a Quimper-ware bowl between the flowers and the fruit.[4] Other still lifes, with their bold colors and tropical motifs, reflected his sojourns in Tahiti.[5] Each is firmly grounded in a specific place. *Flowers and Fruit* could be nearly any table in nearly any room.

Any table in any room: but Gauguin himself owned a painting, Cézanne's *Still Life with Fruit Dish*, that showed a not entirely dissimilar table with a not entirely dissimilar setting. Gauguin acquired this painting, which he referred

to as "the apple of his eyes" in the early 1880s. It is now part of the collection of the Museum of Modern Art.[6] Like *Flowers and Fruit*, Gauguin's Cézanne has a background of blue wallpaper that contrasts with a foreground of yellows and ambers. Like Gauguin's Cézanne, the apples in the foreground of *Flowers and Fruit* are painted in broken brushstrokes with flecks and daubs of contrasting colors; they tumble across the canvas in a similarly calculated disorder. Curator Caroline Shields has observed that Gauguin frequently quoted from other artists, especially in his still lifes.[7] Could *Flowers and Fruit* be, in part, an allusion to Cézanne? And if it is: Is it an allusion made by Gauguin, or is it one made by an artist who knew enough about Gauguin's attraction to Cézanne to reference it?

Another puzzle: Who was this "friend Roy" to whom the painting was inscribed? The inscription implied a relationship between Gauguin and Roy. But who was Roy? Meticulous culling of source materials turned up exactly one journal article about *Le Seigneur Roy*, written by a French curator in 1978. An artist himself, Louis Roy had exhibited with Gauguin and his circle in 1889 and, later, had worked briefly with Gauguin on making prints from his 1894–1895 *Noa Noa* series. Gauguin had painted his portrait: a jowly, flushed young man with red hair and a beard. Roy had, according to the 1978 article, worked as a high school drawing instructor in Paris.[8] In the copious art historical literature on Gauguin, in collections of his letters, in collections of his friends' letters, Louis Roy barely surfaces. And yet here was his name inscribed on a still life in Stockton, California. Why? Had the painting originally been a gift from Gauguin? And if it had, how had it traveled from Roy's hands all the way to Stockton, California?

The presence of a Gauguin, any Gauguin, in the Haggin's collection was a puzzle in itself. The Renoir hanging nearby was one of over four thousand that the prolific painter had turned out. The other Impressionists on the wall—Chase, Hassam, and de Nittis—had all been active in the Paris and New York art scenes at the time that the second generation of Haggin collectors had been active. It is possible—likely, even—that those paintings came directly off the easel of the artists themselves. Gauguin sold few paintings in his lifetime, and almost none of those to wealthy Americans. American collectors, for the most part, only began to take an interest in Gauguin after his death. And Gauguin left a smaller catalog of total works: there are fewer than one thousand known paintings. In the Western United States, there are ten Gauguin oil paintings in museum collections. Four of those are in the Los Angeles County Museum of Art. The Getty Museum has one. The others are at museums that are small but located in significant metropolitan areas: the Norton-Simon in Pasadena, the Honolulu Museum of Art, the Berkeley Art

Museum, the Portland (OR) Art Museum. *Flowers and Fruit* is the only one of Gauguin's rare oils that found its way to a small Western city well off the common museum track.

On that January day I did not know how many Gauguin paintings were at large in the world, or who Louis Roy was, or the composition of most of Gauguin's still lifes. What I knew was that something was odd. In the next months I began reading a little here and there, pulling at threads and looking at images. The months turned into years, and the occasional reading turned into archival research. What I uncovered is a complex, layered story. There are unexpected connections and surprising gaps. I have traced the trail of *Flowers and Fruit* across Paris, from the neglected Pantin Cemetery to the grand halls of the Institut national de l'histoire d'art in Paris. I have followed clues across Brittany, from archives through museums and up an overgrown seaside path to an empty house. In New York, Washington, DC, and San Francisco, I have hunted down references and even examined fingerprints. The few moments in 2016 that I paused in front of a painting I had never seen, in a museum I had never visited, have turned into years of research and conversations, dead ends and discoveries. They have produced this biography of a painting.

This biography is the story of *Flowers and Fruit*'s journey in and out of authenticity. It is also a story about dealers, collectors, and museum directors. It is a story about interwar Paris, and a story about mid-century Stockton. It is a story about Gauguin and what, and who, he left behind when he sailed off to Tahiti in 1895: the men and women who stored his works and eventually passed them on to others. It is a story about cultural power and identity, and the way that the art world assigns value. At its core, this is the story of how one object, one stretched length of painted canvas, passed through the lives of different individuals over the course of a century. To each of those people it provided an affiliation, a membership in the elite echelons of the art world. From the first dealer who brought it to auction in 1923 to the museum director in 2018 who received news that *Flowers and Fruit* would no longer make up part of Gauguin's official *catalogue raisonné*, each person who encountered the painting became part of its story. Small objects can contain large meanings.[9] *Flowers and Fruit*'s meaning as a link to the bigger story of the art world has not altered over a century. That meaning contains within it notions of belonging and connection that point us toward conversations about identity, about who can claim a space as a member of the cultural elite, who cannot—and why.

In the beginning was the *catalogue raisonné*. A *catalogue raisonné*, sometimes called a critical catalog in English, is "a systematic listing of all known works" by a particular artist. The listing is usually chronological and includes, for each work, its "date, medium, dimensions, provenance, references and sometimes exhibition history."[10] Georges Wildenstein and Raymond Cogniat, in their 1964 catalog of Paul Gauguin's paintings, identified *Flowers and Fruit* as number 381ter, an oil on canvas that measured 18.11 x 21.65 inches.[11] They dated it to 1889, during Gauguin's sojourn in Marie Henry's inn in the hamlet of La Pouldu on the Breton coast. Wildenstein and Cogniat traced the painting's provenance—its "chain of transfer of ownership and possession"[12]—from Louis Roy to the Galerie Barbazanges, from the Barbazanges to a 1923 auction where it was purchased by the French celebrity Sacha Guitry. Guitry held it until 1929, when he sold it at auction to a Russian Jewish emigrant, Max Kaganovitch. Kaganovitch, wrote Wildenstein and Cogniat, had passed it on to the Reinhardt Galleries in New York City before 1957. And then the painting had disappeared.

So I learned when I examined the 1964 catalog in the Haggin's library, a few yards away from where the disappeared painting was installed in the museum's public gallery. Postcards and mugs bearing its image were for sale in the museum shop. The painting was, so far as museum visitors were concerned, the real thing. Inclusion in, or exclusion from, a *catalogue raisonné* does not necessarily confirm or deny the authenticity of a work of art. A critical catalog's quality reflects the work of its researchers—as well as the quality and quantity of documentary evidence available to them. The 1964 Wildenstein-Cogniat catalog was controversial from its publication for the "inconsistency of its attributions."[13] So controversial was it that work began on a revised catalog almost immediately. The Wildenstein Institute published a revised, two-volume catalog of Gauguin's work from 1873 to 1888 in 2002 and, in 2021, a digital *catalogue raisonné* of Gauguin's work from 1891 to 1903. The final volume of the catalog, which will cover the years 1889–1901, is in process.

Why does it take so long? Every painting has its own story. Hundreds of paintings means there are hundreds of stories, hundreds of letters, auction catalogs, gallerists' ledgers, exhibition checklists, photographs, memoirs, legal documents. Reconstructing the chain of ownership for every painting in a life's work is a monumental task. In Gauguin's case, reconstructing that story is made more complex by his peripatetic life and fractured relationships. When he died in the Marquesas Islands at age fifty-five, he was thousands of miles from home, estranged from his wife and children, and out of touch with many of his old friends. For several years he had been shipping works

to different contacts in France. Gauguin had also stored paintings, drawings, prints, notebooks, ceramics, and carvings with family, colleagues, friends, and creditors in Copenhagen, Paris, and Brittany before leaving Europe for the last time. Each of those works has been bought, sold, lost, found, donated, and researched regularly in the last century.

Many of them have also been questioned. Gauguin specialists do not always agree on the authenticity of a particular work. At the Detroit Institute of Arts, an 1893 *Self-Portrait* by Gauguin hangs near other treasures.[14] The Wildenstein Plattner Institute opted not to include that self-portrait in its 2021 digital *catalogue raisonné*.[15] Is it a genuine Gauguin? In the Detroit gallery it is; according to the Gauguin experts, it isn't. A work that is not authentic, that cannot be identified as the work of Gauguin, could be a forgery or it could be a fake. Noah Charney distinguishes between the two categories. A forgery, he writes, is "a wholesale creation of a fraudulent work . . . the manufacture of a new work of art that professes to have been made by someone whose authorship would result in a greater sale value of the object." A fake is distinct from a forgery because it involves "the alteration of, or addition to, an authentic work of art in order to suggest a different authorship or subject matter that results in a greater sale value of the object."[16] The Detroit *Self-Portrait* may be either the authentic work of Paul Gauguin, as demonstrated by evidence that was unavailable or unpersuasive to the Wildenstein experts. It may be a forged Gauguin, a work created by someone with the dishonest intent of passing it off as a Gauguin. Or it may be a fake Gauguin: someone may have painted Gauguin's portrait in all integrity, and another person may have altered the work to make it appear to be by Gauguin himself. That alteration can be as simple as the addition of a signature. For an artist like Gauguin who signed his name in so many ways that the endpapers of the 1964 *catalogue raisonné* used his various signatures as a design motif, it would not be difficult to choose one to copy.

Flowers and Fruit, like the Detroit *Self-Portrait*, could be authentic; it could be a fake; it could be a forgery. I set out to discover which it was. What I discovered instead was that the painting's biography told a story more richly textured, more layered, and more complicated than I had imagined. In her object biography *Portrait of a Woman in Silk*, historian Zara Anishanslin examines how an eighteenth-century oil portrait, a "thing fashioned of oil paint on a framed canvas"[17] contains within it "histories of the human lives that coalesced" around it.[18] *Flowers and Fruit*'s biography contains histories not only of specific human lives, but of networks of trade and of symbols of wealth and prestige. If it is a painting that Gauguin made, then it holds the

memory of his touch, carries the weight of his choices. If it is a painting made by someone else to be presented as a Gauguin, it carries those marks, too; if it is someone else's work that has been subtly revised into a Gauguin, those echoes are present, if we could but hear them.

Listen closely to the canvas and you can hear art dealers and auctioneers deciding how much it might bring. You can hear the buzz of actors and playwrights gossiping over champagne, the eager questions of a young emigrant learning a new language and a new profession. You might hear the household sounds of a private collector, the construction sounds of a new museum being built, the murmurs of gallery-goers, and the exuberance of a town only a few generations from frontier days. Whether or not *Flowers and Fruit* is an authentic Gauguin, it is an authentic object that has traveled across time and space. Questions around its authenticity are, themselves, part of that story. Those questions are not simply about authorship but also about status and access. The painting carries in it the memories of all that it has witnessed. It carries a wealth of possibilities as well, of narratives that could elucidate its story if we could only find the missing key. *Flowers and Fruit* is a portal to the past. Our first stop is on a French country lane in 1903.

Notes

1. "Elizabeth Gorayeb to Stephanie Brown," October 22, 2018.

2. Caroline D. Shields, "Objects of Memory: Paul Gauguin and Still Life Painting, 1880–1901" (Ph.D. diss., College Park, University of Maryland, 2017), 4.

3. "Property from the Ambroise Vollard Collection: Lot 110, Paul Gauguin, Nature Morte Avec Pivoines de Chine et Mandoline," Sotheby's, May 16, 2023, https://www.sothebys.com/en/buy/auction/2023/modern-evening-auction/nature -morte-avec-pivoines-de-chine-et-mandoline.

4. Paul Gauguin, "Flowers and a Bowl of Fruit on a Table, 1894," MFA Boston, 1894, https://collections.mfa.org/objects/33275/flowers-and-a-bowl-of-fruit-on -a-table.

5. Paul Gauguin, "Nature Morte à La Coupe [Still Life with Bowl]," Virginia Museum of Fine Arts, 1891 1889, https://vmfa.museum/piction/6027262-12947296/.

6. Paul Cézanne, "Still Life with Fruit Dish," Museum of Modern Art, about 1879–1880, https://www.moma.org/collection/works/78670?artist_id=1053&page=1 &sov_referrer=artist.

7. Caroline D. Shields, "Objects of Memory: Paul Gauguin and Still Life Painting, 1880–1901," 7.

8. Elisabeth Walter, "'Le Seigneur Roy': Louis Roy, 1862–1907," *Bulletin des Amis du Musée de Rennes* 2 (1978): 61–78.

9. Henry Glassie, "The 2011 Charles Homer Haskins Prize Lecture: A Life of Learning," in *ACLS Occasional Paper*, vol. 68, 2011, x.

10. Michael Findlay, "The Catalogue Raisonné," in *The Expert versus the Object: Judging Fakes and False Attributions in the Visual Arts* (Oxford: Oxford University Press, 2004), 55.

11. Georges Wildenstein, *Gauguin* (Paris: Les Beaux-Arts, 1964), 146, https://wpi .art/2019/01/14/gauguin/.

12. Ronald Spencer, "Authentication in Court: Factors Considered and Standards Proposed," in *The Expert versus the Object: Judging Fakes and False Attributions in the Visual Arts* (Oxford: Oxford University Press, 2004), 189–215.

13. John Tancock, "Issues of Authenticity in the Auction House," in *The Expert versus the Object: Judging Fakes and False Attributions in the Visual Arts* (Oxford: Oxford University Press, 2004), 46.

14. Paul Gauguin, *Self-Portrait*, Detroit Institute of Arts, ca. 1893, https://dia.org/ collection/self-portrait-45667.

15. Wildenstein Plattner Institute, Inc., ed. Texts by Richard R. Brettell and Elpida Vouitsis. Research by Françoise Marnoni, Evgenia Kuzmina, and Jennifer Gimblett, "Gauguin: *Catalogue Raisonné* of the Paintings, 1891–1903." Gauguin: *Catalogue Raisonné* of the Paintings, 1891–1903. Edited and compiled by the Wildenstein Plattner Institute, Inc., n.d., https://digitalprojects.wpi.art/artworks/gauguin/.

16. Noah Charney, *The Art of Forgery: The Minds, Motives and Methods of Master Forgers* (London: Phaidon Press, Ltd., n.d.), 17.

17. Zara Anishanslin, *Portrait of a Woman in Silk* (New Haven and London: Yale University Press, 2016), 7.

18. Zara Anishanslin, 3.

CHAPTER ONE

~

The Gauguin Dossier

A man rides his bicycle along a country lane in southwestern France. It is a Sunday afternoon in August in 1903; the cicadas sing in the hedges. The man is on his way to his family's grand country home with its terrace that looks out across the valleys to the Pyrenees's snow-covered peaks. It is a grand house, but it is also a comfortable family house. Visitors stop by regularly for a long lunch or tea. The cyclist's companion Annette and their daughter Agnès come and go. The man—his name is Daniel de Monfreid—is an artist, and he is also the friend of artists. He is lean and balding with a glorious, carefully maintained beard and piercing eyes. A self-portrait from about this time shows him in his studio, wearing a linen smock tied at the neck with a blue silk spotted scarf; his graceful long fingers are interwoven. A painting of the family home hangs behind him as he regards the viewer.[1] Monfreid's journal, which he updated every day for thirty-three years, opens the door to his daily life: he works each day in his studio. He rides his bicycle to town and back. Sometimes his daughter is sick; sometimes his companion has a migraine. Sometimes there are raspberries for tea.[2] He corresponds with friends and connections in Paris, Copenhagen, Tahiti. He looks after the affairs of a friend who has left France: he watches over his own collection of this artist's work, sends him supplies, writes encouraging, gossipy letters.

Monfreid is nearly home now, riding into the courtyard and stepping off his bicycle. Up the stairs and inside, the doors open to catch the breeze. There is a letter. Posted nearly four months earlier, it has arrived today, Sunday, August 23, 1903. The letter is not from his usual correspondent in

11

Tahiti; it is from the local authorities. He opens it, reads it quickly and then slowly. The artist Paul Gauguin is dead.[3]

Gauguin died on May 8, 1903, in Atuona, on the coast of Hiva Oa, part of the Marquesas Islands colonized by France. Word of his death reached Europe on August 23: Daniel de Monfreid, coming home from a trip to the thermal baths in the next village, was the first to receive the news. Monfreid had been Gauguin's most regular correspondent during his years in Tahiti and the Marquesas, the friend who continued to write even when the responses were cranky and demanding. Gauguin regularly sent Monfreid works: by 1903, Monfreid had a dozen paintings, ten sculptures, several manuscripts, and countless works on paper.[4] These works are now dispersed around the world, from the Musée d'Orsay to the Art Institute of Chicago, the Los Angeles County Museum of Art, and the Kunsthaus Zürich.

That day Monfreid posted a letter (and noted in his journal that the stamp cost 15 centimes) to Gauguin's Paris dealer, Ambroise Vollard, and ordered printed announcements of Gauguin's death.[5] Over the next few weeks he spread the news, mailing out the announcements on August 30,[6] writing to Gauguin's old friends Emile Schuffenecker and Gustave Moreau, and to the critic Roger Marx, sending a note to the artist Paul Signac on September 8.[7] Not until almost two weeks later did Monfreid realize that no one would have informed Gauguin's widow Mette, in Copenhagen, of her husband's death, and sent off a letter.[8] As the word spread across Europe, Monfreid spent more and more of his time over the next few months working to settle Gauguin's estate. There were letters back and forth to administrators in Tahiti regarding the artist's property; letters and artworks back and forth to Vollard and to a few other collectors; articles and memoires to write for artistic reviews, eulogizing his friend.[9] Monfreid's journals for the rest of his life would reference Gauguin, regarding lending out his collection, selling pieces, visiting other collections of Gauguin, working with Gauguin's survivors to market his works.[10] Monfreid was only one source of Gauguin's pieces; there were others who had Gauguins in back closets, over the mantel, under the bed. Dozens would appear on the market over the next decades. The peripatetic nature of the last two decades of Gauguin's life meant that canvases, sculptures, ceramics, and works on paper were scattered. And there would be no central authority, no wife or child or gallerist, who could authenticate them with certainty. There is no consensus still.

Leavings

Paul Gauguin left things behind. Not only things; people and places, too. Over the last twenty-five years of his life—the years in which he began to make art, and then dedicate himself to his work as an artist—he moved over a dozen times. The first moves were across Paris. Then he moved his family to Rouen, where life was cheaper. From Rouen, he moved to Copenhagen, then back to Paris in 1886. A short time later, he began to spend summers in Brittany. Then it was off to Martinique for a year; back to Paris; back to Brittany; back and forth, Paris to Brittany;[11] and, in 1891, off to Tahiti for two years. He returned to France in 1894 for a brief stay before departing again for Tahiti. In Tahiti Gauguin moved almost as regularly as he had in Europe, from one village to another and, ultimately, to the Marquesas Islands. There he died in 1903, in a house he had built on land he did not own.[12] On none of these peregrinations did Gauguin take a long lease, much less purchase property: he lived in short-term rentals, slept in friends' studios, stayed in inexpensive hotels. There was no family home. For most of those years, there was no close family.

Gauguin had married Mette Gad, a Danish woman, in Paris in 1878, when he was thirty. They met through his guardian and mentor, Gustave Arosa. Young Gauguin was making a good living as a stockbroker and the couple took up a bourgeois life. Children arrived, five in seven years. The beginning artist painted the children, painted the comfortable apartment, painted his wife and their nursemaids.[13] He visited galleries exhibiting the new art and bought paintings here and there; he kept one Cézanne still life with him for over a decade, studying the arrangement of its apples.[14] Pissarro invited Gauguin to paint with him. The artists and their families spent holidays in the countryside, the men with their easels and paint boxes and the women with the children and picnics. Pissarro brought Gauguin into the Impressionist circle and Gauguin exhibited with them. Life may have gone on in this way, and we might remember Gauguin as a minor painter and collector who moved at the edges of the Impressionist movement. Paul and Mette might have brought up their children in middle-class Parisian comfort, with shopping trips to the Bon Marché and seaside vacations in Normandy.

But the French stock market crashed in 1882. Gauguin, at thirty-four, lost his job. Instead of joining another firm, the father of five decided to devote himself to his art. This was the beginning of his artistic career and the end of his family life. After a few years of declining income Mette persuaded him that they should move to Copenhagen, to be closer to her family. Gauguin halfheartedly joined a firm selling canvas wholesale. Within a year he was

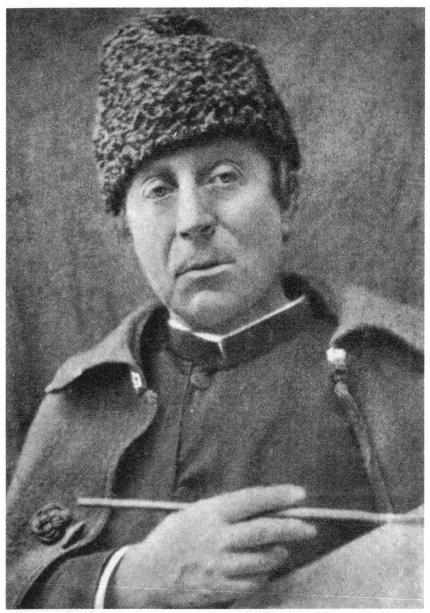

Fig 1.1. Paul Gauguin, French Post-Impressionist painter, 1888. A photograph from Album de Photographies, Dans L'Intimite de Personnages Illustres, 1850-1950, Editions MD, 22 Rue de L'Arcade, Paris 8, 1850-1950. *Source:* HIP, Art Resource, NY

back in Paris, convinced that he could find more success on his own than with his wife and children. There were rented attic rooms and miserable jobs. One winter he took hourly work putting up posters. Still, he kept painting, sketching, drawing. He took up ceramics. He exhibited when and where he could.[15] And when he moved on from one temporary address to the next, Gauguin stored his work with his friends, or shipped a few crates off to Copenhagen for Mette to try to sell. Gauguin's work held almost no economic value. It was not important to keep close track of where he stored it, where he left it. He was always thinking that he would be back shortly, that his friend with the spare closet did not need the extra space, that his studio-mates would not mind packing things up and shipping them on to the next, surely long-term, address. The result? There was art here and art there, but everything was nowhere.

Gauguin saw no financial success as an artist in his lifetime. He fulfilled a few commissions: he sold some paintings in gallery shows and, in 1894, at auction. But there was no steady stream of buyers, no patron. His career and his life were never, once he left the financial world, on a steady foot-ing. What he did not lack was friends or, more often, followers. As he grew more confident in his artistic experiments, younger artists were drawn to him, drawn to his charisma and personality, his commitment and certainty. Whether it was young Charles Laval, who agreed to accompany Gauguin on an artistic mission to Panama and Martinique, or Emile Bernard, who set up his easel beside the older man in the Breton village of Pont-Aven; whether Gauguin's peer (and former stockbroking colleague) Emile Schuffenecker putting him up in Paris, or the Dutch artist Meier de Haan paying for his room and board in exchange for painting tips in Le Pouldu on the Breton coast, there always seemed to be someone coming along who was good for a few months or years of support.[16] Often those friendships ended. Sometimes they ended precipitously. And when they did, the canvases and sketchbooks that Gauguin had traded with his friends of the moment might not have been returned.

Contrasting Gauguin's life and death with his near-contemporary Pierre Renoir can be instructive. Renoir lived to be seventy-eight, spending the last decades of his life living with his companion of almost forty years and their children in retirement on the Riviera.[17] His adult sons, Claude, Pierre, and Jean, took charge when their father died. They chose the Galerie Barba-zanges to act as one of the primary dealers for their famous father's treasured works; the staff at Barbazanges kept careful records of the canvases that came and went from their gallery, and the Renoir sons paid careful attention that the family was being paid appropriately. Well over three hundred paintings,

drawings, and works on paper by Renoir passed through the Barbazanges gallery between 1918 and 1924.[18] Many of those works traveled directly from the artist's studio or the family to the gallery and thence to public and private collections. The journey was short. From easel to family storage to gallery, not many hands touched the art.

When Gauguin died at fifty-five, his body of work was scattered around the world. Some works were in the Marquesas and would find their way back to France over time. Some were in Tahiti. Some were with Monfreid.[19] Some were with his wife Mette Gad in Denmark,[20] some with the former innkeeper Marie Henry in Brittany. The art dealer Ambroise Vollard held a number of works in Paris.[21] So did Gauguin's estranged friend Emile Schuffenecker,[22] and so did assorted other friends, like Paco Durrio.[23] Even Louis Roy had a few canvases stored in his apartment in the rue Lafayette.[24] The scattered locations of Gauguin's work at the time of his death created opportunities for confusion that persist over a century later. There was no constant place, and no constant person, who could take charge of the artist's legacy.

Defining a Legacy

There was no one to take charge of defining a legacy, but there were those who tried. On September 30, 1903, Gauguin's friend and literary collaborator Charles Morice, editor of the journal *Le Mercure*, asked a "a small number of well-placed individuals" to offer their opinions "in a page or more, on what you think of Paul Gauguin: his talent, his doctrine, his body of work, his influence, his attitude?" Morice published responses from eighteen artists and writers on November 1.[25] Some were abrupt: the socially well-placed collector and editor Alidor Delzant wrote that "about M. Gauguin, [he] had nothing in particular to say." "I am one of those retrogrades," he confessed, "who prefers talent without genius to genius without talent!" The art critic Jean Dolent recalled Toulouse-Lautrec's comment that Gauguin "was a hard pill to swallow." The artist Maximilien Luce responded that it had been so long since he had seen any works by Gauguin that he had forgotten what they looked like. The Symbolist poet Henri de Regnier did not feel qualified to judge Gauguin himself but did remember that Stephane Mallarmé, whose work Regnier admired, had thought a lot of him "and that's something."

Morice included Louis Roy, to whom *Flowers and Fruit* is inscribed, on his list of Gauguin watchers. Roy replied with observations that suggested that he separated his thinking about the artist from his experience with the man. Gauguin, he wrote, was both "cunning" and "as ingenuous as a child." He often pretended to know less than he did about the craft and practice

of art, yet he invented a new technique that turned traditional methods upside down. Roy noted that Gauguin could sometimes get in his own way ("an overweening desire to shock"), but the importance of his work was without doubt. "He was a master whose talent, sometimes disconcerting for his friends, was undeniable even for his enemies."[26] Roy's reflection demonstrated a degree of distance. Francisco Durrio, known as Paco, a Spanish painter whom Gauguin had befriended on his return from Tahiti to Paris in 1893, expressed something close to adulation: "My affection for the man was profound; my admiration for the artist, absolute." Gauguin was, for Durrio, "the equal of the greatest old masters."[27] Durrio is effusive where Roy is restrained, which is perhaps a measure of the comparative lengths of time they had spent in Gauguin's company. The painter and collector Antoine de la Rochefoucauld, who had known Gauguin briefly, reflected that he hoped someday to see Gauguin's work as respected as that of Manet, Monet, Pissarro, and Renoir, even to see it hanging in the Louvre, "but," he sighed, "what a revolution, what upheavals" would have to occur for that result.[28]

The seeds of that revolution were already growing. While Morice's memorial article was still on newsstands, Ambroise Vollard opened an exhibition of Gauguin's works at his gallery at 9, rue Lafitte. Vollard had begun buying and selling paintings out of his apartment in Montmartre in the early 1890s; by 1893, he had opened his first gallery. He had exhibited Gauguin's works twice before, in 1896 and 1898. Those shows each included around a dozen works that Gauguin had brought back to Paris from Tahiti after his 1891–1893 sojourn there as well as works he had sent to Monfreid after his 1894 final return to the South Seas. They were brightly colored scenes of partially clothed Tahitians, mostly women, in lush tropical surroundings. There were mangoes and bananas, dormant volcanoes, and stone-faced idols, utterly different from everyday sights in Paris. From November 4–28, 1903, Vollard hung fifty paintings and twenty-seven drawings on the walls of his gallery. That many works by Gauguin would not appear together again for two decades.[29]

Although Vollard's exhibition was not a short-term financial success, it marked the beginning of a series of exhibitions of Gauguin's works in Europe and the United States. His work would figure in two shows in 1904; three in 1905; five in 1907; and ten in 1910. The shows would take place across Europe: from Brussels to Moscow, Stockholm to Florence, Paris to Budapest. Many of the exhibitions featured the same artists. As early as 1903 at the 16th Secessionist Exhibition in Vienna, works by Gauguin, van Gogh, Redon, and Denis were hung together.[30] As the decade continued, the same works traveled Europe together. The *Libre Esthetique* gallery in Brussels hung

Manet, Cézanne, Signac, Denis, and Gauguin together in 1904; in 1905, works by Manet and Gauguin traveled to Berlin for a show at the Weimar Museum. The crates of paintings were unpacked in Budapest in May 1907 and in Prague that October. In 1908, they went to Moscow.[31] In each venue, they were shown as part of a wide-ranging group of artists. The thread through each of the exhibitions was generalized: here was some art from the last half century, come take a look. Critics did, and their responses showed they were aghast and appalled. The German art journal *Die Kunst-Halle* printed a warning to its readers about the 1905 Berlin exhibition: "Watch your pocketbooks." The show, brought to Berlin by nefarious dealers out to hoodwink the public, included the work of an artist—Gauguin—even more idiotic than van Gogh.[32]

Initially, Vollard lent most of the traveling Gauguins. As time went on, though, works appeared on loan from private collectors. The paintings and drawings, watercolors and engravings, initially owned or consigned to Gauguin's circle of friends and family began to disperse. The collector Jeanne Chausson lent *Why Are You Angry*, purchased from Monfreid in 1897, to a show in Brussels in 1904.[33] In 1909, the German writer and editor A. W. von Heymel lent a landscape to the International Art Show organized by artists Gustav Klimt, Egon Schiele, and Oskar Kokoschka in Vienna, a show that brought together the leading avant-garde artists of the time.[34] Baron Adolf Kohner, of Budapest, bought two Tahitian canvases from the Galerie Miethke, in Vienna, which had acquired them from Vollard in about 1905; he lent them to the National Impressionist Show in Budapest in 1910.[35] That dispersal rippled across the Atlantic, reaching the United States. Chicago native Emily Crane Chadbourne was a regular traveler to Paris in the years before World War I. Her friends Gertrude Stein and Alice B. Toklas likely introduced her to Spanish artist Paco Durrio, with whom Gauguin had left behind paintings and works on paper. Chadbourne bought drawings and watercolors from Durrio, and would lend them to a series of exhibitions before donating them to the Art Institute of Chicago in 1922.[36]

On November 5, 1910, at London's Grafton Galleries, an exhibition opened that, in the words of scholar J. B. Bullen, "became at once the most widely publicized and also the most notorious exhibition in the history of art."[37] Called "Manet and the Post-Impressionists," it introduced the British public to the work of the late nineteenth-century French avant-garde. Manet (8 paintings), Cézanne (21 paintings), and van Gogh (22 paintings) were all there. But the artist with the most wall space was Paul Gauguin: there were thirty-six paintings and ten drawings.[38] The art critic, connoisseur, and editor of the *Burlington Magazine* Roger Fry had made several trips to Paris to

assemble the exhibition, borrowing from dealers like Vollard and collectors like Durrio.

London critics called the 1910 Grafton show "debased," "intolerable," "sickening," and "morbid."[39] Gauguin's works drew particular attention. Fry had chosen Gauguin's 1896 *Poèmes Barbares* [*Savage Poems*] as the image on the exhibition's publicity poster. It depicted a young Tahitian woman with brilliant blue wings, nude from the waist up, seeming to make the Christian sign of the cross. A small monkey, eyes open wide, sits on a pedestal to her right.[40] The abstract background is a vivid shade of orange. Everything about it was shocking: the repurposing of Christian iconography, the colors, the title. A dozen of the Gauguins on view came from his time in the tropics.[41] Many of those were, according to the *Daily Express*'s critic, "primitive, almost barbaric, studies of Tahitian women." The paintings were "pornographic":

> In a typical canvas, hideous brown women, with purple hair and vitriolic expressions, crouch in the middle of a nightmarish landscape composed of sickly palm trees, apple green grass, red rocks, and many garishly colored plants, impossible to identify.[42]

Would the paintings have been less shocking if they depicted identifiable tropical plants? Perhaps. But as it was, the message was clear: the temple of art was under siege from the forces of barbarism and anarchy.

And yet, alongside this perhaps overloud revulsion, there were murmurs of curiosity and connection. When Fry's show closed, the critic for the *Daily Graphic* observed that "during the first week or two of the exhibition spectators used to shout with laughter in front of Van Gogh's *Girl with the Cornflower*, or Gauguin's *Tahitians* . . . but on Saturday the general attitude was one of admiration."[43] A few critics argued that primitive did not necessarily equal barbaric. They compared Gauguin and his peers' experimentation with representation to earlier European artists, to the painters in fourteenth-century Italy who experimented with form and line. That shift—from classifying Gauguin's work as barbaric, as in a rejection of European models, to primitive, meaning a return to the study of form and color—carried the critical day. When the Stafford Gallery opened a show of Cézanne and Gauguin later in 1911, critics praised Gauguin's "genius for decoration" and his "strong and sensitive gift for drawing."[44] Gauguin was, for the first time, welcomed into the broader art world, a critical step toward his work increasing in economic and cultural value.

Breaching the Museum Walls

In the same year that Fry hung thirty-seven Gauguins in London, the Louvre accessioned, almost by accident, its first painting by the artist. *Still Life with Oranges* (about 1881) shows us a fruit bowl containing five oranges. Two more sit on the table beside the bowl, next to one that has been peeled and broken open. A white porcelain vase ornamented in blue sits beside the fruit; all are arranged on a tabletop before a wall covered in lightly patterned blue and white paper. The painting came into the Louvre's collection as a part of the legacy of Ernest Chaplet.[45] Chaplet was a celebrated ceramicist; in the 1880s Gauguin had been his student and perhaps in payment he had given Chaplet this still life. The Musée du Luxembourg, the branch of the Louvre which held modern and contemporary art, had acquired several of Chaplet's works directly from the 1900 *Exposition universelle*,[46] and so when Chaplet's heirs approached the museum in 1910, the staff was happy to accept the collection of beautifully formed and glazed vessels. The catch? Chaplet's vases and ashtrays came with a painting by Paul Gauguin. At least the museum was not obligated to exhibit it. It went deep into collections storage, not to emerge until 1929—by which time, Gauguin's work had breached other museum walls.

After 1910, dealers continued to organize exhibitions including Gauguin, and sometimes centered around him: in 1911, Galerie Bernheim-Jeune in Paris included his work in two exhibitions, and he also figured in exhibits in Cologne and London. The French Institute in St. Petersburg showed twenty Gauguins in the winter of 1912, and assorted works traveled across Germany, Austria, and the Netherlands that year and the following.[47] A few museums began to add Gauguins to their collections. The Danish National Art Museum purchased a landscape entitled *Late Winter, Pont-Aven, Breton and Calf* in 1912.[48] It showed a rural scene, with the village of Pont-Aven in the middle distance. Pastures beyond and before it are beginning to turn green, and in the foreground a cowherd adjusts his clog while his calf nibbles at a hedgerow. Barren trees divide the canvas diagonally, creating two scenes: the village in the distance, and the Breton and his calf on a path. It is startling in terms of perspective—the Breton's backside is cropped out of the frame, and the trees are almost fence-like in their division of the canvas—but ordinary in terms of subject matter: no Tahitians here, just a country scene. The perspective was innovative, and the style, but the topic was no different than a dozen other artists at the time could have chosen.

In 1917, London's Contemporary Art Society donated an oil, crayon, and charcoal drawing of a Tahitian scene to the Tate Gallery.[49] The study, made

on about a square yard of paper, is unfinished. The left side features a loin-cloth-garbed Tahitian man striding across a background of lush palm trees; on the right is a roughed-out pencil image of women sitting and reclining on the floor of a veranda. One of the women appears to be playing a concertina. The women, unlike the man, are modestly clothed in the long-sleeved, high-necked cotton gowns distributed by Christian missionaries in Tahiti. The subject matter is exotic, but not all the way to scandalous—and, as a work on paper, it was a lesser investment than an oil painting would have been. Easier to accept, perhaps, without calling a board meeting. England's National Gallery, the Tate's more conservative cousin, acquired a painting from Gauguin's Tahiti period in 1918: his 1896 *Bouquet of Flowers*.[50] Tahitian, yes, but a still life: exotic but familiar blooms (bougainvillea, frangipani, and hibiscus) but no exotic people.

The broader the circle of collectors, the more Gauguin's reputation could begin to shift from being a dangerous rebel to being the inventor of a new style. His works became more valuable, more coveted, as his reputation shifted; they ceased being nightmarish daubs and turned into colorful innovations. During World War I, well-to-do Danish art enthusiasts William and Henny Hansen bought seven paintings by Gauguin, which formed the core of the collection that is now in the Ordrupgaard Museum in Charlottenlund, Denmark.[51] The Hansens put Gauguin on their Paris shopping list alongside Manet and Degas, Renoir and Monet, Cézanne and Pissarro, Matisse and Vlaminck. The Paris gallery world was small, the number of dealers who specialized in late nineteenth- and early twentieth-century works smaller still. Word was passed from dealer to dealer when works were bought and sold. The father and son gallerists Robert and Léon Marseille might hint, over a quick morning coffee with one of their makers of picture frames, that they had sold Gauguin's *Femme maorie couchée, vue de dos [Tahitian Woman]* to the Hansens,[52] and that framer could pass the information along over that evening's aperitif with a colleague. The next morning that colleague could deliver to Vollard, or Bernheim-Jeune, or Druet, or any of the dealers with Gauguins in their storerooms, the news that the Marseilles, father and son, had sold a Gauguin to some Danes this week, along with some newly gilded frames. And Vollard, or Bernheim-Jeune, or Druet, could check their stockbooks and flip through the canvases leaning against their storage walls, and think about who might be enticed.

Ambroise Vollard sold Gauguin's *Tahitian Pastoral* to the wily dealer Joseph Duveen, who helped wealthy Americans like Andrew Mellon build their collections, in 1918 or 1919.[53] Vollard had been lending the large landscape with figures to exhibitions at least since 1906. Duveen was nearing

the height of his career as an international art dealer and connoisseur. He worked regularly with wealthy collectors building prestigious collections, and had a network spread throughout Europe and across the Atlantic that kept him informed of who was buying and who was selling. Duveen promptly, and with characteristic flair, donated his new Gauguin to the Tate Gallery,[54] with which he had an ongoing relationship of patronage. Duveen donated funds and art to the Tate, and in return, being known as a patron of the Tate increased Duveen's status in the art world.[55] The mural-like *Tahitian Pastoral* [*Faa Iheihe*], over five feet long, shows groups of figures in what appears to be an earthly paradise of fruit, flowers, and harmony: exotic plants abound, and the six human figures are stylized. The partially nude figures appear to be almost in a dream state, unfocused eyes looking away from the viewer and one another, absorbed in their tropical surroundings. The atmosphere is more folklore than bohemia. That may have made it more welcome to the Tate. Gauguin's work was slowly shifting from being seen as scandalous to merely shocking.

Gauguins for Sale

Perhaps the most significant shift in recognition of Gauguin's work on the market came in the wake of the sale of artist Edgar Degas's collection in 1918. The Impressionist artist had died in 1917, and his studio collection—consisting of his own work and the works of others he had amassed over the previous decades—was sold in eight separate sales, organized by the dealers Bernheim-Jeune, Durand-Ruel, and Vollard. Degas's own works went into five separate sales and his collection, into three.[56] The first collection sale was held on March 26 and 27, 1918.[57] World War I still raged; Germany had begun what would be its final offensive on March 21. The *Gazette de l'Hôtel Drouot* recounted that "the sale took place during one of the most critical moments of the war, when the German armies [were making] their final and supreme effort to march on Paris, and the [German and French cannons] were unloading on the capital their murderous, destructive weapons."[58] Many fled the auction. Those who stayed—those who, in the words of the *Gazette*, "maintained their *sang froid*, their full confidence in the ultimate success of our cause"[59]—bid big on canvases from Old Masters including El Greco, to nineteenth-century French stalwarts Ingres, Delacroix, and Corot. But what was most surprising to some were the prices that Degas's collection of his contemporaries' work brought. Nine works by Gauguin came under the hammer, works that ranged across the artist's career from his early amateur days to his time in Pont-Aven, and even onward to

Tahiti. They brought some of the artist's highest prices to date: art dealer Paul Rosenberg bought two Tahitian Gauguins, *Woman of the Mango*[60] and *The Moon and the Earth*, each for 14,000 francs.[61] Ambroise Vollard bought the 1889 *La Belle Angèle* for 3,200 francs; the dealer Jos Hessel bought two landscapes, one from Martinique (8,000 francs) and one from Tahiti (14,010 francs). There was bidding competition, too: Rosenberg's *The Moon and the Earth* had been estimated at 10,000 francs, Hessel's Tahitian landscape at 8,000.[62] These were high prices for Gauguin; one critic noted that they simply "defied common sense."[63]

They may have defied common sense for some, but for others they signaled a warming of the climate for Gauguin sales. The following year brought another shocking price: in March 1919, agents from the Knoedler Gallery purchased Gauguin's masterwork *Hail Mary* [*Ia Orana Maria*] at Drouot for 58,000 francs.[64] The *Gazette* was astonished. The sale was "the event of the auction." Dealers and experts had tripped over one another bidding on it: Georges Bernheim, his cousin Bernheim-Jeune, their cousin Jos Hessel, the Scandinavian dealer Hansen, had all competed for the winning bid. It was a shocking amount, in 1919, for a modern painting to bring. The *Gazette* noted that the previous owner "had bought the painting for only 300 francs in 1894."[65] It was not a bad return on investment. Others noticed.

Three months after *Hail Mary* sold at Drouot, Gauguin's former innkeeper Marie Henry signed the first of several contracts with the Galerie Barbazanges, which regularly exhibited artists from the avant-garde.[66] Madame Henry ultimately consigned or sold to the gallery twenty-eight works that the artist had left behind when he left Le Pouldu in 1891. Le Pouldu was 14 miles south and west of Pont-Aven, far enough from the crowds of painters and vacationers who occupied the larger town. Gauguin moved into Henry's Buvette de la Plage in October 1889. The buvette remained his base for much of the next year, barring a few trips to Paris. In autumn 1890, Gauguin left the inn, leaving behind an unknown number of paintings, drawings, and sculptures. He went to Tahiti in April 1891 and returned to Le Pouldu in May 1894, looking to recoup his crates and canvases from Henry. But she had moved away from Le Pouldu and had taken his work with her. Gauguin brought two lawsuits against Henry, seeking to take back what he had left behind. Both judges ruled in favor of the former innkeeper: the painter had left his strange work behind, and left his bills unpaid. Marie Henry was entitled to the work, such as it was, as recompense. Gauguin left Brittany and, a few months later, France, never to return. His Le Pouldu work had moved with Marie Henry, first to the nearby town of Moëlan-sur-Mer and then to the large, comfortable house that she and

her companion Henry Motheré built overlooking the sea in Kerfany, in a remote corner of Brittany.[67]

Almost thirty years later, Marie Henry decided it was time to sell some of her collection. Word of the Degas sale would have traveled to Kerfany; the Henry Motheré household had close ties to Paris. Motheré was a writer and translator; he had been an art critic.[68] The artist Pierre Bonnard had been his classmate at the elite Lycée Louis le Grand, and the two had become lifelong friends.[69] Marie Henry and Motheré lived in a comfortable two-story home with a sunny terrace; their house was a gathering place for artists and visitors from the capital. Gauguin's associate, the artist Charles Filiger, became a close friend. Gauguin's student and follower Paul Sérusier was a visitor; the Polish painter Wladyslaw Slewinski, whom Gauguin had painted, was a regular guest. The scientists Pierre and Marie Curie vacationed in Kerfany. Madame Alfred Dreyfus, whose husband had been at the center of the Dreyfus affair, came to take the sea air.[70] When visitors came to the house, they saw Henry's collection; decades later, Breton artist André Jolly would recall seeing "paintings by Jourdan, Laval, Seguin, Sérusier, Bernard, Moret, Maufra and Meijer de Haan, very interesting, like Gauguin, but even more aggressive."[71] And the couturier Paul Poiret, from whom the Galerie Barbazanges rented its premises in the rue du Faubourg Saint-Honoré, lived down the lane.

Perhaps after reading the reports of the prices that the Gauguins brought in March, Marie Henry decided to sort through her paintings and sell a few. She did not travel to Paris to negotiate a deal with a gallerist; she did not work with a *commissaire-priseur* to put her collection up for auction. Instead, she chose her neighbor, Francis Norgelet, a writer and critic who lived much of the year in Paris, to represent her in negotiations with Paul Poiret's friends at the Galerie Barbazanges. Madame Henry negotiated four contracts with the Galerie Barbazanges between June 1919 and October 1920, ultimately selling them twenty-eight works by Gauguin for a price of around 75,000 francs.[72] It was a fortune in rural Brittany, where, in October 1919, one could purchase a small house for 6,000 francs and a 17-acre farm for 38,000 francs.[73] For the retired innkeeper, it was a significant windfall—and an impressive return on her investment in feeding and housing the artist. She celebrated by taking an extended trip to the Mediterranean coast.[74]

The Necessary Gauguin

In October 1919, the Galerie Barbazanges presented an exhibition they titled "Paul Gauguin: Unknown Works," at their showrooms in the rue du

Faubourg Saint-Honoré in Paris. Norgelet wrote the introduction to the exhibition catalog. He created a context in which visitors to the exhibition could imagine Gauguin, whom they would have known primarily for his Tahitian works, painting at the far edge of Brittany: "a wild bay where the Breton ocean changes color as it rumbles and breaks against the craggy deep purple rocks," "a great cloud of fog," "grey, white, gilded sand dunes." Beyond the dunes? Valleys with rocky outcroppings, and a forest of chestnut trees, twisted oaks, and aged apple trees. On the sea cliffs, "three or four small, weathered houses." The windswept, remote setting is worthy of a Gothic novel; all it needs is a mysterious hero.[75] Norgelet provides one:

> There—springing from the headland—something—an eagle or a seagull? It is a figure that embodies dignity: a proud face crowned with brown hair; a strong, imposing figure with a slow and serious gait, somber and confident movements. But in his sharp eyes and strong mouth we see a knowing keenness. It is Gauguin at Le Pouldu.[76]

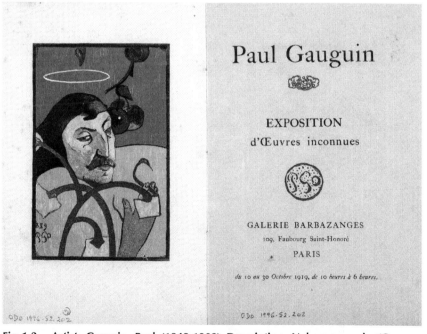

Fig 1.2. Artist: Gauguin, Paul (1848-1903) Description: Unknown works (Oeuvres inconnues). Frontispiece and title page. 1919. Fonds Barbazanges. ODO 2007 10 160. Photo: Allison Bellido. *Source:* © RMN-Grand Palais, Art Resource, NY

Norgelet's Gauguin is dignified, strong, proud, confident, keen, as much a part of the landscape as a bird of prey. We can hear the wind off the sea snapping his cape around his shoulders, smell the sea air, taste the salt of the spray. This is Gauguin the heroic genius, ready to capture the imagination of gallerygoers.

The Barbazanges exhibition presented the twenty-eight Gauguins the dealers had purchased from Marie Henry. It introduced a new version of Gauguin: Gauguin's work from Le Pouldu. The Paris art world knew the painter's Tahitian work, and knew his work from Pont-Aven. Vollard had made sure that those works had been exhibited everywhere that they might be likely to fetch a good price, or lay some useful groundwork. Other dealers and collectors had bought and sold works from Tahiti and Pont-Aven. A small group of friends and associates with connections to Brittany might have remembered that Marie Henry had kept paintings from her lodgers—but the larger art market, the dealers in the rue de la Boétie, the auctioneers in the streets around the Hôtel Drouot, had no idea. This group of paintings had spent decades hidden away in deepest Brittany. Barbazanges brought it to light. Reviewers were impressed. One critic wrote that

> what is striking is that the canvases are both powerful and delicate, of a profound quality that envelopes you, saturates you, moves your senses to the core. . . . All Gauguin is here, even his pair of carved and painted wooden clogs. In the center of the gallery is a stunning self-portrait of the artist. Its eyes pull you in like a fish in a net.[77]

Works from the show traveled to New York the following April, where dealer Maurice de Zayas exhibited them in his gallery. The *New York Herald*'s critic, Henry McBride, noted that "Gauguin has now become as powerful a bait as any art dealer cares to use to attract visitors to his galleries," and remarked on the continuity in style and color between these Brittany works and those from Tahiti.[78] The *Self-Portrait, 1889*, that had hung at the center of the Barbazanges Gallery was among the works that went to New York; it eventually found its way to the collection of Chester Dale, and thence to the National Gallery in Washington, DC.[79] Other works from Marie Henry's collection never went back to France: Gauguin's *Caribbean Woman* went to the collector John Quinn days after de Zayas's exhibition closed. His *Bonjour Monsieur Gauguin* and *View of Pont-Aven near Lézavan* went into the collection of New York enthusiast Meyer Goodfriend.[80]

A wave of interest in Gauguin and his work was building. Daniel de Monfreid had published some of his correspondence with Gauguin in 1918,

with a long biographical preface about Gauguin by the critic Victor Sega-len.[81] In 1919, Gauguin's old friend Charles Morice published a memoir of Gauguin whose opening sentence proclaimed Gauguin to have been "one of the most NECESSARY [sic] French artists of the nineteenth century."[82] English novelist Somerset Maugham's novel *The Moon and Sixpence*, loosely based on Gauguin's life, came out the same year.[83] Critics and journalists rushed to review the new books, and Maugham's novel was a bestseller, which "catapulted Gauguin to instant fame."[84] Maugham's novel, which told of an English stockbroker who abandons his family and friends to take on the life of an artist, succeeded in shifting Gauguin's reputation from being a scoundrel to being an anti-hero, as fascinating and even misunderstood as he was dishonorable.

Two years later, in 1921, writer Charles Chassé published *Gauguin et le Groupe de Pont-Aven: Documents Inédits*,[85] based on his correspondence with Henry Motheré. Marie Henry and Motheré had been together for nearly thirty years but had never married. Chassé wrote that he had asked "Mademoiselle Henry (today Madame Motheré)" to tell him what she remembered about the year that Gauguin and his friends had spent with her; Motheré had responded on "his wife's" behalf.[86] The subterfuge around the couple's unmarried state suggests that Chassé was writing for an audience to whom married respectability mattered, an audience, perhaps, more bourgeois than bohemian. Chassé described in detail, for the first time, Gauguin's stay in Le Pouldu. The "bohemian life" that American and English artists came to Pont-Aven to enjoy was too much of a distraction for Gauguin. He needed peace and quiet in which to work, an "artistic sanctuary" where he could devote himself to work "without fear of interruption or disturbance." With his newfound friend and sponsor, the Dutch artist Meier de Haan, Gauguin retreated to Le Pouldu and Marie Henry's Buvette de la Plage. "Le Pouldu," Chassé wrote, was Gauguin's "first Tahiti; his French Tahiti"[87]:

> Gauguin spent his whole life in this simple pursuit: to be able to work independently, with no servile obligation towards current trends, be they imposed by fashion or dealers or clients. He happily accepted the darkest physical misery . . . as long as it meant he was free to create with all the ardor and exuberance of his creative temperament.[88]

Chassé connected Gauguin's work from Le Pouldu with his work from Tahiti. Both demonstrated, he suggested, Gauguin at his best, undistracted and unconcerned by what anyone else thought. Drawing this connection served to increase the value of Gauguin's Le Pouldu work, something of

which the Motheré-Henry household was likely aware. The postman brought a copy of Chassé's book to the Motheré-Henry household on November 28, 1921. Two days later Marie Henry's daughter Léa wrote out Motheré's note thanking the author. Motheré was delighted with how the book had turned out; it would remain a classic work on "the Gauguin dossier."[89] Marie Henry had more Gauguins in the attic. She would divide her collection of dozens of works by Gauguin, de Haan, Sérusier, Filiger, and others between her two daughters, which the family would continue to sell from time to time.[90]

Between 1919 and 1923 there were a handful of Gauguins sold in Paris. The collector Alden Brooks bid a Gauguin painting of a willow tree up to 7,200 francs in December 1919,[91] and sold it the next year to Bernheim-Jeune.[92] In 1921 the Moch family purchased the painting now known as *Spring at Lézaven*[93] for 11,650 francs.[94] The Parisian dentist and collector of modern art Georges Viau purchased two still lifes at a sale of "Mantel clocks, Furniture, and Paintings by Gauguin," one for over the asking price of 4,000 francs and one for under.[95] And then, in April 1923, the gallerist Léon Marseille consigned a group of paintings by Gauguin and his Le Pouldu friend Charles Filiger to auction. Some of them were said to have come from the Roy Collection—a reference to Gauguin's associate, the schoolmaster and artist Louis Roy. One of the paintings was called *Flowers and Fruit*.

Notes

1. George Daniel de Monfreid, "Autoportrait à La Chemise Bleue, 1901," Musée d'Art Hyacinthe Rigaud Perpignan, accessed September 19, 2023, https://monfreid .musee-rigaud.fr/oeuvres/autoportrait-la-chemise-bleue.

2. George Daniel de Monfreid, "Carnet, Troiséme Trimestre, 1899," July 12, 1899, La vie au jour le jour de George Daniel de Monfreid, 1896–1929, Musée d'art Hyacinthe Rigaud Perpignan, https://monfreid.musee-rigaud.fr/.

3. George Daniel de Monfreid, "Carnet, Troisième Trimestre, 1903," August 23, 1903, La vie au jour le jour de George Daniel de Monfreid, 1896–1929, Musée d'art Hyacinthe Rigaud Perpignan, https://monfreid.musee-rigaud.fr/.

4. "Les Carnets de George Daniel de Monfreid, 1892–1929," Musée d'Art Hyacinthe Rigaud Perpignan, accessed September 19, 2023, https://monfreid.musee -rigaud.fr/les-gauguin-de-george-daniel-de-monfreid.

5. George Daniel de Monfreid, "Carnet, Troisième Trimestre, 1903," August 23, 1903.

6. George Daniel de Monfreid, "Carnet, Troisième Trimestre, 1903," August 30, 1903, La vie au jour le jour de George Daniel de Monfreid, 1896–1929, Musée d'art Hyacinthe Rigaud Perpignan, https://monfreid.musee-rigaud.fr/.

7. George Daniel de Monfreid, "Carnet, Troisième Trimestre, 1903," September 8, 1903, La vie au jour le jour de George Daniel de Monfreid, 1896–1929, Musée d'art Hyacinthe Rigaud Perpignan, https://monfreid.musee-rigaud.fr/.

8. George Daniel de Monfreid, "Carnet, Troisième Trimestre, 1903," September 12, 1903, La vie au jour le jour de George Daniel de Monfreid, 1896–1929, Musée d'art Hyacinthe Rigaud Perpignan, https://monfreid.musee-rigaud.fr/.

9. George Daniel de Monfreid, "Carnet, Quatrième Trimestre, 1903," La vie au jour le jour de George Daniel de Monfreid, 1896–1929, Musée d'art Hyacinthe Rigaud Perpignan, accessed September 11, 1903, https://monfreid.musee-rigaud.fr/.

10. George Daniel de Monfreid, "Carnet, Deuxième Trimestre, 1907," May 1, 1907, La vie au jour le jour de George Daniel de Monfreid, 1896–1929, Musée d'art Hyacinthe Rigaud Perpignan, https://monfreid.musee-rigaud.fr/carnets.

11. Daniel Wildenstein, Gauguin, A Savage in the Making: Catalogue raisonné of the Paintings, 1873–1888 (Milan and Paris: Skira; Wildenstein Institute, 2002), 269–331, https://wpi.art/2019/01/07/gauguin-a-savage-in-the-making/.

12. On Gauguin's life, see: David Sweetman, Paul Gauguin: A Complete Life (London: Hodder & Stoughton, 1995); Wladyslawa Jaworska, Gauguin and the Pont-Aven School (New York: New York Graphic Society, Ltd., 1972); Bengt Danielsson, Gauguin in the South Seas (New York: Doubleday, 1966); Cornelia Homburg, Gauguin: Portraits (London: National Gallery, 2019); Charles Chassé, Gauguin et le Group de Pont-Aven: Documents inédits (Paris, 1921); Daniel Wildenstein and Sylvie Crussard, Gauguin, A Savage in the Making: Catalogue raisonné of the Paintings, 1873–1888 (Paris, 2002); Richard R. Brettell and Elpida Vouitsis, "Gauguin in Tahiti, First Period, 1891–1893"; "Gauguin in Paris and Brittany, 1893–1895"; "Gauguin in Tahiti, Second Period, 1895–1901"; "Gauguin in the Marquesas, 1901–1903," in Gauguin: Catalogue raisonné of the Paintings, 1891–1903, edited and compiled by the Wildenstein Plattner Institute, Inc., https://digitalprojects.wpi.art/gauguin/introduction.

13. Wildenstein, Gauguin, 269–331.

14. Paul Cézanne, "Still Life with Fruit Dish," Museum of Modern Art, about 1879–1880, https://www.moma.org/collection/works/78670?artist_id=1053&page=1&sov_referrer=artist.

15. Wildenstein, Gauguin, 269–331.

16. Wildenstein, 269–331.

17. Hilary Spurling, Matisse the Master: A Life of Henri Matisse, the Conquest of Color, 1909–1954 (New York: Alfred A. Knopf, 2005), 216–20.

18. Claude Renoir and Jean Renoir, "Letter to Pierre Renoir, ODO 1996.52.249" (Cagnes-sur-Mer, March 3, 1922), Fonds Barbazanges, Documentation Center, Musée d'Orsay.

19. Wildenstein Plattner Institute, Inc., ed. Texts by Richard R. Brettell and Elpida Vouitsis. Research by Françoise Marnoni, Evgenia Kuzmina, and Jennifer Gimblett, "Te Raau Rahi, 1891, PGKJ37," Gauguin: Catalogue raisonné of

the Paintings, 1891–1903, 2023, https://digitalprojects.wpi.art/gauguin/artworks/detail?provenance=monfreid&a=71614-te-raau-rahi.

20. Wildenstein Plattner Institute, Inc., ed. Texts by Richard R. Brettell and Elpida Vouitsis. Research by Françoise Marnoni, Evgenia Kuzmina, and Jennifer Gimblett, "Paysage Tahitien Aux Troncs Bleus et Chevaux, 1892, PGLEM1," Gauguin: *Catalogue raisonné* of the Paintings, 1891–1903. Edited and compiled by the Wildenstein Plattner Institute, Inc., n.d., https://digitalprojects.wpi.art/gauguin/artworks/detail?provenance=mette&a=71810-paysage-tahitien-aux-troncs-bleus-et-chevaux.

21. Wildenstein Plattner Institute, Inc., ed. Texts by Richard R. Brettell and Elpida Vouitsis. Research by Françoise Marnoni, Evgenia Kuzmina, and Jennifer Gimblett, "Faaturuma, PG9246," Gauguin: *Catalogue raisonné* of the Paintings, 1891–1903. Edited and compiled by the Wildenstein Plattner Institute, Inc., 1891, https://digitalprojects.wpi.art/gauguin/artworks/detail?provenance=monfreid&a=71601-faaturuma.

22. Wildenstein Plattner Institute, Inc., ed. Texts by Richard R. Brettell and Elpida Vouitsis. Research by Françoise Marnoni, Evgenia Kuzmina, and Jennifer Gimblett, "Autoportrait à l'idole, c. 1893-95, PGYO1N," Gauguin: *Catalogue raisonné* of the Paintings, 1891–1903, n.d., https://digitalprojects.wpi.art/gauguin/artworks/detail?provenance=schuffenecker&a=71592-autoportrait-a-l-idole.

23. Wildenstein Plattner Institute, Inc., ed. Texts by Richard R. Brettell and Elpida Vouitsis. Research by Françoise Marnoni, Evgenia Kuzmina, and Jennifer Gimblett, "Tête de Tahitienne, 1891, PG1311," Gauguin: *Catalogue raisonné* of the Paintings, 1891–1903, n.d., https://digitalprojects.wpi.art/gauguin/artworks/detail?provenance=durrio&a=71625-tete-de-tahitienne.

24. "Le Collectionneur Olivier Sainsère . . .," n.d., Dossier Louis ROY, Musée de Pont-Aven Archives.

25. Charles Morice, "Quelques opinions sur Paul Gauguin," *Mercure de France* 48, no. 167 (November 1, 1903): 413–33, https://www.retronews.fr/journal/mercure-de-france/01-novembre-1903/118/4093401/125.

26. Morice, "Quelques opinions sur Paul Gauguin," 430–31.

27. Morice, 416.

28. Morice, 414, 415, 423.

29. Galerie L. Dru, *Exposition Retrospective de Paul Gauguin* (Paris: Galerie L. Dru, 1923).

30. Christian Heumer, "Historicizing the Avant-Garde: The 1903 Impressionist Exhibiton at the Vienna Secession," Database of Modern Exhibitions (DoME) | European Paintings and Drawings 1905–1915, September 7, 2018, https://exhibitions.univie.ac.at/blog/historicizing-the-avant-garde-the-1903-impressionist-exhibition-at-the-vienna-secession-by-christian-huemer.

31. Ida Gofman, "'Golden Fleece' 1906–1909: At the Roots of the Russian Avant-Garde," *Tretyakov Gallery Magazine* 1, no. 18 (2008), https://www.tretyakovgallerymagazine.com/articles/1-2008-18/golden-fleece-1906-1909-roots-russian-avant

-garde; "[Twenty-Third Exhibition of the Union of Fine Artists Manes in Prague 1907. French Impressionists] Třiadvacátá Výstava Spolku Výtvarných Umělců Manes v Praze 1907. Francouzští Impressionisté," Internet Archive, 2023, https://archive.org/details/frick-31072003190776; Octave Maus, *La Libre Esthétique: Exposition des Peintres Impressionistes 1904, Bruxelles* (Brussels: Imprimerie Veuve Monnon, 1904), bibliotheque-numerique.inha.fr/idviewer/26791/62.\\uc0\\u8221{} Internet Archive, 2023, https://archive.org/details/frick-31072003190776; Octave Maus, {\\i{}La Libre Esth\\uc0\\u233{}tique: Exposition Des Peintres Impressionistes 1904, Bruxelles} (Brussels: Imprimerie Veuve Monnon, 1904

32. Peter Kropmanns, "The Gauguin Exhibition in Weimar in 1905," *Burlington Magazine* 141, no. 1150 (1999): 24–31.

33. Wildenstein Plattner Institute, Inc., ed. Texts by Richard R. Brettell and Elpida Vouitsis. Research by Françoise Marnoni, Evgenia Kuzmina, and Jennifer Gimblett, "No Te Aha Oe Riri, 1896, PGXIE0," Gauguin: *Catalogue raisonné* of the Paintings, 1891–1903, accessed November 18, 2023, https://digitalprojects.wpi.art/gauguin/artworks/detail?title=no%20te%20aha&a=71722-no-te-aha-oe-riri.

34. "Internationale Kunstschau Wien, May–October 1909," Database of Modern Exhibitions (DoME) | European Paintings and Drawings 1905–1915, accessed November 18, 2023, https://exhibitions.univie.ac.at/exhibition/225.

35. Wildenstein Plattner Institute, Inc., ed. Texts by Richard R. Brettell and Elpida Vouitsis. Research by Françoise Marnoni, Evgenia Kuzmina, and Jennifer Gimblett, "L'Appel, 1902, PGRE5C," Gauguin: *Catalogue raisonné* of the Paintings, 1891–1903, accessed November 18, 2023, https://digitalprojects.wpi.art/gauguin/artworks/detail?title=l%27appel&a=71785-l-appel.

36. Robert Nelson, "The Art Collecting of Emily Crane Chadbourne and the Absence of Byzantine Art in Chicago," in *To Inspire and Instruct: A History of Medieval Art in Midwestern Museums* (Newcastle upon Tyne: Cambridge Scholars Publishing, 2008), 131–48; Paul Gauguin, "Two Tahitian Women in a Landscape, c. 1892, 1922.4795," Art Institute of Chicago, 2023, https://www.artic.edu/artworks/5513/two-tahitian-women-in-a-landscape; Paul Gauguin, "Seated Tahitian Youth, 1894/1903, 1922.4796," Art Institute of Chicago, 2023, https://www.artic.edu/artworks/5515/seated-tahitian-youth.

37. J. B. Bullen, "Great British Gauguin: His Reception in London in 1910–11," *Apollo* 500 (October 2003): 3.

38. Anne-Pascale Bruneau, "Aux Sources du Post-Impressionisme: Les Expositions de 1910 et 1912 aux Grafton Galleries de Londres," *Revue de l'art* 113, no. 3 (1996): 8.

39. Bullen, "Great British Gauguin: His Reception in London in 1910–11."

40. Wildenstein Plattner Institute, Inc., ed. Texts by Richard R. Brettell and Elpida Vouitsis. Research by Françoise Marnoni, Evgenia Kuzmina, and Jennifer Gimblett, "Poèmes Barbares,' 1896, PGSU6Q," Gauguin: *Catalogue raisonné* of the Paintings, 1891–1903, accessed December 1, 2022, https://digitalprojects.wpi.art/artworks/gauguin/detail/71720-poemes-barbares?all=poemes%20barbares.

41. Donald E. Gordon, *Modern Art Exhibitions: 1900–1916; Selected Catalogue Documentation*, vol. 2, Materialien Zur Kunst des Neunzehnten Jahrhunderts (München: Prestel, 1974), 436.

42. Anne-Pascale Bruneau, "Aux Sources du Post-Impressionisme: Les Expositions de 1910 et 1912 aux Grafton Galleries de Londres," 9.

43. Bullen, 11.

44. Bullen, 12.

45. Paul Gauguin, "Nature Morte Aux Oranges, Vers 1881," Musée d'Orsay, about 1881, https://www.musee-orsay.fr/fr/oeuvres/nature-morte-aux-oranges-75092#art work-history.

46. Ernest Chaplet, "Vase, Vers 1900," Musée d'Orsay, around 1900, https://www.musee-orsay.fr/fr/oeuvres/vase-3363.

47. M. M. Bernheim-Jeune & Cie, Paris, "L'Eau, June 26–July 13, 1911; La Montagne, July 20–August 5, 1911," Database of Modern Exhibitions (DoME) | European Paintings and Drawings 1905–1915, accessed November 18, 2023, https://exhibitions.univie.ac.at/exhibition/375, https://exhibitions.univie.ac.at/exhibition/379; "Erste Ausstellung der Freien Secession Berlin, April 12–September 30, 1914," Database of Modern Exhibitions (DoME) | European Paintings and Drawings 1905–1915, accessed November 18, 2023, https://exhibitions.univie.ac.at/exhibition/666; Institut Français de St Pétersbourg, "Exhibition 100 Years of French Painting (1812–1912): Выставка Сто Лет Французской Живописи (1812–1912)," Database of Modern Exhibitions (DoME) | European Paintings and Drawings 1905–1915, accessed November 18, 2023, https://exhibitions.univie.ac.at/exhibition/411; Galerie Arnot, Vienna, "Kollektion Moderner Franzosen, March–April 1913," Database of Modern Exhibitions (DoME) | European Paintings and Drawings 1905–1915, accessed November 18, 2023, https://exhibitions.univie.ac.at/exhibition/541; Wallraf-Richartz-Museum, Cologne, "Kunst Unserer Zeit in Cölner Privatbesitz, October 1911," Database of Modern Exhibitions (DoME) | European Paintings and Drawings 1905–1915, accessed November 18, 2023, https://exhibitions.univie.ac.at/exhibition/381; Stafford Gallery, London, "Exhibition of Pictures by Paul Cézanne (1839–1906) and Paul Gauguin (1848–1903), 1911," Database of Modern Exhibitions (DoME) | European Paintings and Drawings 1905–1915, n.d., https://exhibitions.univie.ac.at/exhibition/387.

48. Paul Gauguin, "Landscape from Pont-Aven, Brittany, 1888, SMK 3142," Kunstindeks Danmark & Weilbachs kunstnerleksikon, accessed November 18, 2023, https://www.kulturarv.dk/kid/VisVaerk.do?vaerkId=105253.

49. Paul Gauguin, "Tahitians, c. 1891," Tate, accessed May 10, 2023, https://www.tate.org.uk/art/artworks/gauguin-tahitians-n03167.

50. Wildenstein Plattner Institute, Inc., ed. Texts by Richard R. Brettell and Elpida Vouitsis. Research by Françoise Marnoni, Evgenia Kuzmina, and Jennifer Gimblett, "Bouquet de Fleurs, 1896, PGJYHU," Gauguin: *Catalogue raisonné* of the Paintings, 1891–1903, accessed November 18, 2023, https://digitalprojects.wpi.art/gauguin/artworks/detail?a=71725-bouquet-de-fleurs.

51. See, among others, Paul Gauguin, "Two Vases with Flowers, 1890, 243 WH," Kunstindeks Danmark & Weilbachs kunstnerleksikon, accessed November 18, 2023, https://www.kulturarv.dk/kid/VisVaerk.do?vaerkId=197539; Paul Gauguin, "The Wine Harvest [Misères Humaines]," Kunstindeks Danmark & Weilbachs Kunstnerleksikon, accessed November 18, 2023, https://www.kulturarv.dk/kid/VisVaerk .do?vaerkId=197388; Paul Gauguin, "The Blue Tree Trunks, or Your Turn Will Come, My Beauty! 1888," Kunstindeks Danmark & Weilbachs Kunstnerleksikon, accessed November 18, 2023, https://www.kulturarv.dk/kid/VisVaerk.do?vaerkId =197367.

52. Wildenstein Plattner Institute, Inc., ed. Texts by Richard R. Brettell and Elpida Vouitsis. Research by Françoise Marnoni, Evgenia Kuzmina, and Jennifer Gimblett, "Femme Maorie Couchée, Vue de Dos, 1898, PGGPWH," Gauguin: Catalogue raisonné of the Paintings, 1891–1903, accessed November 18, 2023, https://digi talprojects.wpi.art/gauguin/artworks/detail?provenance=marseille&a=71749-femme -maorie-couchee-vue-de-dos.

53. Wildenstein Plattner Institute, Inc., ed. Texts by Richard R. Brettell and Elpida Vouitsis. Research by Françoise Marnoni, Evgenia Kuzmina, and Jennifer Gimblett, "Faa Iheihe [Tahitian Pastoral], 1898, PGZYJ5," Gauguin: Catalogue raisonné of the Paintings, 1891–1903, accessed November 18, 2023, https://digitalpro jects.wpi.art/gauguin/artworks/detail?a=71742-faa-iheihe%3Fall%3Dfaa%20iheihe.

54. Paul Gauguin, "Faa Iheihe, 1898," Tate, accessed May 10, 2023, https://www .tate.org.uk/art/artworks/gauguin-faa-iheihe-n03470.

55. Philip Hook, Rogues' Gallery: The Rise (and Occasional Fall) of Art Dealers, the Hidden Players in the History of Art (New York: The Experiment, 2017), 91.

56. Ann Dumas, The Private Collection of Edgar Degas (New York: Metropolitan Museum of Art, 1997), 5.

57. Catalogue des Tableaux Modernes et Anciens: Aquarelles, Pastels, Dessins . . . Composant la Collection de Edgar Degas (Paris: Galerie Georges Petit, 1918), https:// gallica.bnf.fr/ark:/12148/bpt6k6476318p.

58. "Ventes Prochaines: Atelier Edgar Degas," Gazette de l'Hôtel Drouot, December 7, 1918, bibliotheque-numerique.inha.fr/idviewer/59638/223.

59. "Ventes Prochaines: Atelier Edgar Degas."

60. Wildenstein Plattner Institute, Inc., ed. Texts by Richard R. Brettell and Elpida Vouitsis. Research by Françoise Marnoni, Evgenia Kuzmina, and Jennifer Gimblett, "Vahine No Te vi, 1892, PGXK16," Gauguin: Catalogue raisonné of the Paintings, 1891–1903, n.d., https://digitalprojects.wpi.art/gauguin/artworks/detail ?title=tahitienne&provenance=degas&a=71626-vahine-no-te-vi.

61. "Revue Des Ventes: Collection Edgar Degas," Gazette de l'Hôtel Drouot, March 30, 1918, bibliotheque-numerique.inha.fr/idviewer/59638/67.

62. "Revue Des Ventes: Collection Edgar Degas."

63. Dumas, The Private Collection of Edgar Degas, 294.

64. In 1919, 58,000 francs was the equivalent of $10,266. In 2023 dollars, that is the equivalent of $182,645. See https://canvasresources-prod.le.unimelb.edu.au/projects/CURRENCY_CALC/ and https://www.officialdata.org/.

65. M. Knoedler & Co., "Painting Stock Book 6: 12653–15139, December 1911–July 1920," Getty Research Institute Special Collections, accessed August 11, 2023, http://hdl.handle.net/10020/2012m54b6.

66. "Sale Contract between Marie Henry and Galerie Barbazanges," June 7, 1919, Fonds Barbazanges, ODO 1996-52, no. 125, Musée d'Orsay, Archives and Documentation.

67. Jean-Marie Cusinberche, *Gauguin et ses Amis Peintres: La Collection Marie Henry, "Buvette de la Plage," Le Poldu, en Bretagne* (Yokohama: Le journal Mainichi, 1992).

68. Venita Datta, *Birth of a National Icon: The Literary Avant-Garde and the Origins of the Intellectual in France* (Albany: State University of New York Press, 1999), 33.

69. Cusinberche, *Gauguin et ses Amis Peintres: La Collection Marie Henry, "Buvette de la Plage," Le Poldu, en Bretagne*, 165.

70. Mallaurie Charles, "Marie Henry (1859–1945): Une Bretonne en quête d'émancipation" (Angers: Université Angers, 2020), 36–39.

71. Charles, "Marie Henry," 38.

72. "Sale Contract between Marie Henry and Galerie Barbazanges"; "Sale Contract between Marie Henry and Galerie Barbazanges-Hodebert & Cie," November 3, 1919, Fonds Barbazanges, ODO 1996-52, no. 126, Musée d'Orsay, Archives and Documentation; "November 3, 1919 Agreement between Marie Henry and Francis Norgelet" (n.d.), Fonds Barbazanges, ODO 1996-52, no. 127, Musée d'Orsay, Archives and Documentation; "Sales Contract between Marie Henry and the Galerie Barbazanges," October 20, 1920, Fonds Barbazanges, ODO 1996-52, no. 129, Musée d'Orsay, Archives and Documentation; "Agreement between Marie Henry and the Galerie Barbazanges," August 29, 1920, Fonds Barbazanges, ODO 1996-52, no. 128, Musée d'Orsay, Archives and Documentation.

73. "A Vendre . . . Une Maison; Adjudication Amiable . . .," *L'Union Agricole et Maritime*, October 12, 1919, Archives départementales du Finistère.

74. "Léa Henry Lollichon to Charles Chassé," November 20, 1919, Fonds Chassé, 97 J 1030, Archives departementales Finistère.

75. Francis Norgelet, "Paul Gauguin: Oeuvres Inconnus" (Galerie Barbazanges, October 10, 1919), Fonds Barbazanges, ODO 1996-52 no. 202, Musée d'Orsay, Archives and Documentation.

76. Norgelet, "Paul Gauguin."

77. Benvenuto, "Flâneries d'un Artiste," *La Gerbe Revue Mensuelle*, no. 14 (November 1919): 55–58, https://gallica.bnf.fr/ark:/12148/bpt6k61373259.

78. Henry McBride, "Brittany Pictures by Paul Gauguin," *New York Herald*, April 11, 1920, https://www.newspapers.com/image/64384736/.

79. Paul Gauguin, "Self-Portrait, 1889," National Gallery of Art, accessed May 10, 2023, https://www.nga.gov/collection/art-object-page.46625.html.

80. Susan Alyson Stein, "From the Beginning: Collecting and Exhibiting Gauguin in New York," in *The Lure of the Exotic: Gauguin in New York Collections* (New York: Metropolitan Museum of Art, 2002), 163–65.

81. Paul Gauguin and Victor Segalen, *Lettres de Paul Gauguin à Georges-Daniel de Monfreid / Paul Gauguin; Précédées d'un Hommage par Victor Segalen* . . . (Paris: G. Crès et Cie, 1918), https://gallica.bnf.fr/ark:/12148/bpt6k6572278m.

82. Charles Morice, *Paul Gauguin* (Paris: H. Floury), 5, accessed September 14, 2023, https://gallica.bnf.fr/ark:/12148/bpt6k6566007t.

83. Elmer Davis, "The Growing Puzzle of Mr. Maugham's Hero," *New York Times*, August 8, 1920, https://nyti.ms/3HGJTDA.

84. Stein, "From the Beginning: Collecting and Exhibiting Gauguin in New York," 161.

85. Charles Chassé, *Gauguin et le Groupe de Pont-Aven: Documents Inédits* (Paris: H. Floury, 1921).

86. Chassé, *Gauguin et le Groupe de Pont-Aven*, 25.

87. Chassé, 28.

88. Chassé, 32.

89. "Letter, Henry Motheré to Charles Chassé, November 30, 1921," n.d., Fonds Chassé, 97 J 1030, Archives departementales Finistère.

90. *Très Belles Estampes par Bonnard, Bresdin* . . . *Pastels - Gouaches - Aquarelles - Dessins par Bonnard, Boudin* . . . *Importante Sculpture par Paul Gauguin, Platre par Rodin, Céramiques Peintes par Filiger, Gauguin, Tableaux par Bauchant, de Belay* . . . *et de l'école de Pont-Avent, Vente Hôtel Drouot, Salle No. 1* (Paris: Hôtel Drouot, 1959); *Très Belles Estampes par E. Bernard, Bonnard* . . . *Pastels - Gouaches - Aquarelles - Dessins par Barye, E. Bernard, Bonnard* . . . *Tonneau Sculpté par Gauguin, Céramiques par Gauguin, Pascin, Tableaux par Sarah Bernhardt, de Chamaillard* . . . *Vente Hôtel Drouot, Salle No. 1* (Paris, 1959).

91. "Collection Hazard (1re Vente)," *Gazette de l'Hôtel Drouot*, December 11, 1919, bibliotheque-numerique.inha.fr/idviewer/59645/501."publisher-place":"Paris", "title":"Collection Hazard (1re Vente

92. Wildenstein, *Gauguin*, 387.

93. Wildenstein, 389–90.

94. "Revue Des Ventes: Collection de M. Pierre Baudin," *Gazette de l'Hôtel Drouot*, March 17, 1921, bibliotheque-numerique.inha.fr/idviewer/59661/127.

95. "Chronique Des Ventes: Pendules, Meubles, Tableaux Par Gauguin," *Gazette de l'Hôtel Drouot*, April 11, 1922, bibliotheque-numerique.inha.fr/idviewer/59669/171.

CHAPTER TWO

~

The Roy Collection

"Dear Daniel," Gauguin wrote on August 3, 1893, from Marseilles: "I arrived today, Wednesday, at noon—with four francs in my pocket!" Daniel de Monfreid had sent 1,000 francs to cover his travel costs, and now Gauguin was broke. The journey from Tahiti had been expensive and wretched. He had traveled second class on the steamer—"what a filthy trip!"—and gone through bad weather in the South Seas, a cold spell in Sydney, and "intense heat in the Red Sea such that we threw overboard three men who had died of heat exhaustion."[1] He was off to Paris, and asked Daniel to send more money and a telegram to the concierge of the building where Monfreid rented a studio, "so that when I arrive in Paris on Friday I will have a place to land."[2]

Gauguin spent most of the next two years in France.[3] His time was taken up with exhibiting and selling, traveling, convalescing, and creating new work. Monfreid lent him an easel and a chair. An uncle died and Gauguin inherited enough to rent his own studio in Paris.[4] Likely with the help of Degas, the artist persuaded the gallerist Durand-Ruel to stage an exhibition of Gauguin's works in the autumn of 1893. Degas was one of the few buyers;[5] the show was not a financial success but was the subject of many reviews and much conversation in Paris's avant-garde art circles.[6] Later that fall, he began work on a series of woodcuts recounting a version of his experiences in Tahiti. He would call it Noa Noa, and Louis Roy would work with him.[7]

In the spring of 1894 Gauguin went to Brittany, to Pont-Aven—still cheaper than Paris—and stayed longer than he had planned. Returning with friends from an excursion to the fair in a neighboring village, Gauguin

suffered a broken ankle in a brawl with some local sailors. He spent several months laid up in Pont-Aven, nursed by a few tenacious friends whom he thanked, of course, with artwork. One of his errands in Brittany had been to recoup the works that he had left with Marie Henry in Le Pouldu in 1891. She refused to surrender them, citing that he could offer no written proof that the works had not been intended as gifts. Two court cases later, the state awarded right of possession to the innkeeper. Marie Henry's collection was left intact, and Gauguin left Pont-Aven in the autumn doubly hobbled.[8]

Back in Paris, Gauguin rented a studio in the rue Vercingétorix, installing stained-glass windows, painting the walls a vibrant yellow, and filling it with "exotic ornaments" as well as an upright piano.[9] He held weekly raucous gatherings of friends and admirers. In December 1894 Gauguin hosted an exhibition at his studio (Degas bought more) and then, in February 1895, arranged for a sale of his works to be held at the Hôtel Drouot.[10] Gauguin used the proceeds to return to Tahiti in the summer of 1895. He planned, he wrote to Monfreid, "to finish his days free and tranquil, without a care for the future and the eternal fight against Imbeciles."[11] He would never return to France.

Before Gauguin packed his trunks for Tahiti in 1895, he stashed paintings, works on paper, sculptures, and ceramics with different people. If he kept lists of what he had stored and with whom, that list has not survived. His dealer, Ambroise Vollard, kept some;[12] Vollard's stockbooks, where he recorded his inventory and sales, are famously vague and inconsistent.[13] Mette Gauguin had some of her husband's work with her and their children in Copenhagen. Daniel de Monfreid corresponded with her about them, and occasionally they traded or sold from each other's holdings.[14] Paco Durrio had some.[15] Emile Schuffenecker had some.[16] Marie Henry had her share. Even a few shopkeepers had acquired some canvases in payment for debts.[17]

Another keeper of Gauguins was Louis Roy. We do not know the full dimensions of his collection. Among all of Gauguin's accomplices and collaborators, friends and hangers-on, Louis Roy is perhaps the most unknown. A Sunday painter, a schoolteacher, a husband and father, Louis Roy died in 1907 at age forty-four. The painter of *Flowers and Fruit* inscribed it to him: "à l'ami Roy [to the friend Roy]." Who was this friend of Gauguin's?

First Encounters: 1889

Louis Roy was forty-four when he died on June 22, 1907, in his apartment at 213 rue Lafayette, in Paris's 10th arrondissement, of what may have been a stroke. His widow, Florence Lokofsky, recounted his last moments

in a document passed down through the family: how he had rushed up the stairs to their apartment only to faint on the landing outside. Neighbors had helped her get her husband into bed and she had sent for a doctor, who applied leeches. The treatment had not helped: another doctor, afterward, assured her that there was nothing anyone could have done. "Since the beginning of the year . . . his health had worried me," she wrote. He had rheumatism and had lost his appetite; he suffered also from neurasthenia.[18] "La neurasthénie," to Florence Lokofsky and her contemporaries, referred to a loosely defined set of symptoms that could include insomnia; anxiety; headaches; tinnitus; feelings of weakness in arms and legs; and indigestion.[19] "The day of his death," Florence continued, "was stormy and I expect that he had not felt well in the afternoon" because he had left work early. He had rushed home, where he died at 8:15 that evening.[20] Roy was buried in the Pantin Cemetery at the edge of Paris.[21] No newspaper printed an obituary. In 1955, one critic suggested that perhaps Louis Roy, whose name appeared in several exhibition catalogs from the turn of the century, had been a pen name used by another artist, that there had been no Louis Roy.[22] So completely had he been forgotten that there were questions as to whether he had existed.

But exist he did. Born in Poligny, in eastern France, in 1862, Louis Roy was the only child of a couple who owned a grocery store. He was a strong student and, a rare occurrence for the son of a small-town grocer in an era when education often stopped after primary school, graduated from university. Roy passed the qualification to become a drawing teacher in the national system of secondary schools. In 1881 he took up a position at the Lycée Michelet,[23] an elite high school at the edge of Paris. He remained there until 1894, slowly rising through the ranks.[24]

Emile Schuffenecker joined the faculty as a drawing instructor in 1884.[25] Gauguin and Schuffenecker had been stockbrokers and amateur painters together before the financial crisis of 1882 cost them their jobs. Where Gauguin turned to painting full-time, Schuffenecker prudently sat for the exams that would qualify him to earn a living teaching in a state-run secondary school.[26] Roy and Schuff, as Gauguin called him, sometimes practiced their technique at the Académie Colarossi, a private art school in Montparnasse where students could, for a relatively low fee, attend informal classes and use studio space. Others enrolled there in the mid-1880s included Daniel de Monfreid and Charles Filiger, both of whom would become part of both Roy and Gauguin's circle.[27] Gauguin, back and forth during these years between Paris, Rouen, and Copenhagen, returned to Paris in 1885 and stayed sporadically with Schuffenecker. "Le bon Schuff" was famously hospitable

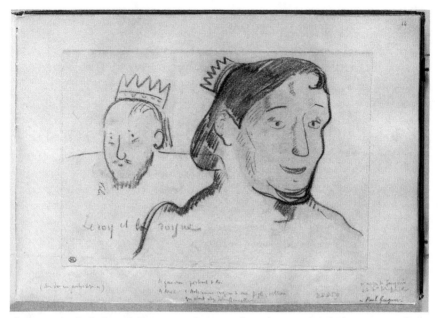

Fig 2.1. Head of a bearded man, wearing a cardboard crown; head of a woman. Album Gauguin Paul -3- Folio 14 attached to the recto. 19th-20th century. Black pencil, 15.9 x 23.1 cm. Gift of Jean Albert Schmit, 1938. Musée d'Orsay, preserved at the Louvre Museum. Photo: Adrien Didierjean. *Source:* © RMN-Grand Palais, Art Resource, NY

and well connected, and his rue Boulard studio in the late 1880s was a center for conversation and artistic experimentation.[28]

In the winter of 1889, while staying with Schuffenecker and his family, Paul Gauguin made a hasty sketch that he labeled *Le Roy et la Royne* [*The King and Queen*].[29] *Royne* is an old spelling for *reine*, the French word for queen; choosing that word for his drawing's title gives us a clue that Gauguin the trickster is at play. It is a double portrait in pencil. *Le roy*, the king, in his cardboard crown looks baffled, perhaps even downcast. He's behind his queen, who looks as smug as he looks dejected. But it's a cartoon dejection, just like the queen is a cartoon queen, with her own cardboard crown and her minimally drawn features. The woman is Marie Ginoux, whom Gauguin had painted in Arles, in his *Night Café, Arles*[30]: in the drawing, she is seated in the same position. Her hair is dressed the same way; the line of her ear matches, and the pupils of her eyes look out from the same angles. We know that his king is Louis Roy because we can recognize his features from an oil portrait that Gauguin made of Roy, now in a private collection: it shows the same beard, moustache, and receding hairline.[31] His hair falls over his brow.

He has a prominent nose. The sketch is almost a caricature. It makes a joke: here are two people who are manifestly not a king and queen, and the title is a play on Roy's name. Perhaps Gauguin drew the quick caricature of Roy on an already existing preparatory sketch for his *Night Café, Arles*, as the artists sketched together at Schuffenecker's studio.

Another sketch presents evidence of the two working side by side. A pastel sketch signed by Louis Roy from about 1889[32] shows a nude woman from behind. Her hair flows down her back. She stands beside a tree and her arms extend over her head as she looks up. The page ends before we can see what she is doing, but the woman looks as though she is about to pick a piece of fruit—perhaps an apple. A disembodied arm reaches in from the left margin. The hand could be about to caress the woman's bottom, or it could be reaching out to stop her in mid-harvest. The penciled caption reads: "Tu feras pas ça." That can translate as "you will not do this," but it can also translate as "thou shalt not." That translation echoes the language of the Ten Commandments in Exodus; it is the way that the commandments are presented in French. With that translation, the naked woman transforms into Eve picking the fruit of the tree of knowledge. She is a naked Everywoman about to be felt up by a stranger, and she's also Eve being warned against original sin. The dejected king in Gauguin's sketch *Le Roy et la Royne* is both a king and his friend Louis Roy. Roy's woman is both a generic nude and Eve. The sketches share the same satirical edge.

Roy's signature on his sketch is in the lower right corner: clear, simple, almost typographic. The straight down stroke of the capital R ends in a serif; the curve of the R stretches across the second letter, o, and the tail of the R strokes down to meet and cross the tail of the lowercase y at the word's end. It is a crafted signature, a self-conscious signature. It is a signature that a junior teacher might have developed while watching over his charges during endless study halls, writing his name one way and then another until he had a form that conveyed the right combination of sophistication and simplicity.[33] *Tu feras pas ça*, on the left of the drawing, is written in a different hand, a sketchy, abbreviated, confident cursive. The *T* of *Tu* suggests the letter more than it embodies it. The *f* of *feras* drops from a loop down below the line of other letters. The handwriting appears to be Gauguin's. The lowercase *f* looks like those in Gauguin's manuscript letters to his friends and family; it drops and loops in the same way. The capital *T* echoes the shape of a lowercase *t* in a scurrilous illustrated poem that Gauguin scribbled in his journal.[34] It is easy to imagine that Gauguin was sitting nearby while Roy sketched his Eve, and, in the same sardonic mode as he drew Roy and Madame Ginoux, he leaned over Roy's shoulder and penciled in the line from Exodus. Gauguin,

forty-one, had already lived a complex life: by the time he was twenty-seven, Roy's age in 1889, Gauguin had traveled the world with the merchant marine, served in the French navy, launched a remunerative stockbroking career, married, and become a father. In the 1880s he had separated from his wife and abandoned his career. Young Roy had spent his life in school, as a student or teacher; there had been no adventures on a grand, or perhaps even a small, scale.

These two sketches are part of an album in the collection of the Louvre, donated in 1938 by collector and furniture magnate Jean Schmit.[35] The previous year, Georges Wildenstein had included it in an exhibition titled "La vie ardente de Paul Gauguin [The fervid life of Paul Gauguin]." The show featured a range of Gauguin's works, from his early forays into Impressionism to his final days in Tahiti. The album comprises sketches by Gauguin, Louis Roy, and their mutual friend Emile Bernard, all from around 1889, as well as photographs of Gauguin, Schuffenecker, Cézanne, and Pissarro. It also contains a handful of letters from Gauguin and others to Schuffenecker, written between 1889 and 1892.[36] Schuffenecker died in 1934, four years before the album joined the Louvre's collection, his daughter Jeanne his primary heir.[37] Annotations in the album refer to "Mme. Schuffenecker," crediting her with identifying the creators of some of the sketches.[38] From this we can assume that Emile Schuffenecker or his family had assembled the album from sketches left behind in his studio and kept as souvenirs, letters from the same period, and a few other odds and ends, photographs, and mementoes.

These sketches lay the foundation for the connection between Roy and Gauguin. The connection grew deeper when, in the summer of 1889, Gauguin and Schuffenecker included Roy in their *Exhibition of the Impressionist and Synthetist Group* in M. Volpini's Café des Arts at the edge of Paris's 1889 Universal Exposition. The Café des Arts was part of a group of temporary cafés, restaurants, and brasseries licensed and built to operate during the run of the Exposition.[39] Volpini, its proprietor, had ordered gold-framed mirrors to cover the walls, but they were on back order and not scheduled to arrive in time for the Exposition's opening day. Schuffenecker, on the prowl for exhibition space, swooped in with a solution: he and his friends would fill the walls with paintings. Volpini agreed. Gauguin hoped to include his friend Vincent van Gogh in the show, but Vincent's art dealer brother Theo objected to Vincent showing in such a cobbled-together space. The final list of participants included Gauguin, Schuffenecker, Emile Bernard, Louis Roy, Louis Anquetin, Charles Laval, Léon Fauché, and Daniel de Montfried.[40]

Each contributor to the exhibition listed his address: Gauguin listed his as *chez* Schuffenecker, and Schuffenecker at 29 rue Boulard. Bernard was

GROUPE IMPRESSIONNISTE ET SYNTHÉTISTE

CAFÉ DES ARTS

VOLPINI, Directeur

EXPOSITION UNIVERSELLE

Champ-de-Mars, en face le Pavillon de la Presse

EXPOSITION DE PEINTURES

DE

Paul Gauguin	Émile Schuffenecker	Émile Bernard
Charles Laval	Louis Anquetin	Louis Roy
Léon Fauché	Daniel	Nemo

Paris. Imp. E. WATELET, 55, Boulevard Edgar Quinet.

Affiche pour l'intérieur

Fig 2.2. Imprimerie Watelet, Poster for the exhibition of the Groupe Impressioniste et Synthétiste in the Café des Arts of M. Volpini, 1889, letterpress printing on paper, 28.4 x 39.8 cm, p2551S010. *Credit:* Van Gogh Museum, Amsterdam

staying with friends in Asnières; Laval, in Pont-Aven. Anquetin was living in Montmartre, and Roy listed his address as Lycée Michelet, in Vanves. The group lent pieces to one another for the show: one of the Lavals on view was listed as belonging to Bernard, and another to an M. Rippipoint, a pseudonym that Gauguin sometimes used. One Bernard on view belonged to Schuffenecker, another to Laval. One of the Gauguins belonged to Schuffenecker, and one of the Roys belonged to Charles Filiger, the group's friend from the Académie Colarossi. Roy exhibited, in the end, seven paintings at the Café des Arts: a still life of pears, another still life of primroses, and several landscapes. The landscapes were painted in Gif and in Vanves. There was also a painting titled simply *Dusk*.[41] While the exhibition made barely a ripple on the surface of the Universal Exposition, many of the works included in it are now in museums today. The Gauguins are in museums from Amsterdam to Cleveland to Los Angeles. Schuffenecker's works from the show are in Houston and Cologne. There are Volpini Bernards in Pasadena and Paris, an Anquetin in Hartford, Lavals in Paris and Indianapolis.[42] The Roys from the Volpini show have been lost; perhaps some lean against attic walls or hang in descendants' living rooms. But none are accounted for in museums.

The number of loans from one artist to another in the Volpini show opens a door into the connections between this group of artists. They exchanged works with each other, lent works to each other, painted and talked and smoked and drank next to each other. They listened together to Gauguin, who was a generation older than most of them. We know that Gauguin gave paintings to many in this circle. In 1888, he sent Vincent van Gogh a portrait of himself as Victor Hugo's hero Jean Valjean and inscribed it "à l'ami Vincent [to the friend Vincent]."[43] In 1890 he gave Laval a portrait, inscribed "à l'ami Laval [to the friend Laval]"; Laval returned it the next year, after a serious quarrel, and Gauguin gave it away again, with a new inscription, to another friend.[44] A tense family portrait of the Schuffeneckers from 1889—Emile standing off to the side, behind his easel, while his wife and children occupy the center of the canvas—was dedicated "Souvenir à ce bon Schuffenecker [In remembrance to the good Schuffenecker]."[45] Perhaps it was during this period that Gauguin leafed through old canvases and chose one for his young friend Louis Roy.

Gauguin specialist Sylvie Crussard suggests in the 2002 *catalogue raisonné* that Gauguin presented Roy with a still life, *Fruit in a Bowl*, at about this time. Crussard dates the painting from three years earlier.[46] Peaches, or perhaps oranges, are arranged in a white bowl with a delicately scalloped edge. The bowl sits on a brown table, the background a muted blue-gray. At the right edge of the canvas, we see part of a footed serving bowl covered with a matching lid. The brushstrokes are broken and distinct, the canvas visible beneath. The inscription in large letters across the lower right corner reads: "Au Seigneur Roy (To Lord Roy) / PG." Crussard, in her notes on the work, suggests that Gauguin may have inscribed the painting to Louis Roy around 1889.

Fruit in a Bowl is the earliest work that connects Louis Roy with Gauguin. The sardonic inscription recalls the title of *Le Roy et la Royne*. Both mock the difference between Louis Roy's social status and his name meaning "king" in French. They suggest the outlines of Gauguin's relationship with Roy: that the older artist may not have taken his younger colleague entirely seriously, that he may have found him a little ridiculous. The word choices also suggest that Gauguin wanted to underscore his superiority, his authority over Roy. The word choices are unusual compared to Gauguin's other inscriptions: his usual practice was to inscribe paintings "à l'ami" or "à mon ami." The inscription on *Flowers and Fruit* is typical of Gauguin's inscriptions. The handwriting is comparable. Both inscriptions share the rounded, fluid shape of the capital *R*, the long tail of the lowercase *y*, and the formation of the initials "P.G." But that is not proof that the same person wrote both.

Tracings

Gauguin spent the balance of 1889–1891 between Paris and Brittany, where he stayed first in Pont-Aven at the pension owned by Marie-Jeanne Gloanec and then, from October 1889, at Marie Henry's Buvette de la Plage in Le Pouldu. He worked alongside the Dutch artist Meijer de Haan; other artists came and went from Le Pouldu, including Paul Sérusier, Charles Filiger, and Henry Moret.[47] De Haan, thirty-six, had come to Paris from Amsterdam, where his family operated a successful wholesale bakery business. Meijer, the eldest son, was prone to illness and unable to manage the business; the family had agreed to support him in pursuing a career as an artist. Gauguin had met Meijer de Haan through Theo van Gogh in the winter of 1889 and persuaded him of the charms of Brittany. De Haan traveled to Pont-Aven and then, in the summer of 1889, to nearby Le Pouldu. Gauguin followed. By October, both had taken up residence in Le Pouldu, at the small inn that Marie Henry had opened the previous March. They—or, more specifically, de Haan—rented the attic in a large house across the lane to use as their studio.[48] Gauguin wrote to Schuffenecker:

> I am on the coast in a big house with a view of the sea just below. The storms are amazing, and I am working with a Dutchman who is my student and a really good fellow. I think I'll probably only come to Paris for a month or so this winter, maybe longer if I sell something. I want to be able to afford a trip to Holland to see some Rembrandts up close.[49]

De Haan and Gauguin were settled in together, painting and comparing notes about other artists they admired. Gauguin could rely on his new friend to cover most of his bills; it was a good working situation. De Haan painted several still lifes that year. One of them he seems to have painted alongside Gauguin. Theo van Gogh described it in a letter to Vincent: "De Haan has sent me a painting . . . it's pink and orange onions, green apples and an earthenware pot."[50] Now in the collection of the Musée de Pont-Aven, De Haan's *Still Life with Pot, Onions, Bread, and Green Apples* depicts a two-handled cooking pot, onions, apples, and part of a loaf of bread. Gauguin used the same props as a model for his *Still Life with Onions*, now in the collection of the Ny Carlsberg Glyptotek in Copenhagen.

The subject of the paintings is almost entirely the same. Both artists sat to the left of the light source, so that objects cast a shadow to the left of the canvas. Gauguin, who saw the arrangement from a sharper angle, included part of a Japanese woodcut on the right side of his painting. De Haan, facing the arrangement more directly, omitted the woodcut and showed the onions

and bread with more detail.[51] Where the subjects are similar, the styles diverge. The Dutch painter imitates his friend's style: the sinuousness of the onion tops, the dabs of contrasting colors in the pot and onions. Gauguin's painting has a unity of style. He has outlined his onions and apples, and put in highlights to suggest reflections from the same light source. De Haan's style is fragmented. Some of his onions are heavily outlined, and others not at all. Highlights vary: some are in vertical strokes, some in horizontal, some blue, some cream-colored. The effect is that the painting feels less finished, less coherent, less confident.

De Haan left his *Still Life with Pot* behind in 1891 when he left Le Pouldu; it was sold in 1959 by the daughters of Marie Henry.[52] It joined a private collection before finding its way to the Norton Simon Museum in Los Angeles in 1983.[53] We do not know whether Gauguin left *Still Life with Onions* at the buvette, or whether he brought it to Paris. In 1927, it joined the collection of the Ny Carlsberg Glyptotek. Arts patron Helge Jacobsen donated it to the Glyptotek after purchasing it from the dealers Goupil and Sons in London; Goupil and Sons had bought the painting from Paris dealer Joseph Allard. Allard had purchased it at the same April 14, 1923, auction at Drouot at which Guitry had taken home *Flowers and Fruit*.[54] The two paintings had both been consigned by Léon Marseille. There is no known trace of the painting between 1890 and 1923. One clue: on the back of Gauguin's *Still Life with Onions* someone wrote "Collection Roy."[55] Another Gauguin linked to Louis Roy.

Gauguin returned to Paris in November 1890. He and Schuff had fallen out, but Daniel de Monfreid stepped into the void and gave Gauguin the key to his studio. Meanwhile, Gauguin had decided that his next destination would be Tahiti, and he was scrambling to come up with money for the trip. On February 23, he held a sale of thirty of his paintings at the Hôtel Drouot, which earned about 7,000 francs.[56] It was enough for him to make travel arrangements. He would settle a few debts in Paris (though not in Le Pouldu) and visit his wife and children in Copenhagen for a week.[57] Returning to Paris, he attended a farewell banquet given for him by the Symbolist poet Stephane Mallarmé and other friends. There were toasts and speeches and readings of the Symbolists' favorite poet, Edgar Allan Poe, late into the night.

Was Gauguin in touch with Roy during these months in Paris? Perhaps. They both knew a retired naval doctor named Charles Charlopin. He had invented a model steam engine that had been exhibited in the 1889 Universal Exposition.[58] Perhaps the artists met him over that summer when Charlopin had visited Volpini's Café des Arts and seen Gauguin and his friends'

work on view. Perhaps there was some other connection. But we know that Charlopin had promised to purchase thirty-eight paintings and five ceramics for 5,000 francs, which would fund Gauguin's trip to Tahiti—but could not make the purchase until he sold his invention.[59] In 1890, Charlopin was working on a method to "produce absolutely pure hydrogen cheaply," but was having trouble getting it patented.[60] Mentions of Charlopin pepper Gauguin's 1890 letters. In June, he wrote to Schuffenecker: "Oh my God, I wish this thing with Charlopin would sort itself out so that I could know what to do. . . . Ask Roy what he thinks."[61] On October 10, Gauguin wrote again to Schuff: "I received a letter from Charlopin saying that he would send me the 4000 francs he promised. . . . Since he promised 5000, that's a mistake." But what should he do? He didn't want to annoy his promised benefactor, but he also wanted the full sum. "I'm going to ask Roy," he wrote, "to mention the error and take it up with him diplomatically."[62] The mission, if Roy chose to accept it, came to nothing. The inventor never produced the money. From October 1890, there is no more trace of the doctor in Gauguin's correspondence.

Gauguin's June 1890 letter tells us that Charlopin, Roy, and Gauguin all knew each other. It is conceivable that Gauguin, back in Paris, could have seen them. Could Gauguin have given or stored his *Still Life with Onions* with his younger friend at that point? Perhaps he did; perhaps, in the last weeks before he left the city, Gauguin arranged to meet up with Roy for a farewell drink. Perhaps Gauguin wanted to talk over the Charlopin affair in more detail, and thank Roy for having done his bit. Partly in thanks and partly because he needed a place to put it, perhaps Gauguin gave him the still life. There is no way to be certain. On April 4, 1891, Gauguin took a ship for Tahiti. He would not return for over two years.

Connections

On the day that Gauguin sailed, Louis Roy married Florence Lokofsky. The witnesses were her uncle, Victor-Alfred Boutiot, and Charles Charlopin.[63] Couples typically chose family members or close friends to sign the marriage license. Charlopin's presence at the wedding suggests a relationship with Roy that was independent of his intended patronage of Gauguin. It hints at a broader world of connections, of friends and conversations and mutual interests, than archival records can reveal. Research into Louis Roy's life in archives and libraries across France has yielded two photographs, a letter, and a handwritten "notice individuelle," similar to a résumé, that Roy wrote for the Ministry of Public Instruction. There are records in archives of

his birth, marriage, and death.[64] There are records in museum libraries and documentation centers of sales and exhibitions of his work.[65] In 1978, curator Elisabeth Walter wrote the only article published about Louis Roy.[66] The record is sparse.

We do not know how the awkward schoolmaster from Poligny met Florence Lokofsky. She lived with her aunt and uncle in a comfortable apartment in the rue Lafayette, in the 10th arrondissement, which was not a district known as flashy or elegant or bohemian, but as steady working class. Her father was dead; her mother lived in America.[67] Anne-Marie Taylor, her maternal aunt, and her aunt's husband Victor-Alfred Boutiot had brought Florence up as their own since she was nine.[68] Florence's uncle earned a medal for working as an accountant for the same coal merchant for over thirty years.[69] Madame Boutiot was renowned in Paris as a music engraver:[70] composers and publishers would bring handwritten scores to her, and she would engrave them onto copper plates that were then used in printing. According to chronicler Henri Robert in 1926, a *graveur de musique* had to understand music theory and harmonies so that when they copied the handwritten scores onto copper plates "they would not make mistakes [in their notation], and they would be able to catch the mistakes or omissions that the composer had made in the manuscript."[71] The profession was considered appropriate for women, "considering the ease of working from home,"[72] and considering that little girls were often taught music as part of their upbringing. The work was skilled, requiring specific training and tools, and thus more lucrative. An accomplished engraver could make up to 5 francs a day; in a busy year, she could earn over 1,000 francs.[73] Madame Boutiot trained her niece Florence to the same trade, and Florence continued to practice it after her marriage.[74]

In 1886 Louis had passed the exam to receive the *Certificat d'aptitude à l'enseignement du dessin*, a three-part, fourteen-hour exam on teaching drawing, and been promoted. His annual salary then was 1,500 francs,[75] enough to be respectable, and with the promise of continuing to advance. Roy was promoted again in 1891 and, again, in 1892; in 1893, he moved to the more centrally located Lycée Buffon, a high school not far from Montparnasse. What he may have lacked in flair he made up for in stability. He was no rebel artist living in a garret, but a government employee with a salary and the promise of a pension. The young schoolmaster from Poligny must have seemed a safe bet for the conventional Boutiots' niece.

Louis and Florence—he was twenty-nine, she was twenty-two—were married at St. Laurent, "our parish church," as Roy noted in his *notice*; "it was a Saturday," and the abbé Schreiner "now first vicar at the basilica of

St. Denis" performed the ceremony. Florence, brought up as a Protestant, converted to Catholicism for the wedding. Roy noted that "she was baptized . . . in March 1891, and made her first communion the day after. She was confirmed on May 14, 1891, by Monseigneur de Forges at the church of St. Laurent."[76] Roy gave these details equal weight alongside his family history, his education, and lists of his various promotions in the *lycée* system. His emphasis on these elements conveys a sense of how he ordered the world. Roy was committed to institutions: to marriage; to the rituals and hierarchy of the Catholic Church; to the French education system, which gave him his stable livelihood.

Roy exhibited his work annually with the *Société des Artistes Indépendantes* in 1890, 1891, and 1892. The mission of the *Artistes Indépendantes*, founded in 1884, was to provide a forum for artists to exhibit their work, a forum that, unlike the state-sanctioned annual Salon des Beaux-Arts, did not require paintings to be approved by a jury, and did not provide awards or prizes: "ni juré, ni recompense." The list of exhibitors in the 1890s with the Society includes Seurat, Signac, Toulouse-Lautrec, Guillaumin, Séguin, and Henri Rousseau as well as others who, like Roy, are almost unknown today.[77] Roy exhibited as well at the Galerie Le Barc de Boutteville. Louis-Léon Le Barc de Boutteville owned an art supplies shop in the rue Le Pelletier, in a neighborhood not far, but far enough to be distinct, from the major art dealers' showrooms. Le Barc was known to take artists to lunch if they turned up in his shop around midday. He welcomed artists and writers "to smoke his cigarettes, and warm their feet by his fireplace."[78] The first exhibition of "Impressionist and Symbolist Painters" opened on December 25, 1891. Roy showed two paintings, one nude and one landscape scene from near Poligny. Le Barc held four more exhibitions over 1892 and 1893, and Roy participated in each.[79] His works hung alongside the usual suspects: Bernard, Anquetin, Bonnard, Filiger, Schuffenecker, Toulouse-Lautrec, Sérusier. Works that Gauguin had stored with someone in Paris made it into the first and third exhibitions in the winter of 1891–1892.[80] Maxime Maufra and Henri Moret joined in 1892; so did Signac.[81] In the fifth exhibition, held in October–November 1893, Roy included six paintings and a series of lithographs.[82] Roy and his music-engraving wife may have compared their printing and engraving techniques, and even have learned from each other.

Collaboration

Gauguin returned to Paris in 1893 and set about reconnecting with his friends and admirers. He managed to get two paintings into a show opening on September 23 at Le Barc de Boutteville: *Portraits du Prochain Siècle*

[*Portraits from the Next Century*]. It was an exhibition of portraiture, as the title promised, and included artists' self-portraits as well as portraits of their friends. No catalog of the show has survived, but it gained enough attention in arts newspapers that we have an idea of what was installed. There were self-portraits by Cézanne, van Gogh, Filiger, and Bernard. Bernard also provided a portrait of Schuffenecker. Gauguin provided a self-portrait as well as his portrait of Louis Roy.[83] Gauguin's portrait of Roy is the fully formed version of his quick caricature sketch in his 1889 *Le Roy et la Royne*. The "intensely colored" canvas focuses on Roy's piercing blue eyes gazing off into the middle distance. His auburn hair is brushed back from his high forehead, his beard neatly trimmed, his moustache luxuriant. Over his shoulder Gauguin has included one of his own ceramics, an abstract, curvy vessel, and above it, what is perhaps an advertisement for the 1889 Volpini exhibition. The letters "Expo Synthe" are at the upper right corner of the image; perhaps Roy is gazing out toward that installation.[84] Later in the same decade, Roy would sell this portrait to Olivier Sainsère, a politician and patron of the avant-garde.[85] He likely already owned the painting and lent it to Gauguin, or directly to Le Barc, for the exhibition, since Gauguin had only been back from the tropics for a few weeks.

The fifth Le Barc de Boutteville exhibition included Gauguin's *Copy of Manet's Olympia*, which Degas would purchase two years later,[86] as a last-minute addition.[87] Gauguin and Roy met up in the rue Le Peletier; perhaps Roy even helped make sure that there was room for Gauguin on the walls. And from December 8, when he joined the faculty of the Lycée Buffon, Roy was working just a short walk from Gauguin's studio in the rue Vercingétorix. On December 26 that year he wrote to Schuffenecker: "Cher Maître," he begins respectfully: "Dear Teacher,

> I have good news for you. I think, at least, that it will not be disagreeable. Here it is: the secretary at the Lycée Buffon, M. Leroux, has a brother who is the librarian and curator at the museum of the city of Annecy. Now, M. Leroux mentioned to me that he would like to have one of my canvases in his museum, I thought that first of all it was correct to offer this honor to my dear Teachers, to whom I owe the little that I know.[88]

Roy is excited and proud: after less than a month at his new post at the Lycée Buffon, he has already made a valuable connection. What an honor to be asked to donate a painting to a museum, and to be able to share that honor with his friends and teachers!

So I am asking you to offer a painting as a gift, and to take your place among the donors to the Annecy Museum. I have already spoken to Gauguin, who will offer a painting from Tahiti, and who let Daniel [de Monfreid], [the artist Maxime] Maufra, and Sérusier know. He also talked to [the painter] Anquetin. I wrote to Filiger and am waiting for his reply.[89]

He has been hatching plans with Gauguin. The letter brims with a sense of achievement and belonging; it is in the voice of a student who believes he has done well, and hopes to please his mentor.

Roy ends the letter by apologizing for not having been in closer touch since he took his new job. "I have almost no free time, and I try to work [at my art] in the little that I have . . . since I've been at Buffon," his new school. "I've been much better in every way and I have started to paint again."[90] The letter continues a conversation that he and Schuffenecker have had before on the necessity of taking the time to work at his art. There is another conversation here, too: a conversation about Roy having stopped painting for a time because he was unwell. What variety of unwell we do not know; just that he had been unwell, and that he had talked it over with Schuffenecker.

When Marc Le Roux, the curator of the Musée d'Annecy, published a catalog of the museum's holdings in 1900, he did not mention any Impressionist paintings, or any paintings by Roy and his circle.[91] Perhaps Roy's networking came to nothing. We know that, in the winter of 1893, Gauguin was in funds thanks to a small inheritance.[92] Does that mean that he would have been eager to donate a painting to a provincial museum at the edge of the Alps? It seems difficult to imagine. But it is easy to imagine Gauguin listening to Roy's proposition and deciding that it was worthwhile not to refuse immediately. He was always looking for opportunities to exert influence and build fame; who knew what a small donation could lead to later.

Gauguin brought Roy into another plan at about this time. He decided that there might be money to be made in a story about his time in the tropics. He recruited an underemployed journalist, Charles Morice, to help with the writing;[93] then Gauguin bought ten boxwood blocks of wood into which he carved a series of illustrations. The series would come to be known as *Noa Noa*, and the woodblock prints that Gauguin created changed the medium. He used the woodblocks "in ways that were inimical to established practice and, in their deliberate crudity and expressivity, strikingly modern."[94] Gauguin's *Noa Noa* prints today are recognized as some of his most influential work, regularly exhibited in major museums.[95]

Each of the ten woodblocks presents another scene of the artist's Tahitian adventures. Gauguin invited Roy to create a set of prints from the

woodblocks for a limited edition of *Noa Noa*. He had seen Roy's lithographs in the show at Le Barc de Boutteville that autumn and knew that the younger artist had experience with printmaking. Gauguin created two sets of prints from the blocks, and Roy created another set. Roy's are distinct from Gauguin's in their use of color: he used stencils to add vivid reds, oranges, yellows, and even a chartreuse that made his prints "electrifying."[96] Gauguin began work on the woodblocks in December 1893 and made prints during the winter and spring of 1894. In April 1894 he repaired to Pont-Aven, and stayed longer than he intended, nursing his broken ankle; he did not return to Paris until December 1894. Roy, in Paris, was likely working on his own set of prints from Gauguin's woodblocks.

We can infer that Roy worked on his prints during that summer from the existence of the prints themselves; from knowing Gauguin's whereabouts; from knowing the academic calendar, which gave Roy holidays in July and August. There are no surviving letters between the two men to confirm it. Gauguin kept few, if any, letters that he received. Most of his surviving correspondence survives because the recipient—usually his wife Mette or Daniel de Monfreid—preserved it. No letters in Roy's possession have come to light. The only letter from Roy in an archive is his December 1893 letter to Schuffenecker.[97] Schuffenecker kept letters; some found their way into scrapbooks, and some occasionally come to auction today.[98] But that no letters from Gauguin to Roy have survived does not imply that no letters existed. The man who would write so fulsomely to Schuff about donating a painting would certainly have written copiously to Gauguin about their woodcuts project.

Roy's prints, now in museum collections from Stockholm to New York, may reflect artistic choices with which Gauguin disagreed; scholar Richard Field argues that Gauguin's use of the back of some of the Roy prints for other work "is an eloquent witness of his disapproval."[99] It may be that. Or it may be that Gauguin was short on printing paper. Regardless of Gauguin's thoughts on Roy's *Noa Noa* prints, their collaboration on the series is evidence of the artists' close relationship during Gauguin's 1893–1895 stay in France.

Divergence

The *Noa Noa* collaboration was to be Gauguin and Roy's only project together. Gauguin spent the first half of 1895 preparing to depart once again, and for good, for Tahiti. Roy exhibited again with Le Barc de Boutteville in the gallery's ninth Impressionist and Symbolist show in April 1895;[100] Gauguin sat that one out. Roy published a lithograph in the avant-garde

journal *L'Ymagier* in the same month; Gauguin published a print from a woodcut.[101] He sailed for Tahiti from Marseille on July 3. Before he left, he packed up his studio. Some furnishings and collections he brought with him. Much of his work he tried to sell; what he could not sell, he gave to friends to store. Paco Durrio had as many as thirty of his paintings.[102] His neighbors in the rue Vercingétorix had many of both his and Roy's *Noa Noa* prints.[103] And Louis Roy had an unknown number of works by Gauguin.

In 1895 word reached Paris that Meijer de Haan, Gauguin's painting partner in Le Pouldu, had died.[104] Roy painted a notecard-sized double portrait, *Méditation* or *Portraits de Meijer de Haan et de Gauguin*.[105] The painting shows the two artists in the foreground, de Haan in profile and Gauguin facing the painter, but with his eyes cast down. The portraits resemble other portraits of the two friends: de Haan wears a cap and a beard, as he does in his own self-portraits from 1889 and 1890 and as Gauguin depicts him in his 1889 *Portrait of Meijer de Haan*, now part of the Museum of Modern Art.[106] Roy's Gauguin is wearing an outfit that resembles the one in which Gauguin had been photographed in 1894. Louis Roy would have had to have seen the portraits of de Haan and the photo of Gauguin in order to create this painting, additional evidence of his presence in Gauguin's circle. Behind and above the artists, two women, swathed in the Breton costume of shawls and starched white caps, walk down the beach away from the viewer. The women are anonymous: we do not see their faces, and they seem less to be characters, individuals, than to be eternal fixtures of the landscape around them.[107] In the middle ground of the painting the ocean roils[108] under a disturbed, stormy sky. De Haan and Gauguin at the extreme foreground seem disengaged from each other, individuals who although they are beside each other are disconnected. The tone of the painting is elegiac. The painters in the foreground seem disconnected not only from each other but from their surroundings; it is almost as though the sandy beach, the retreating women, and the ocean are a dream or a symbol of a past life.

Louis and Florence Roy's son Jean was born April 11, 1896, their only child to live past infancy. Jean was born when the family was on holiday in Fontvannes, a village near Troyes, in the Aube region, where Florence's aunt and uncle had connections.[109] Roy was thirty-four. He had been promoted to a position at the Lycée Voltaire, on the Avenue de la République, in September 1895. The new school gave him a closer commute to home in the rue Lafayette. Madame Boutiot died in 1896 and Florence's uncle retired to the country. Florence and Louis were on their own with their baby. It was a new way of living, a new school, a new child, a newly organized household.

Fig 2.3. Louis Roy and his son Jean, born 1896, Louis Roy et son fils Jean né en 1896. *Source:* Reproduction, Musée de Pont-Aven

Roy exhibited with the *Société des Artistes Indépendants* again between 1894 and 1897, and regularly with Le Barc de Boutteville's group. In 1896 and 1897 Roy provided the preface for Le Barc's thirteenth and, final, fourteenth, exhibitions. He takes as his guide the words of the progressive Catholic priest Lamennais for his first preface: "The times make the man, said Lamennais, and men respond to their times. From time to time nature invests a sort of sovereignty in some men" and those men have an impact on art. Roy is referring, in the same earnest tone as he had written to Schuffenecker three years earlier, to Le Barc de Boutteville himself. Le Barc's "eclectic taste and kindness towards artists" had created the circumstances "in which we can contemplate, successively or simultaneously, in his gallery, the works of painters representing different strains which, for thirty years, have battled to conquer the hegemony in painting."[110] Roy used more words when fewer would have sufficed. He continues his preface by breaking down the various schools of painting: naturalism, synthetism, symbolism. Roy finds faults in each school. What cannot be faulted, he writes, is the man who is "born an artist." If one is an artist, "he will strive to make art, whatever the material conditions of his life; he must obey the irresistible force that he carries within himself." The best way to learn was to study the masters. Roy ends with a paean to the "idea" in painting: "The idea is the essential necessity for any work of art: it constitutes the thing to signify, and thus, it is the only reason to create an artwork."[111] Subservient to the idea behind a work of art is the creator's use of line and color. The preface aims for large thoughts but falls short of articulating them.

Roy's preface to the fourteenth exhibition is no less verbose. He begins by warning his reader to be patient while reading his "fastidious, pretentious" thoughts on the "role of Science as an auxiliary to Art."[112] Does describing his own writing as pretentious suggest a degree of self-awareness? After debating how much knowledge of science an artist needs to have for his art to be compelling, Roy comes back again to the importance of line and color, and of being born with "the artistic sentiment."[113] Roy sets out to convey bold ideas but, in both prefaces, manages simply to take more words than necessary to speak simply. His sentences are long. His vocabulary is obscure. He is valiant in his defense of art and artists, but gets in the way of his own argument. In a letter of 1900, Armand Séguin describes Roy as he saw him at an exhibition: "Rotund Roy, fatter than ever and decorated with his medals."[114] Roy cared about those medals, mentioning each one he received for length of service to public instruction in his memorandum.[115] We can imagine the large bearded man putting on his good suit, pinning his medals to the breast pocket, and going to a gallery opening. Knowing that he would likely run

into Séguin, who would make fun of him, or Schuffenecker, who, perhaps, he was afraid of having disappointed. Wishing, perhaps, that he were at home with Florence and Jean in the rue Lafayette, or better still, working at his easel in the countryside with his wife and son picnicking nearby. Taking the tone of Séguin's letter together with the overblown language of Roy's prefaces, we may be able to see a bit more of the unknown artist's character. A serious, perhaps self-serious man who only visited the bohemian world that Séguin, Gauguin, and others inhabited. A man more at home in his classroom and at home with his family than at an exhibition opening. A man who painted his entire adult life—his last known canvas comes from 1906, the year before he died—but never felt confident as an artist.

Le Barc de Boutteville died in 1897 and the shows at his gallery came to an end. Roy continued to exhibit sporadically in the 1900s—an exhibition of painted fans with Armand Séguin in 1898, an exhibition with some of his old friends in 1900—but after 1897 he published no more known criticism. His documented works dating from after 1894, most of which have been dispersed into private collections, are predominantly landscapes or scenes of people outdoors.[116] Peasants prepare the grape harvest; children play beside a pond; the sun sets behind trees. There is nothing shocking or even surprising: they are works of art that could hang in a hallway and inspire little more than a glance.

In Roy's known body of work there are a handful of still lifes. Only one is in a public collection, his 1890 *Still Life with a Quimper Vase* in the collection of the Musée de Beaux Arts, Brest. The canvas shows us a blue and white ceramic vase on a surface covered in a patterned cloth of yellows, blues, and oranges. Pink roses, which seem to have been cut a little too short, fill the vase. The roses stand straight up, bunched together, too many and too short for grace. Behind and to the right of the vase a brass-footed fruit bowl stands empty, its bowl out of proportion to its pedestal. The background is a grayish blue. On first glance, the painting seems related to *Flowers and Fruit*: another vase with pink roses, another ochre cloth-covered surface. Close examination of Roy's painting reveals how a different style of brushwork alters the painting. Some of Roy's brushstrokes are vertical; some are horizontal, crossing the grain of the background. In some areas the paint is heavily worked and in others the paint seems to have been laid down hastily. It looks like the work of someone who was trying out different techniques. Where the perspective of *Flowers and Fruit* is calculated, the perspective in *Quimper Vase* is inconsistent. The vase casts a shadow; the fruit bowl does not. Objects in *Flowers and Fruit* have been carefully drawn, sharply outlined. Roy's fruit bowl is outlined; his vase is not. The maker of *Flowers and Fruit* displayed

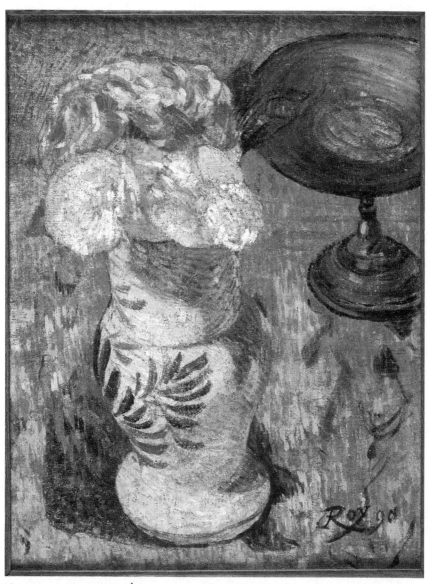

Fig. 2.4. Louis Georges Éléonor Roy (Poligny, 1862 – Paris, 1907), *Nature morte au vase de Quimper* (inv. 998.2.1), 1890, huile sur toile, 32,7 cm x 24,7 cm, musée des Beaux-Arts de Brest métropole. © Musée des Beaux-Arts de Brest métropole

far more mastery of his craft than Roy in his 1890 still life. It is difficult to imagine that the artist who made the 1890 *Still Life* had the skill to create his own Gauguin.

In 1904, Roy sold a half dozen Gauguins to the dealer Ambroise Vollard. The canny dealer paid the schoolmaster 400 francs for four oil paintings and two sketches; Vollard, as was his wont, would hold on to them for decades. One, *Cow Lying at the Foot of a Tree*, he bought for 40 francs; it was valued at 800 francs in 1922.[117] Roy did not only have Gauguins in his apartment in the rue Lafayette. His friend Filiger left works on paper there,[118] and he owned Emile Bernard's 1887 *Après-midi à St-Briac*, which was included in a retrospective of Bernard's work in 2015.[119] Sérusier had several works by Louis Roy in his collection,[120] which implies, perhaps, that Roy had a few Sérusiers as well. One overexposed photograph shows Roy sitting in front of a wall hung with paintings. There were more works in his collection than we know.

After Louis died in 1907, Florence sold two works by Gauguin to Olivier Sainsère: Gauguin's 1888 portrait *Captain Jacob*[121] and a painting, or perhaps a sketch, titled *Jeune Annamite*.[122] While no known painting of that name exists, there is a page of sketches of young men wearing loose clothing, one in a conical hat and another sporting a fez, by Gauguin from about 1889 in the French national collections.[123] *Annamite* was, at that time, the word used in French to refer to people from Vietnam. There is a painting in the collection of the Musée du Luxembourg called *Etudes de Personnage Annamites* whose history is uncertain: staff taking inventory in 1967 found it in the collection of the Musée du Luxembourg, then the national modern art museum.[124] Sainsère was a regular donor to the national collections. Although there is no documentary proof, it is possible that the *Etudes* and the *Jeune Annamite* that Sainsère purchased from the Roys in 1907 are the same.

There is another complicated provenance connected to Louis Roy. The provenance for Gauguin's 1886 *Fruit in a Bowl* lists the painting as having belonged first to Louis Roy, having been purchased by the English artist Sir Matthew Smith in Pont-Aven "in the early 20th century," and thence, by descent, into a private collection in Great Britain.[125] According to his biographer, Matthew Smith spent nine months in Pont-Aven in 1908,[126] where the provenance states that he acquired this still life from Louis Roy. Except: Louis Roy had died in 1907, in Paris.[127] Did the painting travel from Paris to Pont-Aven after Roy's death? Is it possible to account for that gap in ownership? Like *Flowers and Fruit*, *Fruit in a Bowl* is a still life with a mysterious provenance attached, legitimately or not, to both Paul Gauguin and Louis Roy.

The mystery of the provenance for both works stems, in part, from all that we do not know about Roy, his collection, and his life. It stems, too, from the complexity of Gauguin's life and legacy. Gauguin was as peripatetic as Roy was rooted. His works were scattered around the world when he died. Because of their potential value on the art market, and because of the artist's charismatic hold on the imagination of many of his peers, there were dealers eager to collect and connections eager to tell Gauguin's story.

Roy's comparatively ordinary life attracted no attention when he died. His art was dispersed, some kept by friends, some by family, some sold or, likely, disposed of. There was no dealer eager to take inventory. Florence buried her husband in the Pantin Cemetery, on the east side of Paris. One can either purchase a cemetery plot in perpetuity in Paris, or can lease a plot for a few decades. At the end of a lease, the headstone is removed, and the plot becomes available for another interment. The site of Louis Roy's grave—in the twenty-fourth plot of the eighth row of the eighty-third division of the cemetery, bordered by avenues of sycamores and maples—is still there.[128] His gravestone is long gone, though, and his name does not appear on the cemetery's list of famous people buried there.[129]

The mystery of *Flowers and Fruit* illuminates the gap between Gauguin's fame and Roy's obscurity.

Notes

1. Paul Gauguin and Victor Segalen, *Lettres de Paul Gauguin à Georges-Daniel de Monfreid / Paul Gauguin; Précédées d'un Hommage par Victor Segalen* (Paris: G. Crès et Cie, 1918), 118, https://gallica.bnf.fr/ark:/12148/bpt6k6572278m.

2. Gauguin and Segalen, *Lettres de Paul Gauguin*, 119.

3. Richard R. Brettell and Elpida Vouitsis. Edited and compiled by the Wildenstein Plattner Institute, Inc., "Gauguin in Paris and Brittany, 1893–1895," accessed October 11, 2023, https://digitalprojects.wpi.art/gauguin/introduction/essay-detail?essayId =2.

4. Gauguin and Segalen, *Lettres de Paul Gauguin*, 122.

5. Françoise Cachin, "Degas and Gauguin," in *The Private Collection of Edgar Degas* (New York: Metropolitan Museum of Art, 1997), 221–33.

6. Brettell and Vouitsis, "Gauguin in Paris and Brittany, 1893–1895."

7. Elizabeth Prelinger, "The 'Noa Noa Suite,'" in *Paul Gauguin: The Prints* (Kunsthaus Zürich: Prestel, 2012), 59–85.

8. Mallaurie Charles, "Marie Henry (1859–1945): Une Bretonne en quête d'émancipation" (Angers: Université Angers, 2020), 35–36.

9. Paul Gauguin and Maurice Malingue, *Lettres de Gauguin a sa Femme et a ses Amis* (Paris: B. Grasset, 1946), 307.

10. Brettell and Vouitsis, "Gauguin in Paris and Brittany, 1893–1895."

11. Paul Gauguin and Victor Segalen, *Lettres de Paul Gauguin à Georges-Daniel de Monfreid / Paul Gauguin; Précédées d'un Hommage Par Victor Segalen . . .*, 126.

12. Wildenstein Plattner Institute, Inc., ed. Texts by Richard R. Brettell and Elpida Vouitsis. Research by Françoise Marnoni, Evgenia Kuzmina, and Jennifer Gimblett, "Drame Au Village, Pont-Aven, 1894, PGQIZX," 1894, https://digitalprojects.wpi.art/gauguin/artworks/detail?provenance=vollard&page=2&a=71700-drame-au-village-pont-aven.

13. Ann Dumas, "Ambroise Vollard, Patron of the Avant-Garde," in *Cézanne to Picasso: Ambroise Vollard, Patron of the Avant-Garde* (New York: Metropolitan Museum of Art, 2006), 2–27; Douglas W. Druick, "Vollard and Gauguin: Fictions and Facts," in *Cézanne to Picasso: Ambroise Vollard, Patron of the Avant-Garde* (New York: Metropolitan Museum of Art, 2006), 60–81.

14. See, for example, Wildenstein Plattner Institute, Inc., ed. Texts by Richard R. Brettell and Elpida Vouitsis. Research by Françoise Marnoni, Evgenia Kuzmina, and Jennifer Gimblett, "Vahine No Te Tiare, 1891, PGWEHB," n.d. and Te raaù rahi, 1891, PGYZA3.

15. Daniel Wildenstein, *Gauguin: A Savage in the Making*: Catalogue raisonné *of the Paintings, 1873–1888*, 2 vols. (Milan and Paris: Skira; Wildenstein Institute, 2002), https://wpi.art/2019/01/07/gauguin-a-savage-in-the-making/. See, for example, *Children Wrestling* (W299), v. 2, p. 426. And PGH570 Paysage Breton (Breton Landscape), 1894.

16. Wildenstein. See, for example, *Basket of Flowers* (W148), v. 1 p. 167–69; v. 2 *Aven Valley, Upstream of Pont-Aven* (W270), v. 2 p. 378–79.

17. Gauguin and Malingue, *Lettres de Gauguin a sa Femme et a ses Amis*, 280.

18. Louis Roy, "Notice Individuelle" (n.d.), Dossier Louis ROY, Musée de Pont-Aven Archives.

19. Dr. Edmond Delmas, *La Neurasthénie, Syndrome Cérébelleux* (Lyon: Imprimerie de A. Storck, 1902), 3–4, https://gallica.bnf.fr/ark:/12148/bpt6k57137254.

20. Roy, "Notice Individuelle."

21. "Répertoires Alphabétiques de Transports de Corps," 1907, 2484W 29, Archives de Paris.

22. Elisabeth Walter, "'Le Seigneur Roy': Louis Roy, 1862–1907," *Bulletin des Amis du Musée de Rennes* 2 (1978): 61.

23. When Roy joined the faculty, the school was known as the Lycée de Vanves; it was renamed the Lycée Michelet, by which name it is still known, in 1888. See Gustave Dupont-Ferrier, *Les écoles, lycées, collèges, bibliothèques: L'enseignement public à Paris* (Paris: Librairie Renouard, 1913), https://books.google.com/books?id=Ghcb9A_k6MgC&hl=fr&pg=PP17#v=onepage&q&f=false, pp. 173–84.

24. Roy, "Notice Individuelle."

25. Claude Emile Schuffenecker, Jill Grossvogel, and Catherine Puget, *Emile Schuffenecker: 1851–1934* (Pont-Aven: Saint-Germain-en-Laye; Musée de Pont-Aven; Musée Maurice Denis "Le Prieuré," 1996).

26. Jill-Elyse Grossvogel, *Claude-Emile Schuffenecker* Catalogue raisonné 1 (San Francisco, CA: Alan Wolfsy Arts, 2000).

27. André Cariou, *Filiger: Correspondances et Sources Anciennes* (Paris: Locus-Solus, 2019), 19.

28. Jill-Elyse Grossvogel, *Claude-Emile Schuffenecker* Catalogue raisonné 1.

29. Paul Gauguin, Tête d'homme barbu, coiffé d'une couronne de carton; tête de femme, Album Gauguin, Paul - 3 - Le Sourire. Cabinet des dessins, Fonds des dessins et miniatures, collection du musée d'Orsay, RF 28859, Recto, http://arts-graphiques.louvre.fr/detail/oeuvres/29/228227-Tete-dhomme-barbu-coiffe-dune-couronne-de-carton-tete-de-femme, accessed August 7, 2022. *Royne* was an antiquated spelling of *reine*, the French word for queen; see, for example, Geoffroy Chassins, *Discours de la nécessité, utilité et sublimité des Roys . . . à la Royne* (Paris, 1606), https://gallica.bnf.fr/ark:/12148/bpt6k79955b, accessed August 10, 2022. Louis Roy's family name is also the French word for king.

30. Paul Gauguin, "Night Café, Arles," *Gauguin: A Savage in the Making*: Catalogue raisonné *of the Paintings, 1873–1888*, 1888.

31. Paul Gauguin, *Portrait of Louis Roy*, 1890–1891, Private Collection. See Homburg, Cornelia, Christopher Riopelle, Elizabeth C. Childs, Alastair Wright, Jean-David Jumeau-Lafond, Linda Goddard, Dario Gamboni, et al. 2019. *Gauguin: Portraits*. Fig. 30, p. 69.

32. Louis Roy, "Femme nue, debout, levant le bras droit; bras droit," Cabinet des dessins, Fonds des dessins et miniatures, collection du musée d'Orsay, RF 28849, Recto, accessed August 25, 2022.

33. Louis Roy, *Femme Nue, Debout, Levant Le Bras Droit; Bras Droit*, 30.6cm x 21.3cm, Album Gauguin Paul -3- Le sourire, Folio 5, Cabinet des dessins, Fonds des dessins et miniatures, collection du musée d'Orsay, accessed May 8, 2023, http://arts-graphiques.louvre.fr/detail/oeuvres/2/228217-Femme-nue-debout-levant-le-bras-droit-bras-droit.

34. Paul Gauguin, *Homme penché; homme vu de dos brandissant une pancarte*; texte manuscrite, RF 28851, Recto, Fonds des dessins et miniatures, collection du musée d'Orsay, Réserve des grands albums, Album Gauguin Paul -3- Le Sourire, Folio 6, dessiné au verso, http://arts-graphiques.louvre.fr/detail/oeuvres/22/228219-Homme-penche-homme-vu-de-dos-brandissant-une-pancarte-texte-manuscrit-max, accessed August 10, 2022.

35. Clémence Becquet, "SCHMIT Jean (FR)," *Répertoire Des Acteurs Du Marché de l'art En France Sous l'Occupation, 1940–1945, RAMA (FR) - INHA*, accessed October 12, 2023, http://agorha.inha.fr/detail/247.

36. "Album Gauguin Paul -3- Le Sourire," n.d., Cabinet des dessins, Fonds des dessins et miniatures, collection du musée d'Orsay.

37. Schuffenecker's brother, Amédée, died in 1936, and left his estate, including his art collection, to his niece Jeanne, Emile's daughter. The scrapbook may have been in Amédée's possession when he died, or Jeanne may have inherited it from her father. We do not know when Jean Schmit acquired it; only that he donated it

to the Louvre in 1938. See Grossvogel, *Claude-Emile Schuffenecker*, xx, and Album Gauguin Paul - 3 - Le Sourire, Cabinet des dessins, Fods des dessins et miniatures, collection du musée d'Orsay.

38. "Album Gauguin Paul - 3 - Le Sourire."

39. See, in particular, Thomson, "Gauguin Goes Public," in Lemonedes, 29–73. See also David Sweetman, *Paul Gauguin: A Life* (New York: Simon & Schuster, 1995), 222–25; Thomson, 2010; Siberchicot; Grossvogel et al., *Emile Schuffenecker*.

40. Lemonedes, 49.

41. Heather Lemonedes and Paul Gauguin, *Paul Gauguin: The Breakthrough into Modernity* (Ostfildern: Cleveland Museum of Art; Van Gogh Museum; Hatje Cantz Verlag, 2009), 222.

42. Lemonedes, 216–25.

43. Wildenstein 2002, v. 2, p. 478, "Self-Portrait (Les Misérables)," no. 309, https://view.publitas.com/wildenstein-plattner-institute-ol46yv9z6qv6/c-r_paul _gauguin_volume_ii_wildenstein_institute/page/190-191, accessed August 11, 2022.

44. Wildenstein 2002, v. 2, p. 404, "Self-Portrait at Lézaven," no. 291, https:// view.publitas.com/wildenstein-plattner-institute-ol46yv9z6qv6/c-r_paul_gauguin _volume_ii_wildenstein_institute/page/116-117, accessed August 11, 2022. Gauguin changed the inscription to "à l'ami Carrière" after Laval returned the painting to him.

45. Paul Gauguin, "L'Atelier de Schuffenecker, 1889, RF 1959 8," Musée d'Orsay, n.d., https://www.musee-orsay.fr/fr/oeuvres/latelier-de-schuffenecker-287.

46. Wildenstein, *Gauguin*, 261.

47. Moret, Henry and Musée des beaux-arts, Quimper, *Henry Moret: Un Paysagiste de l'Ecole de Pont-Aven* (Quimper: Musée des beaux-arts, 1998), 8.

48. André Cariou, "Meijer de Haan et Paul Gauguin Au Pouldu," in *Meijer de Haan, Le Maître Caché* (Hazan, 2009), 110–20.

49. Gauguin and Malingue, *Lettres de Gauguin a sa Femme et a ses Amis*, 191–93.

50. "Theo van Gogh to Vincent van Gogh, Paris," February 9, 1890, https://van goghletters.org/vg/letters/let852/letter.html.

51. Gauguin's *The Ham* (Phillips Collection) and de Haan's *Still Life with Ham* (Norton-Simon Museum) likewise depict the same arrangement of objects from a different angle. See: Paul Gauguin, *The Ham* (1889), oil on canvas, 0761, The Phillips Collection, and Meijer de Haan, *Still Life with Ham*, oil on canvas, (1889), F.1983.12.P, The Norton Simon Foundation.

52. Meijer de Haan, "Nature Morte: Pot, Oignons, Pain et Pommes Vertes," Musée de Pont-Aven, 90 1889, https://webmuseo.com/ws/musee-pont-aven/app/col lection/record/587.

53. Jacob (Isaac) Meyer de Haan (Dutch, 1852–1895), "Still Life with Ham," The Norton Simon Museum, 1889, https://www.nortonsimon.org/art/detail/F.1983.12.P.

54. Georges Wildenstein, *Gauguin* (Paris: Les Beaux-Arts, 1964), 145, https://wpi .art/2019/01/14/gauguin/.

55. Line Clausen Pedersen, "Personal Communication," 2018.

56. "Revue des Ventes: Tableaux par M. Paul Gauguin," *Gazette de l'Hôtel Drouot*, February 26, 1891, bibliotheque-numerique.inha.fr/idviewer/59616/123.

57. Sweetman, *Paul Gauguin*, 269.

58. David Haziot, *Gauguin* (Paris: Fayard, 2017), 347.

59. "Note 10, 888 (Br. 1990: 892 | CL: T37): Theo van Gogh to Vincent van Gogh. Paris, Sunday, 15 July 1890. Vincent van Gogh Letters," n.d., https://van goghletters.org/vg/letters/let888/letter.html#n-10.

60. "Société Française de Navigation Aérienne, Séance du 18 Décembre 1890," *L'Aéronaute: Moniteur de la Société Générale d'aérostation et d'automotion Aériennes*, February 1, 1891, 30, https://gallica.bnf.fr/ark:/12148/bpt6k5700061c/f4.item.

61. Gauguin and Malingue, *Lettres de Gauguin a sa Femme et a ses Amis*, 214.

62. "Lot No. 595 Gauguin Paul (1848–1903)," La Gazette Drouot, n.d., https://www.gazette-drouot.com/lots/8927497-gauguin-paul-1848-1903-.

63. Roy, "Notice Individuelle."

64. Roy; "Roy, Louis Georges Eléonor, Acte de Décès 3157, June 23, 1907," n.d., 1907, Décès, 10, 10D 304, Archives de Paris; "Roy, Louis Georges Eléonor, Acte de Naissance, No. 61," July 22, 1862, Série du greffe: Naissances 3E/6130, 1858–1862, Poligny, Archives départementales du Jura, http://archives39.fr/ark:/36595/a011423563651zc1yPY; "Roy, Louis Georges Eléonor and Lokofsky, Florence, Acte de Mariage, No. 394," April 4, 1891, Etat Civile, Mariages, 10e arr., 04/04/1891. V4E 6495, Archives de Paris.

65. See Dossier Louis Roy, Archives, Musée de Pont-Aven; Dossier Louis Roy, Centre de Documentation, Musée d'Orsay.

66. Elisabeth Walter, "'Le Seigneur Roy': Louis Roy, 1862–1907."

67. "Roy, Louis Georges Eléonor and Lokofsky, Florence, Acte de Mariage, No. 394."

68. "Mrs. Elizabeth Lokofsky, a. 30, Passenger Lists of Vessels Arriving at New York, New York, 1820–1897" (Ancestry.com Operations, Inc., January 6, 1879), Year: 1879; Arrival: New York, New York; Microfilm Serial: M237, 1820–1897; Microfilm Roll: Roll 416; Line: 18; List Number: 6.

69. "En Exécution du Décret du 16 Juillet 1886 et des Arrêtés en Date des 16 Juillet 1886 et 21 Avril 1893, Le Ministre du Commerce . . . a Accordé des Médailles d'honneur . . . Qui Comptent plus de Trente Années de Services Consécutifs dans le Même Établissement," *Journal Officiel de La République Française* 25, no. 199 (July 25, 1893): 3853, https://gallica.bnf.fr/ark:/12148/bpt6k6257084x/f37.item.

70. Henri Robert, *Traité de Gravure de Musique sur Planches d'étain et des Divers Procédés de Simili Gravure de Musique* (Paris: En Vente Chez L'Auteur, 67, rue Meslay, 1926), 50.

71. Henri Robert, *Traité de Gravure*, 61.

72. Henri Robert, Traité de Gravure de Musique Sur Planches d'étain et Des Divers Procédés de Simili Gravure de Musique, 61.

73. "La Gravure de Musique," *Le Conseil Des Femmes*, November 15, 1904, https://gallica.bnf.fr/ark:/12148/bpt6k14210927.

74. "213 Lafayette, Roy (Mme) Graveur de Musique," in *Annuaire-Almanach du Commerce, de l'industrie, de La Magistrature et de l'administration: Ou Almanach des 500.000 Adresses de Paris, des Départements et des Pays Étrangers* (Paris: Firmin-Didot frères, 1897), https://gallica.bnf.fr/ark:/12148/bpt6k9681939r/f329.item; "Graveurs de Musique, Roy, (Mme), r. Lafayette, 213," in *Annuaire-Almanach Du Commerce, de l'industrie, de la Magistrature et de l'administration: Ou Almanach des 500.000 Adresses de Paris, des Départements et des Pays Étrangers* (Paris: Firmin-Didot frères, 1896), https://gallica.bnf.fr/ark:/12148/bpt6k9690125x/f79.item; "213 Lafayette, Roy (Mme) Graveur de Musique."

75. Jules Grévy, "Décret Sur Les Maîtres Répétiteurs Des Lycées et Collèges," *Bulletin Administratif de l'instruction Publique* 41, no. 734 (1887): 11–17, education.persee.fr/doc/baip_1254-0714_1887_num_41_734_113602.

76. Roy, "Notice Individuelle."

77. Salon des indépendants, ed., *Trente Ans d'art Indépendant, 1884–1914: Catalogue, Exposition Rétrospective des Oeuvres des Membres Inscrits au Cours des Trente Premières Expositions de la Société . . . du 20 Février au 21 Mars . . . 1926* (Paris: L'Emancipatrice, 1926), https://gallica.bnf.fr/ark:/12148/bpt6k851641q.

78. Francis Jourdain, né en 1876, quoted in Pierre Sanchez and Dominique Lobstein, eds., *Les Expositions de La Galerie Le Barc de Boutteville (1891–1899) et du Salon des Cent (1894–1903): Répertoire des Artistes et de Leurs Œuvres* (Dijon: L'Echelle de Jacob, 2012), 15.

79. Sanchez and Lobstein, *Les Expositions*, 404.

80. Theodore, Reff, ed., "Catalogue de L'Exposition de Peintures du Groupe Impressioniste et Synthétiste Faite dans le Local de M. Volpini Au Champ-de-Mars 1889," in *Modern Art in Paris, 1855–1900: Two-Hundred Catalogues of the Major Exhibitions Reproduced in Facsimile in Forty-Seven Volumes*, vol. 28, 47 vols. (New York and London: Garland, 1982).

81. Reff, "Catalogue de L'Exposition."

82. Sanchez and Lobstein, *Les Expositions*, 404.

83. Sanchez and Lobstein.

84. Cornelia Homburg et al., eds., *Gauguin: Portraits* (Ottawa, Ontario, and London: National Gallery of Canada; National Gallery, 2019), 68–70.

85. Georges Wildenstein, *Gauguin*, 120.

86. Ann Dumas, "Degas and His Collection," in *The Private Collection of Edgar Degas* (New York: Metropolitan Museum of Art, 1997), 56.

87. Theodore Reff, "Peintres Impressionistes et Symbolistes 5e Exposition, 1893," in *Modern Art in Paris: Two-Hundred Catalogues of the Major Exhibitions Reproduced in Facsimile in Forty-Seven Volumes: Post-Impressionist Group Exhibitions*, vol. 28 (New York and London: Garland Publishing, Inc., n.d.), 15.

88. "Louis Roy to Emile Schuffenecker," December 26, 1893, Dossier Louis ROY, Musée de Pont-Aven Archives.

89. "Louis Roy to Emile Schuffenecker."

90. "Louis Roy to Emile Schuffenecker."

91. Marc Le Roux, *Catalogue Sommaire du Musée d'Annecy: Collections Artistiques, Industrielles, Archéologiques, Numismatique, Céramique, Armures, Collections Régionales, Histoire Naturelle de La Savoie et de La Chaîne du Mont-Blanc* (Annecy: Imprimerie de Abry, 1900), https://gallica.bnf.fr/ark:/12148/bpt6k65247545.

92. Sweetman, *Paul Gauguin*, 354.

93. Sweetman, 352–85.

94. Elizabeth Prelinger, "The 'Noa Noa Suite,'" 59.

95. See, for example: Claire Bernardi, *Gauguin, L'Alchimiste* (Paris: Réunion des Musées Nationaux), 2017, and Homburg, *Gauguin: Portraits*.

96. Elizabeth Prelinger, "The 'Noa Noa Suite,'" 61.

97. "Louis Roy to Emile Schuffenecker."

98. "Lot No. 595 Gauguin Paul (1848–1903)."

99. Richard S. Field, "Gauguin's Noa Noa Suite," *The Burlington Magazine* 110, no. 786 (1968): 500–511, http://www.jstor.org/stable/875731.

100. Reff, "Catalogue de L'Exposition."

101. Louis Roy, "Paysage, Lithographie Originale Sur Zinc," *L'Ymagier*, no. 3 (April 1895): n.p., https://gallica.bnf.fr/ark:/12148/bpt6k10656525/f11.item.

102. Sweetman, *Paul Gauguin*, 408.

103. Elizabeth Mongan, Eberhard Kornfeld, and Harold Joachim, *Paul Gauguin: Catalogue Raisonné of His Prints* (Bern: Galerie Kornfeld, 1988), 49.

104. Caroline Boyle-Turner, "Meijer de Haan, de Paris Au Pouldu," in *Meijer de Haan: Le Maître Caché* (Paris: Hazan, 2009), 108.

105. Boyle-Turner, "Meijer de Haan, de Paris Au Pouldu."

106. See Kröger, color plate 100, Meijer de Haan, *Autoportrait sur fond japonisant*, 1889–1890; Kröger, color plate 99, Meijer de Haan, *Autoportrait en costume Breton*, 1889; Kröger, color plate 84, Gauguin, *Nirvana: Portrait de Meijer de Haan*, 1889–1890, and Kröger, color plate 98, *Portrait de Meijer de Haan à la lueur d'une lampe*, 1889.

107. This echoes Gauguin's depictions of Breton women. See, for example, Gauguin, *Landscape from Brittany (Le Pouldu) / Field by the Sea*, 1889; *Landscape at Le Pouldu / Harvest by the Sea*, 1890; *Landscape at Le Pouldu / The Isolated House*, 1889, *Laveuses à Arles*, 1888, and *La Vision du serment*, 1888. The women in the background of Roy's painting also echo the women in the background of Gauguin's *Old Women of Arles / Garden at Arles*, 1888, and *Grape Harvest at Arles (Human Anguish)*, 1888. See also the women in de Haan's *Paysage avec deux faneuses*, 1889–1890.

108. See the ocean in Gauguin, *Nirvana: Portrait de Meijer de Haan*, 1889–1890, and Gauguin, *Beach at La Pouldu*, 1889

109. Roy, "Notice Individuelle."

110. Theodore Reff, "Treizième Exposition des Peintres Impressionistes et Symbolistes Chez Le Barc de Boutteville, 1896," in *Modern Art in Paris, 1855–1900: Two-Hundred Catalogues of the Major Exhibitions Reproduced in Facsimile in Forty-Seven Volumes*, vol. 28, 47 vols. (New York and London: Garland Publishing, Inc., 1982).

111. Reff, "Treizième Exposition."

112. Theodore Reff, ed., "Peintres Impressionistes et Sympoliste, 14e Exposition, 1897," vol. 28, 47 vols., *Modern Art in Paris, 1855–1900: Two-Hundred Catalogues of the Major Exhibitions Reproduced in Facsimile in Forty-Seven Volumes* (New York and London: Garland Publishing, Inc., 1982).

113. Reff, "Peintres Impressionistes."

114. André Cariou, *Filiger: Correspondances et Sources Anciennes*, 164.

115. Roy, "Notice Individuelle."

116. "Dossier ROY (Louis), Poligny (Jura) 1862–1907 (Paris)," n.d., Musée d'Orsay, Archives and documentation; "Dossier Louis ROY," n.d., Musée de Pont-Aven Archives.

117. Wildenstein, *Gauguin*, 396.

118. Cariou, *Filiger: Correspondances et Sources Anciennes*, 175.

119. "Dossier Louis ROY."

120. *Tableaux Modernes . . . Provenant de La Succession P. Sérusier et de La Succession de Mademoiselle Boutaric, Vente à Paris Nouveau Drouot—Salles 5, 6, et 7, Mardi 19 Juin et Mercredi 20 Juin, 1984* (Adar Picard Tajan, 1984).

121. Wildenstein, *Gauguin*, 452–53.

122. "Mention Manuscrite dans l'agenda de Louis Roy, Année 1907, Archives Familiales," n.d., Dossier Louis ROY, Musée de Pont-Aven Archives.

123. Paul Gauguin, "Etudes de Personnage Annamites, RF 29877.1, Recto," Louvre, n.d., https://collections.louvre.fr/en/ark:/53355/cl020032616396.

124. Gauguin, "Etudes de Personnage Annamites."

125. Paul Gauguin, "Fruit in a Bowl, 1886," *Gauguin: A Savage in the Making: Catalogue raisonné of the Paintings, 1873–1888*, 261, accessed November 20, 2023, https://view.publitas.com/wildenstein-plattner-institute-ol46yv9z6qv6/c-r_paul_gauguin_volume_i_wildenstein_institute/page/300-301.

126. Andre Lambirth, *Sir Matthew Smith 2015 by Browse & Darby Ltd - Issuu* (London: Browse & Darby, 2015), https://issuu.com/joshdarby/docs/catalogue_-_matthew_smith.

127. "Roy, Louis Georges Eléonor, Acte de Décès 3157, June 23, 1907."

128. "No. 1157, Roy, Louis Georges Eléonor, Registres Journaliers d'inhumation, Cimetière Du Pantin," June 25, 1907, PAN_RJ19071907_02, Archives de Paris.

129. "Liste Des Personnalités Inhumées Au Cimetière Parisien de Pantin" (Paris Ville, June 5, 2022), https://www.paris.fr/lieux/cimetiere-parisien-de-pantin-4501.

CHAPTER THREE

~

April 1923

Was April too late in the year to wear his fur coat? On this dreary April Saturday in 1923 Sacha Guitry gazed out at the drizzle from his mansion in Paris's 17th arrondissement as he pondered which clothes to choose for his outing. Guitry was wealthy, famous, well connected, and admired. An actor, writer, and theatrical producer whose name on a playbill guaranteed a full house, he was also a collector and connoisseur of French art. Guitry planned to attend the auction of modern paintings that was to be held that afternoon at two o'clock in Room 10 of the Hôtel Drouot, the center of the Western art market. The auction catalog promised a sale divided into two sections: first, a group of modern paintings, watercolors, pastels, and drawings from the collections of "assorted amateurs," and second, the collection of the recently deceased Jules Dupré, consisting mostly of nineteenth-century academic art.[1] Guitry was planning to bid, and he knew he could use his appearance to his advantage, to distract and even intimidate the other buyers. Although he was only 5 feet 8 inches,[2] he carried himself like the successful performer he was. Guitry knew how to make an entrance: he was the most celebrated actor and playwright in France. So, the fur or the cashmere?

Born in St. Petersburg in 1885, Alexandre "Sacha" Guitry was the son of actors Lucien Guitry and Renée de Pont-Jest. The family was living in the Russian capital because Lucien was performing at the Théâtre Michel, the city's so-called French Theater, where plays were performed in French for an aristocratic and cosmopolitan audience that sometimes included the imperial family. Alexandre was named for his godfather, Tsar Alexander III—but

everyone knew him as Sacha. His parents separated shortly after his birth and Sacha and his older brother Jean returned to France with their mother. Lucien returned to France permanently in 1894, and the Guitry boys spent time with him at his elegant apartment in the exclusive place Vendôme. On Thursdays, the elder Guitry hosted friends and associates for lunch: the Impressionist painters Monet and Renoir, the actress Sarah Bernhardt, the art critic Octave Mirbeau, and the politician Georges Clémenceau were all regulars at his table. Sacha grew up at the center of the cultural life of the capital.[3]

At seventeen, Sacha left school. He had bounced between eleven institutions over his academic career but never advanced past the French equivalent of seventh grade. He dabbled in drawing, selling a few sketches to daily newspapers, and, in 1901, wrote his first play: *Le Page* [*The Page Boy*], a one-act musical comedy. The family pulled some friendly strings, and the play was produced in 1902 in Paris[4]; it was the first of over one hundred plays that Guitry would write. In 1904, the satirical journal *Gil Blas* hired him to provide drawings, poems, articles, and anything else that might fill column space.[5] Sacha's career as a film and stage actor, producer, and writer would become steadily more successful over the next few years, earning him enough money to live comfortably in Paris with a succession of wives and mistresses—and to begin collecting.

Sacha was a voracious collector. He traced his interest in collecting to a gift from his grandfather when he was a child: a signed letter from the painter Eugène Delacroix. The letter, and its autograph, connected the young man to one of the legends of French painting. Lucien gave Sacha his first work of art, a watercolor by the Impressionist Jean-Louis Forain, in 1900.[6] In 1911, the younger Guitry bought his first Cézanne, a landscape, from the Galerie Bernheim-Jeune.[7] Family friend Claude Monet chose one of his paintings of water lilies to give to Sacha in 1914;[8] Guitry gave it pride of place in his drawing room for decades. Sacha wrote about collecting in a 1952 memoir:

> When the items you have acquired—each time through love, never through self-interest or vanity—are grouped with discernment and form a harmonious, varied whole, and when the neighbors you have chosen do not clash—for example, the green of your Gauguin shouldn't contradict the blue of its Rouault companion—and they all of them . . . go happily together and seem in a word to be the reflection of yourself, then you have the right to describe yourself as a collector.[9]

Fig. 3.1.　Edouard Vuillard (right) and Sacha Guitry. *Source:* Bibliothèue nationale de France, Arts du spectacle, Fonds Guitry, 4-COL-41, Photographies, boîte 579, "Amis-collaborateurs, R-W"

Guitry's collection, he observed, reflected his identity back to him—and reinforced his cultural status with others. He arranged his collection in the room where he received journalists who had come to interview him, long-time friends who had stopped in for a visit, younger guests who had come seeking grace and favor. Poet and journalist René Bizet was a frequent visitor in the 1920s. He recalled that Guitry would receive him "in that vast studio where remarkable [paintings by] Vuillard hung beside velvety Monets, where the masters of painting from the eighteenth century to our time were all represented by a drawing or a canvas chosen with love."[10] Guitry was often photographed with his collections, attired in dramatic smoking jackets and tasseled slippers, sitting next to his Rodin, his Cézanne, his first edition of Molière.

Guitry and Gauguin

Lucien Guitry's circle had included men who had known Gauguin. The art critic and journalist Octave Mirbeau, one of the elder Guitry's closest associates, was an early supporter of the artist. In 1891, just before Gauguin made his first trip to Tahiti, Mirbeau had written a three-column part biography, part review, and mostly paean to Gauguin and his work in the daily paper L'Echo de Paris. Three columns, Mirbeau opined, was not nearly enough:

> To approximate in a few short words the significance of an art that is so complicated and so primitive, so crystalline and so enigmatic, so uncivilized and so refined as M. Gauguin's, is almost impossible, and beyond my talents.[11]

Mirbeau supported Gauguin when few other Paris art critics did, and well before the artist's work became a sought-after commodity. The critic wrote to his and Lucien's mutual friend Claude Monet about meeting Gauguin: "he's a likable character and absolutely tormented by the suffering of art. And he has a fine head. I liked him a lot."[12] Mirbeau and Monet, the Guitry father and son, were all linked to the avant-garde art world in which Paul Gauguin played a part.

There were a number of exhibitions of Gauguin's works in Paris in the 1900s and 1910s: at the Galerie Ambroise Vollard in 1903, 1905, and 1910; at the 1903, 1906, and 1912 Salons d'Automne, major annual shows of modern and contemporary art; at the Bernheim-Jeune Gallery in Paris in 1907, 1910, 1911;[13] and at the Galerie Barbazanges in 1919.[14] Guitry visited these galleries and purchased from these dealers; he even exhibited his own sketches at Bernheim-Jeune.[15] As Sacha was launching his career in the first decades

of the twentieth century, he had opportunities to see and study Gauguin's paintings—and contemplate adding one or more to his own collection.

He knew the area around the Hôtel Drouot well: the Galerie Ambroise Vollard was at 6, rue Lafitte, and Bernheim-Jeune was at 15, rue Richepanse. If you were shopping for some modern art, you could start out at Bernheim-Jeune (Cézanne, Vuillard, Seurat, Matisse),[16] and walk up the Boulevard des Capucines to Vollard's (Picasso, Renoir, Degas, Gauguin).[17] Between 1894 and 1925, forty-nine galleries opened in the area around the rue Lafitte.[18] The rue Drouot, home to the auction house, was only three streets over from the rue Lafitte—and the Théâtre Edouard VII, where Guitry was performing that spring, was a few minutes' walk back down the Boulevard des Capucines. Not only did Guitry know the galleries and their owners; he frequented the auction house. The previous month he had placed the winning bid on a drawing by the eighteenth-century master Boucher, and throughout 1922 he had been a regular purchaser of everything from paintings by Manet[19] to an autographed letter from Jean-Jacques Rousseau.[20] Sacha was in his element on these boulevards.

From February through July 1923, Sacha Guitry headlined the musical comedy *L'Amour Masqué* [*Love in a Mask*]. The operetta, written by Guitry and the composer André Messager, opened to breathless reviews on February 16. Raymond Charpentier, critic for the cultural daily newspaper *Comoedia*, described the comic opera of mistaken identity as "seductive, elegant, and refreshing."[21] Charpentier effused that Guitry's "ingenious inventions," his constant wordplay, his stunning facility for repartee,

> this poetry melded with humor, tenderness balanced with the most sensitive of comments; this unlooked for, unexpected ability to find the right word for every moment; this constant reinvention and variety of detail—all of this is too much to analyze: we can but surrender and be charmed.[22]

Surrender indeed. Charpentier's front page, lavishly illustrated (two sketches and four photos) review of Guitry's play revealed and confirmed the actor's celebrity.

That winter and into the spring Guitry was also working on a film adaptation of his play *La Voyante* [*The Clairvoyant*]. He had written the leading role for the legendary actress, and Guitry family friend, Sarah Bernhardt and had recruited the fashionable dress designer Paul Poiret to create costumes.[23] It was not Guitry's first film; his 1915 *Ceux de chez nous* [*Those of Ours*] was an early documentary featuring short scenes with some of France's most beloved cultural figures, including Monet, Renoir, Degas, the composer Camille

Saint-Saëns, the novelist Edmond Rostand, and Bernhardt herself.[24] Bernhardt, the most famous actress of her generation, died during the making of *La Voyante*, throwing the production schedule into disarray and stealing the front page of Paris daily papers. *Comoedia* talked of almost nothing else for the next week. On March 29, 1923, the day of her funeral, the newspaper printed an open letter from Sacha Guitry on its front page suggesting that every theater in Paris donate its takings that evening to a fund for the creation of a marble statue of Bernhardt. "For the statue to be very beautiful, for it to be made of eternal marble, every actor, every writer, every director" may contribute "and, in an hour, the thing will be done."[25] If you wanted funds raised in the theatrical and cultural community, Sacha Guitry's was the voice to sound the call: his prominent position in that world ensured that his call would be heard. His persona as an actor, writer, producer, and collector meant that, when Guitry entered Room 10 on Saturday, April 14, a few minutes before two o'clock, people noticed.

Auctions, Auctioneers, and Experts

The atmosphere in sales rooms at the Hôtel Drouot was notoriously raucous. An imposing nineteenth-century building in a narrow street between the Louvre and the stock exchange, the auction house centralized not only art sales but sales of all sorts, from household goods to musical instruments and wine to old books. The journalist René Benjamin described the atmosphere of the building as suffused with the scent of Paris—in addition to the atmosphere that the goods to be sold brought with them:

> the suspect odors of the former owners, of their dwellings, their clothes, the papers that had been kept in drawers, the smell of one or several lives which blanketed this atmosphere that was already heavy and unpleasant, and which kept accruing more layers. Trying for the nose, despairing for the soul.[26]

The atmosphere was dense with literal and figurative smells, the smell of objects kept for years in small, smoky, coal-heated apartments, and the smell of dreams deferred or disregarded. The Hôtel Drouot was the place to bid both on a secondhand piano and a Rembrandt, open to everyone, "artists, junk dealers, businessmen, thieves . . . dance-hall girls, overdressed dandies . . . malaria-tinged colonial bureaucrats, crusty old scholars."[27] It was a place where the wealthy climbed staircases next to the poor, the famous stood alongside the nearly invisible, a liminal space in which the commodity value of art and objects was hammered out.

Fig. 3.2. Facade of the 1852 Hôtel Druot in the early 1900s. *Source:* Charles Lansiaux, Public Domain

Auctions took place every afternoon at two o'clock in twenty different dedicated rooms, where the things to be sold were displayed in varying degrees of disorder. Over it all presided the *commissaires-priseurs*, the legally credentialed auctioneers who brought goods to market, and their colleagues the *experts* who set attributions as well as the estimated prices.[28] The role of the auctioneer had been closely regulated in France for over three hundred years.[29] The state held a monopoly on auctions: an auction was only legal if it was held by someone licensed by the state. Each license was numbered and once issued, could be held indefinitely. In Paris in 1923, according to the *Journal des commissaires-priseurs*, there were eighty-two licensees. Those who held the license tended to hold it for life; according to the 1923 table of seniority, the most experienced auctioneers had held their licenses since 1884, almost forty years.[30] Sometimes the license, which had to be purchased at significant cost, was passed from father to son.[31] A committee elected from the group oversaw the details and scheduling of auctions, and managed any legal issues that arose. The auctioneers each had an office for their daily business, most of them clustered in the 9th arrondissement, in the area around the Hôtel Drouot and art dealers' galleries. Five had offices

in the rue de la Grange-Batelière, a moment's walk from the rue Drouot; others had offices in the rue Lafitte or on the boulevards that bounded the neighborhood.[32]

The auctioneers' fees were based on a percentage of the sale prices realized at auction: they benefited when prices were high. About half of their sales came from "auctions prescribed by law" (*ventes judiciaires*).[33] A judicial sale could happen because goods had been seized as part of a legal action. For example, at the outbreak of World War I, the French state confiscated the paintings and art objects that made up the stock of Galerie Kahnweiler. Daniel Kahnweiler, its proprietor, was a German citizen, and thus when France and Germany went to war, his inventory qualified as enemy property. The works—including paintings by Picasso, Derain, Vlaminck, and others—were sold in a series of auctions between 1921–1923 as enemy property impounded during wartime.[34] An estate sale was another type of *vente judiciare*. It took place to disperse of the worldly goods of the recently deceased, whether to pay off their creditors or enrich their heirs: on April 14, 1923, part of the auction was of works "having belonged to M. Jules Dupré, sold due to his death."[35]

The second type of auctions were voluntary sales (*ventes volontaires*). Private individuals hired a *commissaire-priseur* to auction their collections—whether of old masters or their grandparents' linens. The fashion designer Paul Poiret worked with the auctioneer Alphonse Bellier to sell his Dufys and Modiglianis to pay off his debts in 1925.[36] A voluntary sale was not always the result of financial crisis; sometimes, it was simply an occasion to get rid of things you no longer needed, whether they were paintings with an important history or furniture that was out of fashion. The first part of the auction that Sacha was planning to attend that Saturday was made up of works that "various Amateurs," meaning private collectors who did not work as art market professionals, had asked the auctioneer Henri Baudoin to sell for them.

Drouot, observed the critic Jules Claretie, was "the stock exchange for art and *bric à brac*,"[37] odds and ends. Auctioneers like Baudoin had a financial interest in the outcome of the sales they organized. Higher sale prices meant more money in their till at the end of the day. In a voluntary sale, the *commissaire-priseur* had some discretion about what to sell, when, and in what order. The decision he made could impact the market for an artist's work: he could flood the market or starve it, lowering or raising the value of objects based on their supply. The composition of a sale was a strategic act in which the auctioneer and his staff took into consideration a range of variables. The result of the sale could impact an artist's reputation and, more concretely, the market value of his work.[38]

Baudoin had purchased license number 63 for 750,000 francs in 1908[39]; he moved his offices into a grand eighteenth-century mansion at 10, rue de la Grange-Batelière.[40] By 1923, Baudoin had presided over hundreds of sales of goods, everything from jewelry to Belgian lace to Chinese porcelain to the print collection of the art critic Roger Marx.[41] For the April 14, 1923, sale, he and his staff had assembled lots from twenty-three different consignors. There were a few watercolors from the collection of the Russian emigré and theater critic Prince Wolkonsky, who lived in the tony 16th arrondissement. Baron Henri de Rothschild, an industrialist who underwrote Pierre and Marie Curie's research, was looking to sell a couple of still lifes. Gallerist Paul Cailleux, whose shop was at 39, rue Lafitte, was selling a few drawings and paintings; Léon Marseille, owner of a small gallery on the rue de Seine on the Left Bank, had consigned an assortment of works by Gauguin.[42] Baudoin had been auctioning Gauguins for over a decade. In 1912 he and fellow auctioneer Fernand Lair-Dubreuil had managed the sale of Gauguin's *Nave Nave Mahana* to the prominent gallerist Eugène Druet, who had then passed it on to the Musée des Beaux Arts of Lyon, where it remains.[43] The following year, Baudoin sold another Gauguin; and then another in 1914. Since 1920, Gauguins had come under his hammer in four different auctions.[44]

Henri Baudoin's partner in the sale was the *expert* André Schoeller (1879–1955). An *expert*, in the French sense, "is a specialist in art who decides on the artistic value of a work and, at the same time, is a specialist in the art market who assesses a work's market value."[45] In the English and American art markets, the roles of the art specialist, who determines artistic merit, and art appraiser, who determines market value, are separated; in France, in 1923, they were played by the same *expert*. André Schoeller reviewed each work that Baudoin planned to present and pronounced judgment on its authenticity and its market worth. He judged their authenticity based on the similar works that he had studied and sold. The physical characteristics of the work, such as the size and type of canvas, the way the canvas had been fastened to a stretcher, the age of the canvas and its state of preservation were clues to its authenticity.[46] So was its subject matter: Courbet, for example, was known for his paintings of voluptuous sleeping women.

In 1923, André Schoeller was the director-general of the Galerie Georges Petit: in addition to being an *expert*, he was an art dealer who specialized in exactly the kind of art that was being sold. The Georges Petit Gallery, at 8, rue de Sèze, a short walk from Drouot, was one of Paris's most prestigious. Petit exhibited works by Claude Monet in 1885, and from that time began to draw more of the Impressionist painters into his stable. André Schoeller joined the gallery as a secretary in 1902 and became, by the late 1910s, its

director.[47] Schoeller and Baudoin had worked together at previous auctions, including several that featured works by artists whose work was featured on April 14. Since 1920, Schoeller had examined works by Gauguin regularly. He had worked with Baudoin in the June 1920 sale of a Gauguin watercolor of two peasant girls that had sold for 1,305 francs.[48] Schoeller provided his expertise for an auction in December 1921 that included works by Gauguin,[49] and for two more auctions in 1922.[50] They had worked together again, this time during a sale of items from the collection of the Georges Petit gallery—a kind of elite garage sale.[51]

The handwritten minutes of this auction survive in the Paris city archives. French law requires auctioneers to deposit their records in the archives; the extent to which they follow the law varies.[52] Files sometimes contain little more than elliptical lists, or nothing at all. But for this particular auction, the file brims with details. Baudoin's clerks were careful and thorough. Bound into a folio with the other auctions over which Baudoin presided between March 1 and April 30, 1923, the handwritten minutes of the April 14 auction go on for eight pages. They begin with formal, old-fashioned legal language:

> And Saturday April 14, 1923, at two o'clock in the afternoon, we Henri Baudoin, *Commissaire-priseur* listed above and signed below, betook ourselves to the . . . Hôtel Drouot, Room no. 10, in order to proceed with the continuation of the sale with which we had been charged.

There follows the numbered list of twenty-three consignors with their addresses, from number 1, Monsieur le Prince Wolkonsky to number 23, Monsieur Carrette.[53] For each item in the auction, the minutes list the consignor, the item's number in the printed sale catalog, the order in which the item was sold, a brief description, its purchaser, and its sale price. After the record of the final item's sale—a bronze of Theseus battling the minotaur, by Antoine-Louis Barye, 1,600 francs to an M. Cripette—follows contractual language attesting to the legality of the sale, the profits earned, the commissions retained, and the signature of the witnesses, M. Jean Page, of 64, rue Ramey in the 18th arrondissement, and M. André Mignon, of 57, rue St. Jacques in the 5th. The auction would last for four hours and garner 179,491 francs.[54] It was the most profitable auction by a significant margin of the nineteen over which Baudoin presided in March and April, due in large part to the 55,500 francs art dealer—and later Gauguin specialist—Georges Wildenstein paid for a painting of a graciously proportioned nude napping by a stream by the respected nineteenth-century realist Gustave Courbet.[55] Four

years later, Wildenstein's partner Paul Rosenberg would manage a transaction that sent the painting to the collection of the Detroit Institute of Arts, where it remains today.[56]

The next highest price was 14,000 francs. Sacha Guitry paid it for *Flowers and Fruit.*[57]

Room 10

An assortment of art dealers, experts, and collectors—with some in attendance playing all three roles—filled Room 10 that afternoon. The sale had been listed in the auctioneers' calendar and, as Baudoin noted in the auction's minutes, "a number of merchants and amateur collectors had gathered."[58] There were representatives of some of Paris's most successful auction houses, celebrities, scientists, and at least one international spy. Some of the most well-known dealers in modern art had found seats: representatives from the Galerie Bernheim-Jeune had greeted dealers from the Galerie Marcel Bernheim. Georges Wildenstein was there representing his family's prestigious gallery, on the prowl for something significant to carry off. Georges Frederic Keller, who would later work for the Galerie Georges Petit, dropped by with his copy of the sale catalog; bidders came, too, from the Galerie Georges Petit, perhaps alerted by their director Schoeller as to what they should bid on. Joseph Allard, whose gallery bought and sold Impressionist and Post-Impressionist paintings, took his place as well.[59]

Not all the dealers in the room came from well-known galleries. Henri Cottereau had made his fortune manufacturing trendy new bicycles in the 1890s before opening a small gallery in Paris, where he bought and sold works by Manet, Monet, Pissarro, Toulouse-Lautrec, and Gauguin.[60] Some gallerists who were there have been forgotten: Graat et Madoulé, whose shop was at 12, rue de Sèze, near Georges Petit, and Rosenthal et Chaperon, who came over from 57, Boulevard Haussmann.[61] Félix Simonson had kept a gallery for years, and was now working as an independent dealer. Ernest Le Véel, a dealer in "paintings and prints from modern artists [and] old Japanese prints,"[62] had two shops, one with the booksellers on the quai Malaquais across the Seine from the Louvre and the other at 24, rue Lafayette, a block or so from the Galeries Lafayette department store and a few minutes' walk to the Hôtel Drouot. The sale was enough to have brought these men out on a Saturday afternoon looking for more inventory for their shops or decorations for their flats.

Many of the dealers and art merchants who were present were also experts themselves. André Schoeller was both the director of the Georges

Petit Gallery and the expert of record for this auction. Graat and Madoulé served as experts occasionally; so did Simonson and Bernheim.[63] Nathan and Georges Wildenstein would offer their expertise later in the year at a sale of French eighteenth-century works.[64] Depending on what day it was, these men decided both the artistic merit of a work and its market value: they bid, they bought, and then they sold again. Buyers outside of the tight quarters of the art dealers, auctioneers, and the Hôtel Drouot itself, could but believe what they were told about the authenticity and the worth of a work of art.

The room was full of amateur collectors as well. They were amateurs as opposed to being, like Schoeller, an expert: they were amateurs because they did not buy and sell professionally, but as a hobby. One collector was Albert André, an artist himself. He had studied at the Académie Julian; the doyen of Impressionist gallerists, Durand-Ruel, had shown his work in 1908 alongside artists like Monet. André served in World War 1 and after the Armistice left Paris for Endoume, a village on the coast not far from Marseille. The artist Paul Signac was one of his lifelong friends.[65]

Daniel Tzanck was a dentist by trade and a collector by choice. One of Duchamp's first patrons—Duchamp famously paid for some bridge work with a drawing of a check—Tzanck favored modern artists and, in 1923, founded the Société des Amateurs d'art et des Collectionneurs [Society of Art Aficionados and Collectors].[66] Tzanck's medical colleague Dr. Albert Sézary had come along that afternoon, too; the men lived around the corner from each other, Tzanck in a grand building on the Boulevard Saint Germain and Sézary at an equally posh address in the Rue de Luynes.[67] Sézary was the head of the dermatology department at the Hôtel-Dieu, Paris's largest research hospital. His specialty was the treatment of syphilis with arsenic, hailed at the time as a breakthrough.[68]

Another celebrity of a different sort was there: Sir Basil Zaharoff. An international man about town, a polymath who could and did pass himself off under different names and nationalities, Zaharoff owed his fortune to arms deals and to passing secrets between governments. Zaharoff, called ZedZed by his near and dear, was the first to sell the Maxim gun in Europe. The gun, invented by American Hiram Stevens Maxim, was one of the first quick-firing guns—the forerunner of what we now call machine guns. ZedZed sold it to governments from Vienna to London in the years around 1900. A confidante of French premier Clemenceau and English prime minister Lloyd George, a clandestine owner of munitions factories in Russia and Germany during World War I, Zaharoff by 1923 carried himself as an elder states-man. He wintered in Monte Carlo and spent the summers at his Chateau

Balincourt, which he had bought from the last mistress of Leopold, King of the Belgians.[69] He needed art to adorn his many walls.

What was for sale that afternoon? A bit of this, a bit of that, as might be expected from putting together objects from nearly two dozen different consignors. To begin, there were forty-one "watercolors, pastels and drawings" on paper from artists as varied as the Impressionist Camille Pissarro (1830–1903) and the portraitist Gustave Jacquet (1846–1909). There was a watercolor whose creator was unknown, but which Schoeller decided they could say was from "l'école anglaise," and a handful of works from living artists like Ker-Xavier Roussel (1867–1944) and Abel Faivre (1867–1945). The sixty-nine paintings on canvas were equally varied. There were a few Barbizon landscapes; some scenes from foreign lands; a few contemporary scenes of Paris and the suburbs. If you were looking for paintings of animals, you could choose between some cows in autumn by Charles Le Roux (1814–1895) or a herd of sheep in a snowstorm by August Schenck (1828–1901). There were two headliners from Gustave Courbet. And there were eight works by Paul Gauguin. A few were drawings: a fishing boat, some Tahitian women, an old man. There were two studies of Gauguin's associate, the artist and teacher Louis Roy, one a charcoal and crayon profile and the other a pen and ink full-length portrait. Among the paintings, one landscape showed a shepherdess and her sheep, another, a woman collecting firewood in the snow. And there were three still lifes—still lifes that had been, according to the auction catalog, in Louis Roy's collection.

Gauguin's reputation in Paris and beyond was growing in the early 1920s. There had been a three-week exhibition of thirty-two paintings, a bronze, two plaster casts, and four ceramics in 1917 at the Galerie Nunès & Fiquet, a short-lived gallery in the Avenue Malakoff. Goupil & Cie had included his works in a group show in the spring of 1917, and in the summer, the Paul Rosenberg gallery had included one of Gauguin's Tahiti paintings in an exhibition to benefit wounded war veterans.[70] Seventeen Gauguins were part of the 1918 auction of artist Edgar Degas's collection.[71] There had been a significant, much-discussed exhibition of Gauguin's works in 1919 at the Galerie Barbazanges.[72] His reputation—and the market value of his work—was on the rise.

The Auction Begins

The works on paper came under the hammer first, sold in alphabetical order by artist: M. Leroy was the first purchaser, 130 francs for Albert Besnard's *Nude Study*. Besnard was, as of 1922, the director of the Ecole des Beaux Arts;

his work was well within the boundaries of accepted, mainstream art. An ink wash of the Good Samaritan by Alexandre Bida, known for his illustrations of biblical scenes, brought 22 francs. A watercolor of a snowy scene from Louis Delcus, practically unknown during his lifetime and dead since 1915, fetched 30 francs. Then, Abel Faivre: *Jeunesse* [*Youth*], a pastel. Faivre was in his mid-fifties, an accomplished and successful artist who had designed propaganda posters for the French in the Great War. His work brought 910 francs—the first time in the auction room that afternoon when people must have leaned forward in their chairs, craning their necks to see the competition between the bidders. Forain, Jean Louis, was next in order: a pastel of a young woman dressing, to the art dealer Simonson for 600 francs. The energy in the room was beginning to build.

Then the auctioneers brought out the Gauguin drawings, and everyone stretched and shuffled. A few struck up conversations with their neighbors; others lit another cigarette. The five Gauguin drawings would bring some of the lowest prices in this portion of the sale. All had been consigned by the dealer Léon Marseille. The drawing of a fishing boat went to Aris Lampe for 50 francs. The profile of Gauguin's friend Louis Roy went for 55 francs; the full-length portrait drawing to the dealer Cottreau for 65 francs. Le Véel purchased no. 11: *Study of Tahitian Women*, for 65 francs.[73]

What could you buy in Paris in 1923 for 65 francs? You could subscribe to *Comoedia*, the leading cultural newspaper, and stay current with all of Sacha Guitry's performances, for 55 francs for six months. You could contribute to a memorial statue of the actress Sarah Bernhardt—the typing pool from the budget office in the Finance Ministry chipped in 12 francs, and the director of the Théâtre des Capucines put in 100.[74] For 6 francs, you could take home a flask of snake oil called Jouvence de l'Abbé Soury, available in pharmacies everywhere, and guaranteed to heal "troubles with blood circulation, maladies of the stomach, intestines, and nerves, headaches, and neuralgia." You could buy a deluxe, sensually described toothbrush, "its curved surface exactly marrying the shape of the teeth," for 7.50 francs.[75] In the market for silk socks? Barclay, on the Avenue de l'Opéra, was making a special line, "La SUSSEX," available at the exceptional price of 14 francs. Looking for a Persian rug for your entry hall? You could buy one for between 175 and 375 francs, depending on the square meters you were looking for, at a special sale at the Place Clichy on April 19.[76] And if you didn't want to spend that much on a carpet, well, you could drop by the Hôtel Drouot and buy a Gauguin sketch.

Guitry won the next round of bidding: no. 12, a colored pencil drawing of an old man, was his for 400 francs. Guitry spent almost as much on this

as the rest of the Gauguin drawings brought in all together. Was he bid up? Who else wanted the drawing? The archives are silent, but we can imagine that there was competition, that the bidding began to pick up. Baudoin, at his lectern in the front of the room, may have added to his patter, may have encouraged, commented, chatted the bidders up, as he looked to build excitement in the room.

Le Véel, purchaser of the 65-franc Gauguin drawing of Tahitian women, and Guitry sat out the next few lots. The room was shortly to learn that Le Véel and Guitry had both come with an eye on the eleven drawings, pastels, and watercolors by Camille Pissarro in the sale. They had been consigned by Alfred Pacquement, a wealthy and well-connected collector who lived in the decidedly upper-class Boulevard Malesherbes. Pacquement belonged to the exclusive Automobile Club of France;[77] he and his wife were listed as early as 1908 in the *Paris-mondain*, a directory of the addresses (both in Paris and the Côte d'Azur) of the crowned heads of Europe, the surviving French aristocracy, "the diplomatic corps, government ministers, subscribers to the Opera and the Comédie-Française" and then the rest of high society. (A second volume, available for viewing only in person and by appointment, listed the days on which these grand people received visitors at their Paris residences.)[78] Pacquement collected Pissarro and other Impressionists.[79] His brother Charles was likewise a collector and, in the spring of 1924, lent works from his collection to an exhibition in support of the *Société des amis du Luxembourg*, the group that was raising money to establish a museum of contemporary art in Paris. Sacha Guitry also lent objects from his collection to that exhibition.[80] But that event was a year away.

On this afternoon in 1923 Sacha Guitry and Ernest Le Véel would bid against each other for Pacquement's Pissarros. Pissarro was of the first generation of Impressionist artists, exhibiting with them from 1874 onward. His work had first entered museum collections in the early 1900s: Le Véel and Guitry would have both seen Pissarro's paintings and sketches on the walls in commercial galleries, museums, and the homes of their friends. Pissarro was a safe, calculated investment. When the first Pissarro drawing came up, a murmur of recognition went through the room. The first was no. 23: a signed charcoal drawing, *Effet de soir sur la campagne* [*Evening in the country*] went to Le Véel for 170 francs. The art dealer Félix Simonson took the next two—and then, no. 26, a watercolor of the countryside near Pissarro's summer home at Eragny, went to Guitry, 210 francs. The next Pissarro: Guitry, 590 francs for another watercolor, this one signed. The next: a pastel to Le Véel for 430. Then Guitry, 360 francs, and another to Guitry—a spring morning from 1890—for 510 francs. But Le Véel was still

in the game: he took the next, a study of haymakers, for 630 francs. Guitry surged back at 650 francs for an 1890 watercolor of blossoming trees—and with that, the Pissarro sketches were all sold. Did the room bristle as the two men bid against each other? Le Véel was older than Guitry by a generation, a slight, bespectacled collector and dealer who spent his days surrounded by Japanese woodblock prints. Guitry—a compact bear of a man, used to commanding a literal audience from a literal stage—would have loomed over him. Was Le Véel quicker with his paddle? Was Guitry distracted? Did the two men know each other, and compete for the works in a friendly (or less so) way? Once the Pissarros were gone, Le Véel took home two more sketches, a pastel of a valley by Ker-Xavier Roussel, purchased for 420 francs, and a country scene by the Dutch artist Siebe Ten Kate for 115.[81] That was the end of his spree.

Guitry was just getting started. Prices began to rise as the oil paintings came up for sale. A Venice canal scene by Bompard went for 900 francs, a second Bompard Venetian scene for half that. Prices stumbled over works by the lesser known Bouhot and Boutigny. A scene of an old peasant reading with a glass of hard cider at hand went to the Galerie Georges Petit for 455 francs. Two landscapes by Antoine Chintreuil went in the low hundreds. Then Baudoin's assistants brought out Gustave Courbet's *Sleeping Bather*. Schoeller's catalog description read:

> She is undressed near a spring, at the foot of a tree. She leans back, her head in profile, in the shadow, and her body is turned three quarters to the right. She is seated on her shift, which covers her left leg and whose sleeve is draped on her arm, leaning on a branch. One of her feet dangles in the water.
> Signed at the lower left: G. Courbet, '45[82]

The bidding must have been fierce, with the gallerists in the room clamoring for a work they knew they could sell. Courbet was market gold: wealthy industrialists would pay handsomely for his work. And the subject was nude—not so nude as to be naked, but nude in a tasteful sort of way, a nude that your wife might not sniff at when you hung it in your smoking room. Young Georges Wildenstein persisted in the bidding until the very end and triumphed. He may have purchased the Courbet on his father Nathan's recommendation. Nathan had begun dealing in art in the 1870s and, although he preferred to deal in Old Masters and French eighteenth-century artists, he knew that a Courbet was a reasonable investment.[83] Perhaps earlier that week as father and son had pored over the sale catalog, Nathan had circled the Courbet, no. 54, and sent young Georges off to try his mettle.

Almost certainly one of those bidding against Wildenstein was Joseph Allard. Allard had been an art merchant since at least 1900, when he had sold a minor Manet to the dealer Durand-Ruel.[84] Before World War I he had been active in the Buenos Aires art market, organizing group exhibitions in the city and acting as a middleman in the sale of works from the venerable Boussod, Valadon & Cie to the Museo Nacional Buenos Aires. Allard and the dealer Josse Bernheim-Jeune hosted an exhibition of their own in the Argentine capital in 1909.[85] But the Paris market was Allard's base. From his shop at 20, rue des Capucines, he bought and sold and even, on occasion, acted as an expert for auctions.[86] Allard had provided his expertise for two previous auctions that included works by Courbet[87] and, on this day, he was looking closely at the lots by that painter. Wildenstein may have outbid him on the *Sleeping Bather*, but Allard took the other two Courbets in the sale: no. 55, *Gathering of Deer*, showing three young deer resting in a forest near a stream and a grotto (the bidding closed at 7,000 francs), and much later in the afternoon a still life: no. 137, *Iris and Wallflowers in a Porcelain Vase* (3,200 francs).[88]

After the bidding around the Courbets, the auction room fell into a drowsy afternoon haze. A few onlookers may have stepped out for a quick glass of wine or an espresso across the street; others may have wandered into one of the other salerooms to check on the action. Three of the four paintings by the modernist Detroy did not sell at all. One brought all of 100 francs. A few French School landscapes came and went, two nudes by Gauguin's companion in Brittany Charles Filiger (30 francs for one, 75 for the other), neither to a dealer. The representative from the Georges Petit gallery scooped up a landscape by Renoir's friend the minor Impressionist painter Pierre Franc-Lamy.[89]

And then it was time for the Gauguin paintings. First up: no. 72, a still life listed as being from the *Collection Roy*:

On a table are scattered exotic fruits, some on a table napkin, and, to one side, a terracotta dutch oven. To the right, a Japanese print is visible.
Signed lower right, the initials: P.G.[90]

Allard's paddle was up before Baudoin even finished his introduction. Joseph Allard was no stranger to works by Paul Gauguin: he had had the painter's 1886 *Moulin du Bois d'Amour Bathing Place* in stock for the past year or so. An 1888 landscape, *Aven Valley, Upstream of Pont-Aven*, was also in Allard's storerooms. Allard would sell the *Bathing Place* and the landscape by 1926. *Bathing Place* would travel through English and American private collections

for fifty years before, ultimately, settling at the Hiroshima Museum of Art; the American collector Chester Dale would hold the Aven landscape in his collection for almost forty years before donating it to the National Gallery of Art in Washington, DC.[91]

Allard was interested, but so was the art merchant Georges Bernheim, as well as two of the private collectors present, Tzanck and Sézary. And another buyer was ready to jump back in: Sacha Guitry. Watching and waiting since he had purchased his Gauguin and Pissarro sketches, Guitry was perhaps leaning forward, perhaps inclining his head a bit, trying not to show that this was what he was there for. These Gauguins. He wanted to add at least one to his collection, one to unwrap at home and show his wife Yvonne, one to hang on his salon wall and show off to his friends. What would his father say, what would his friend Monet say, when they saw his new acquisition? Where would it fit best, by his Cézanne or his Monet? Or should it have a wall of its own?

Guitry had to focus, to come back to the room and away from the party he was already planning to celebrate his latest addition. Allard beat him to the first still life: Baudoin brought his hammer down on 6,600 francs and the painting was gone, sold to Allard, to be distributed in his network of art world connections. Guitry, focused now, saw the next painting brought to the front. It was another still life associated with Louis Roy:

Roses arranged in two vases, with apples strewn at their base.
Signed at lower right, the initials: P.G., and dedicated: À l'ami Roy.

The greens, the yellows, the soft pinks caught Guitry's eye. He bid and kept bidding. We do not know who bid against him, but there was competition. Over and over, he signaled. Baudoin called 5,000 francs; he called 10. Still bids were rising: 11, 12, 13,000 francs for this Gauguin. Paddles were dropping now, but Guitry still had competitors. At 14,000 francs, he won the auction.[92] The Gauguin still life—which Guitry would call *Flowers and Fruit*—was his. Guitry bought no more that day.

Six more Gauguins came up. A portrait of a man went to Georges Bernheim (2,250 francs). A private collector named Gabariand (38, rue de Liège) claimed a painting of a young man. The physicians Tzanck and Sézary took one Gauguin each. A profile portrait of a man failed to sell. And Allard took the final one, another still life with a connection to Roy (2,600 francs):

On a straw stool, six peaches are arranged, of which two are on a flat faience plate.

Signed in the lower left with the initials: P.G., and the dedication: *Au seigneur Roy.*

Allard stayed on, waiting for the next Courbet and for one by Puvis de Chavannes that he had his eye on, a portrait of the conductor at the Théâtre Italien in 1868. He paid 10,100 francs for that. One last bronze, of Theseus and the Minotaur, sold for 1,600 francs, and Baudoin closed the proceedings. It was six o'clock in the afternoon.[93]

The crowd stood and stretched. Some mingled to gossip: What would Wildenstein do with that Courbet? To whom would he pass it on, the Havemeyers? The Clarks? What about those Filigers? *I hadn't thought of him in ages,* one onlooker might have murmured. *I met him once, I think he's still living, poor man, not what he was in the old days.* And the Gauguins: Was there a buzz about those? Guitry and Allard, perhaps, put their heads together to chat, to compare notes and tease each other's triumphs. Allard came away with two Gauguins for only a few thousand more than Guitry paid for one: Was there some good-natured ribbing about that? Perhaps they both went to shake the hands of Baudoin and Schoeller, congratulating them on a successful sale and diverting afternoon, and making plans for their purchases to be delivered. Then Sacha Guitry wrapped himself up in his coat and went out into the gathering April dusk, thinking of how he would tell the story backstage at the theater that evening and, after the performance, how he and his friends would toast the latest addition to his collection with champagne. The auction house gradually fell silent, merchants and collectors and the merely curious seeping out into the streets, stopping in at their local café to talk over the afternoon before going on to wherever that Saturday night took them.

Later that week, Baudoin's staff oversaw the packing and shipment of the sold paintings. Allard's still lifes, which would be known as *Still Life with Onion and Japanese Woodcut* and *Still Life with Peaches*, went into crates and onto a cart bound for Allard's gallery in the rue des Capucines. Guitry's *Flowers and Fruit* went to his house in the 17th arrondissement. The three paintings associated with Louis Roy would never share a space again. One would find its way to Denmark within a few years. Another would be sold to a dealer in Amsterdam. And the third: that is the painting whose documented life was just beginning.

Notes

1. Hôtel Drouot, *Catalogue des Tableaux Modernes . . . Aquarelles, Pastels & Des-sins . . . Appartenant à divers Amateurs, Tableaux, Pastels & Dessins Modernes . . . Vente pour Cause de Départ, Paris, Hôtel Drouot, salle 10, le Samedi 14 Avril 1923* (Paris: Hôtel Drouot, 1923), https://go.exlibris.link/x0bv6yhS.

2. Registres matricules du recrutement (1887–1921), "Guitry, Alexandre Georges Pierre, Matricule 42" (1907), D4R1 1303, Recrutement militaire de la Seine, Archives de Paris.

3. Jean-Pierre Daniel, *Le Destin Fabuleux de Sacha Guitry* (Asnières-sur-Seine: Marque-pages, 2007), 21–24.

4. Daniel, *Le Destin Fabuleux*, 35–36.

5. Daniel, 41.

6. Sacha Guitry, *19 Avenue Elisée Reclus* (Paris: Raoul Solar, 1952), 34.

7. Walter Feilchenfeldt, Jayne Warman, and David Nash, "Bord de Rivière et Champ, 1890–95 (FWN 1329-TA)," The Paintings, Watercolors and Drawings of Paul Cezanne: An Online *Catalogue raisonné*, accessed April 27, 2023, https://www .cezannecatalogue.com/catalogue/entry.php?id=1351.

8. Daniel Wildenstein, *Monet:* Catalogue raisonné, vol. 4: *Nos. 1596–1983 et Les Grandes Décorations* (Paris: Taschen, 1996), 1702.

9. Guitry, *19 Avenue Elisée Reclus*, 36.

10. René Benjamin and René Bizet, *Sacha Guitry* (Paris: Éditions de la revue le Capitole, 1926), 45.

11. Octave Mirbeau, "Paul Gauguin," L'Echo de Paris, February 16, 1891, https:// gallica.bnf.fr/ark:/12148/bpt6k799124k/f1.item.

12. Laurence Taretreau-Zeller, "Mirbeau Face à Gauguin: Un Exemple de la Nécessité d'Admirer," *Cahiers Octave Mirbeau*, no. 8 (2001).

13. Richard R. Brettell and Elpida Vouitsis, "Exhibition History," Gauguin: *Cata-logue raisonné* of the Paintings, 1891–1903. Edited and compiled by the Wildenstein Plattner Institute, Inc., accessed April 27, 2023, https://digitalprojects.wpi.art/art works/gauguin/indices/exhibitions.

14. Francis Norgelet, "Paul Gauguin: Oeuvres Inconnus" (Galerie Barbazanges, October 10, 1919), Fonds Barbazanges, ODO 1996.52, no. 202, Musée d'Orsay, Archives and Documentation.

15. Sacha Guitry, *Exposition Sacha Guitry par Sacha Guitry* (Paris: Bernheim-Jeune, 1921).

16. "Galerie Bernheim-Jeune," Archives Directory for the History of Collecting in America, The Frick Collection, accessed March 2, 2022, https://research.frick.org/ directory/detail/71.

17. "Vollard, Ambroise (1867–1939)," Archives Directory for the History of Col-lecting in America, The Frick Collection, accessed March 4, 2022, https://research .frick.org/directory/detail/547.

18. Léa Saint-Raymond, Félicie Faizand de Maupeou, and Julien Cavero, "Les Rues Des Tableaux: The Geography of the Parisian Art Market 1815–1955," Artl@s Bulletin 5, no. 1 (2016): 119–59.

19. "Revue Des Ventes: Collection de M. Alfred Savoir," Gazette de l'Hôtel Drouot, March 23, 1922.

20. "Chronique des Ventes: Vente à Bruxelles, Collection Fonson," Gazette de l'Hôtel Drouot, December 12, 1922, bibliotheque-numerique.inha.fr/idviewer/59669/549.

21. Raymond Charpentier, "L'Amour Masqué," Comoedia, February 16, 1923, https://gallica.bnf.fr/ark:/12148/bpt6k7648017q.

22. Charpentier, "L'Amour Masqué."

23. Leon Abrams and Louis Mercanton, "La Voyante (The Clairvoyant)," Silent Era, 1924, https://www.silentera.com/PSFL/data/V/Voyante1924.html.

24. "Ceux de Chez Nous," Institut Français Cinéma, 1952, https://ifcinema.insti tutfrancais.com/en/movie?id=b2df5433-d9ed-6ec9-edd6-359f2801c0a7.

25. Sacha Guitry, "D'un Marbre Impérissable!," Comoedia, March 29, 1923, https://gallica.bnf.fr/ark:/12148/bpt6k7648058n.

26. René Benjamin, L'Hôtel des Ventes (Paris: G. Oudin, 1914), 18.

27. Benjamin, L'Hôtel des Ventes, 12–16.

28. Lukas Fuchsgruber, "The Hôtel Drouot as the Stock Exchange for Art. Financialization of Art Auctions in the Nineteenth Century," Journal for Art Market Studies 1, no. 1 (2017): 37, https://doi.org/10.23690/jams.v1i1.5.

29. Alain Quemin, Les Commissaires-Priseurs: La Mutation d'une Profession (Paris: Anthropos, 1997), 28.

30. "Tableau d'ancienneté Des Commissaires-Priseurs de Paris," Journal des Commissaires-Priseurs: Législation, Doctrine, Jurisprudence 80, nos. 1–2 (February 1923): 12, https://gallica.bnf.fr/ark:/12148/bpt6k11680046.

31. Isabelle Rouge-Ducos, Le Crieur et Le Marteau: Histoire Des Commissaires-Priseurs de Paris (1801–1945) (Paris: Belin, 2013), 365–477.

32. "Commissaires-Priseurs du Département de la Seine," Journal des Commissaires-Priseurs: Législation, Doctrine, Jurisprudence 80, nos. 1–2 (February 1923): 7–8, https://gallica.bnf.fr/ark:/12148/bpt6k11680046.

33. Fuchsgruber, "The Hôtel Drouot," 35.

34. Hôtel Drouot, Catalogue des Tableaux Modernes, Pastels, Aquarelles, Gouaches, par une Association d'artistes: Vente, Paris, Drouot, Salle 13, Le Mardi 4 Juillet 1922 (Paris: Hôtel Drouot, 1922); Hôtel Drouot, Catalogue des Tableaux, Aquarelles, Gouaches et Dessins, par Bernard Boutet de Monvel . . .: Vente, Paris, Drouot, Salle 7, Le Mardi 4 Juillet 1922 (Paris: Hôtel Drouot, 1922).

35. Hôtel Drouot, Catalogue des Tableaux modernes par Bompard . . .: Vente pour Cause de Départ, Paris, Hôtel Drouot, Salle 10, le Samedi 14 Avril 1923 (Paris: Hôtel Drouot, 1923).

36. "Vente Volontaire (Req'on et) de Tableaux de La Collection Poiret, Hôtel Drouot, Salle 6," Juin 1926, D1493.E3.0003, Archives de Paris.

37. Fuchsgruber, "The Hôtel Drouot," 44.

38. Fuchsgruber, 35.

39. Isabelle Rouge-Ducos, Le Crieur et Le Marteau: Histoire des Commissaires-Priseurs de Paris (1801–1945), 372. In 1908, 750,000 francs was worth approximately $127,500; in 2023 prices, that amount would be worth $4,003,000. See https://www.bls.gov/data/inflation_calculator.htm and https://canvasresources-prod.le.unimelb.edu.au/projects/CURRENCY_CALC/.

40. Hôtel Drouot, Antiquités Égyptiennes, Collection de Monsieur Le Baron de Menascé: Vente, Paris, Hôtel Drouot, Salle 5, Lundi 23 et Mardi 24 Février, 1891 (Paris: Hôtel Drouot, 1891).

41. Hôtel Drouot, Catalogue des Estampes Modernes Composant La Collection Roger Marx: Vente, Paris, Hôtel Drouot, du Lundi 27 Avril au Samedi 2 Mai 1914 (Paris: Hôtel Drouot, 1914); Hôtel Drouot, Catalogue des Beaux Bijoux . . .: Vente, Paris, Hôtel Drouot, Salle 9, 12 Novembre 1919 (Paris: Hôtel Drouot, 1919); Hôtel Drouot, Catalogue des Objets d'Art et d'Ameublement du XVIIIe Siècle et Autres . . .: Vente, Paris, Hôtel Drouot, Salle 1, du 22 au 24 Avril 1920 (Paris: Hôtel Drouot, 1920).

42. Henri Baudoin, "Vente Jeunet" (Paris, April 1, 1923), D.48E3 103, Archives de Paris.

43. Wildenstein Plattner Institute, Inc., ed. Texts by Richard R. Brettell and Elpida Vouitsis. Research by Françoise Marnoni, Evgenia Kuzmina, and Jennifer Gimblett, "Nave Nave Mahana, 1896, PGZ1Z1," Gauguin: Catalogue raisonné of the Paintings, 1891–1903, accessed April 27, 2023, https://digitalprojects.wpi.art/artworks/gauguin/detail/71721-nave-nave-mahana.

44. "Revue des Ventes: Successions Ch. M. de Valenciennes et Mme X.," Gazette de l'Hôtel Drouot, August 25, 1920, bibliotheque-numerique.inha.fr/idviewer/59655/387; "Chronique des Ventes: Collection Beurdeley," Gazette de l'Hôtel Drouot, June 23, 1921, bibliotheque-numerique.inha.fr/idviewer/59661/301; "Revue des Ventes: Successions Ch. M. de Valenciennes et Mme X."; Hôtel Drouot, Catalogue des Tableaux Modernes par Bail, Bergeret . . .: Vente, Paris, Galerie Georges Petit, le Lundi 12 Décembre 1921 (Paris: Hôtel Drouot, 1921).

45. Raymonde Moulin and A. Quemin, "La certification de la valeur de l'art: Experts et expertises," Annales: Histoire, sciences sociales 48, no. 6 (December 1993): 14222, https://www.jstor.org/stable/27584571.

46. Moulin and Quemin, "La certification," 14232.

47. Anne-Françoise Ponthus, "La Galerie Georges Petit," La Société Nouvelle (blog), accessed April 27, 2023, http://www.lasocietenouvelle.fr/galerie-georges-petit.html; OAD, "What Does It Mean to Find André Schoeller in the Provenance of an Artwork?," https://www.openartdata.org/2019/07/andre-schoeller.html, Open Art Data (blog), January 18, 2020; "André Schoeller (1879–1955)," BnF Data, accessed April 27, 2023, https://data.bnf.fr/fr/15436984/andre_schoeller/.

48. "Revue des Ventes: Successions Ch. M. de Valenciennes et Mme X."

49. "Chronique des Ventes: Galerie Georges Petit, Tableaux Modernes," Gazette de l'Hôtel Drouot, December 13, 1921, bibliotheque-numerique.inha.fr/idviewer/

59661/513; "Revue des Ventes: Tableaux à Divers Amateurs," *Gazette de l'Hôtel Drouot*, December 27, 1921, bibliotheque-numerique.inha.fr/idviewer/59661/539.

50. "Revue des Ventes: Tableaux à Divers Amateurs," *Gazette de l'Hôtel Drouot*, March 30, 1922, bibliotheque-numerique.inha.fr/idviewer/59669/148; "Chronique des Ventes: Tableaux Modernes," *Gazette de l'Hôtel Drouot*, November 21, 1922, bibliotheque-numerique.inha.fr/idviewer/59669/509.

51. Hôtel Drouot, *Catalogues des Tableaux Modernes, Aquarelles, Pastels, Dessins, par Besnard . . . Composant La Collection Georges Petit: Vente, Galerie Georges Petit, les Vendredi 4 et Samedi 5 Mars 1921* (Paris: Hôtel Drouot, 1921); Hôtel Drouot, *Collection A. Beurdeley (Neuvième Vente). Catalogue des Dessins, Pastels, Aquarelles Modernes [Deuxième Partie] Par Barye . . .: Vente, Paris, Galerie Georges Petit, du 30 Novembre au 2 Decembre 1920* (Paris: Hôtel Drouot, 1920).

52. Rouge-Ducos, *Le Crieur et Le Marteau*, 328.

53. Baudoin, "Vente Jeunet."

54. Baudoin. In 1923, 179,491 francs would have been worth $119,719.83; in 2022 prices, that would be valued at $1,968,362.03. Accessed March 5, 2022.

55. Robert Fernier, *La Vie et l'oeuvre de Gustave Courbet: Catalogue Raisonné*, vol. 1: *1819–1865 Peintures* (Paris: Fondation Wildenstein, 1977), 44.

56. Gustave Courbet, "Bather Sleeping by a Brook, 1845, 27.202," Detroit Institute of Arts, accessed April 27, 2023, https://dia.org/collection/bather-sleeping-brook-41525.

57. Baudoin, "Vente Jeunet."

58. Baudoin.

59. Baudoin.

60. Samuel Johnson, "Cottereau, Henri," Index of Historic Collectors and Dealers of Cubism, Leonard A. Lauder Research Center for Modern Art, Metropolitan Museum of Art, accessed March 11, 2022, https://www.metmuseum.org/art/libraries-and-research-centers/leonard-lauder-research-center/research/index-of-cubist-art-collectors/cottereau.

61. "Graat et Madoulé, 12 Rue de Sèze," in Annuaire du Commerce Didot-Bottin (Paris: Firmin-Didot frères, 1921), https://gallica.bnf.fr/ark:/12148/bpt6k97774838/f722.item; "Galerie Rosenthal et Chaperon, 57 Boulevard Haussmann," in Annuaire du Commerce Didot-Bottin (Paris: Firmin-Didot frères, 1921), https://gallica.bnf.fr/ark:/12148/bpt6k97774838/f1068.item.

62. "Le Véel, 24 Rue Lafayette and 19 Quai Malaquais," in Annuaire du Commerce Didot-Bottin (Paris: Firmin-Didot frères, 1921), https://gallica.bnf.fr/ark:/12148/bpt6k97790697/f1639.image.r=le%20veel.

63. Robert Fernier, "Catalogues des Ventes," in *La Vie et L'oeuvre de Gustave Courbet*, vol. 2, 2 vols. (Paris: Fondation Wildenstein, 1978), 351–57.

64. *Catalogue des Tableaux Anciens, Principalement de l'école Française Du XVIIIe Siècle . . . Vente, Paris, Galerie Georges Petit, le Jeudi 22 Novembre 1923* (Paris: Hôtel Drouot, 1923).

65. Evelyne Yeatman-Eiffel, "Albert André Lyon, 1869–Laudun, 1954," Thyssen-Bornemisza Museo Nacional, accessed April 28, 2023, https://www.museothyssen.org/en/collection/artists/andre-albert.

66. Trevor Stark, "Tzanck, Daniel," The Modern Art Index Project, November 2016, https://www.metmuseum.org/art/libraries-and-research-centers/leonard-lauder-research-center/research-resources/the-modern-art-index-project/tzanck.

67. "Luynes (Rue De)," in Annuaire du Commerce Didot-Bottin (Paris: Firmin-Didot frères), accessed April 28, 2023, https://gallica.bnf.fr/ark:/12148/bpt6k97770619/f126.item#; "Dentistes," in Annuaire du Commerce Didot-Bottin (Paris: Firmin-Didot frères, 1922), https://gallica.bnf.fr/ark:/12148/bpt6k97773294/f1531.image.r=tzanck.

68. Charles Steffen, "The Man Behind the Eponym Dermatology in Historical Perspective: Albert Sézary and the Sézary Syndrome," American Journal of Dermatopathology 28, no. 4 (August 2006): 357–67; Aria Shakeri, "Albert Sézary: The Man, the Cell, and the Syndrome," JAMA Dermatology 154, no. 4 (2018): 496–97, https://doi-org.proxy1.library.jhu.edu/10.1001/jamadermatol.2017.6475.

69. Donald McCormick, Pedlar of Death: The Life of Sir Basil Zaharoff (New York: Holt, Rinehart and Winston, n.d.).

70. Brettell and Vouitsis, "Exhibition History."

71. "Revue des Ventes: Collection Edgar Degas," Gazette de l'Hôtel Drouot, March 30, 1918, bibliotheque-numerique.inha.fr/idviewer/59638/67; "Revue des Ventes: Collection Edgar Degas," Gazette de l'Hôtel Drouot, November 9, 1918, bibliotheque-numerique.inha.fr/idviewer/59638/193.

72. Norgelet, "Paul Gauguin: Oeuvres Inconnus."

73. Baudoin, "Vente Jeunet."

74. "Pour la Statue de Sarah Bernhardt," Comoedia, April 1, 1923, https://gallica.bnf.fr/ark:/12148/bpt6k76480614.

75. "La Brosse à Dents," L'Homme Libre: Journal Quotidien du Matin, April 1923, https://gallica.bnf.fr/ark:/12148/bpt6k7592824w.

76. "Les Tapis à La Place Clichy," Le Journal, April 15, 1923, https://gallica.bnf.fr/ark:/12148/bpt6k7608480r.

77. Baron de Tully, "Automobile-Club de France," in Annuaire des Grands Cercles: Cercle de l'Union, Jockey Club. (Paris: A. Lahure, Editeur, 1925), 291.

78. A. Saint-Martin, "Liste Alphabétique," in Paris-Mondain: Annuaire du Grand Monde Parisien et de La Colonie Étrangère. (Paris: A. Saint-Martin, 1908), 269, https://gallica.bnf.fr/ark:/12148/bpt6k205233j.

79. Joachim Pissarro and Claire Durand-Ruel Snollaerts, Pissarro: Critical Catalogue of Paintings, vol. 2 (Milan: Skira, 2005), 291, https://wpi.art/2019/01/08/pissarro/; Sarah Lees, Nineteenth-Century European Paintings at the Sterling and Francine Clark Art Institute (Williamstown, MA: Sterling and Francine Clark Art Institute, 2013).

80. Exposition de Collectionneurs au Profit de La Société des Amis du Luxembourg. Ouverte du 10 Mars au 10 Avril 1924 (Paris: Chambre syndicale de al curiosité et des Beaux-Arts, 1924).

81. Baudoin, "Vente Jeunet."

82. Hôtel Drouot, Catalogue des Tableaux Modernes par Bompard . . .: Vente pour Cause de Départ, Paris, Hôtel Drouot, Salle 10, le Samedi 14 Avril 1923.

83. Charles Dellheim, *Belonging and Betrayal: How Jews Made the Art World Modern* (Waltham, MA: Brandeis University Press, 2021), 22–41.

84. Denis Rouart and Daniel Wildenstein, *Edouard Manet: Catalogue raisonné*, vol. 1 (Lausanne: La Bibliothèque des Arts, 1975), 264.

85. Maria Isabel Baldasarre, "Buenos Aires: An Art Metropolis in the Late Nineteenth Century," *Nineteenth-Century Art Worldwide* 16, no. 1 (n.d.): 1–53, https://doi.org/10.29411/ncaw.2017.16.1.2.

86. "Tableaux (Marchands De)," in *Annuaire du Commerce Didot-Bottin* (Paris: Firmin-Didot frères, 1922), https://gallica.bnf.fr/ark:/12148/bpt6k9777226j/f1625.item.r=tableaux.

87. Fernier, *La Vie et l'oeuvre de Gustave Courbet.*

88. Baudoin, "Vente Jeunet"; Hôtel Drouot, Catalogue des Tableaux Modernes par Bompard . . .: Vente pour Cause de Départ, Paris, Hôtel Drouot, Salle 10, le Samedi 14 Avril 1923.

89. Georges Rivière, *Renoir et ses Amis* (Paris: Imprimerie Paul Hérissey, 1921).

90. Henri Baudoin, "Vente Jeunet"; Hôtel Drouot, Catalogue des Tableaux Modernes par Bompard . . .: Vente pour Cause de Départ, Paris, Hôtel Drouot, Salle 10, le Samedi 14 Avril 1923.

91. Daniel Wildenstein, *Gauguin: A Savage in the Making: Catalogue raisonné of the Paintings, 1873–1888* (Milan and Paris: Skira; Wildenstein Institute, 2002), 275–77, 378–79, https://wpi.art/2019/01/07/gauguin-a-savage-in-the-making/.

92. According to the Archival Currency Convertor 1916–1940, in 1923 14,000 French francs would have been worth $933.80; in 2022, it would be the approximate equivalent of $15,493.22, https://canvasresources-prod.le.unimelb.edu.au/projects/CURRENCY_CALC/ accessed March 14, 2022, https://www.officialdata.org/, accessed March 14, 2022.

93. Baudoin, "Vente Jeunet."

CHAPTER FOUR

~

The Antechamber of the Museum

Imagine a night at the theater in Paris in the late 1920s. At intermission everyone goes into the lobby for champagne. Gathered around the bar are actors and actresses, civil servants and war heroes. There are poets and journalists, editors and novelists. There are producers and directors discussing what to put on next. And there are auctioneers, art dealers, and artists. Edouard Vuillard is there, checking his pocket watch. Auctioneers Henri Baudoin and Alphonse Bellier have found a sofa and are gossiping about the Hôtel Drouot. Gaston and Josse Bernheim-Jeune are huddled with their cousin Jos Hessel, talking about gallery shows. Promises are made, dates are set in the few minutes before the bell signals the beginning of the next act. Everyone swallows the last of their champagne and files back into the theater to take their seats—seats that their mutual friend Sacha Guitry had reserved for them.[1] The lights go down, the curtain comes up, and there he is, larger than life.

Guitry maintained a network that included everyone from Dr. Wallich, the chief of obstetrics at the Faculty of Medicine, to the playwright Edmond See, to the Italian war hero and diplomat General Piccio.[2] He collected people the way that he collected art and other objects: a little of everything, all mixed together. At home in his lavish bohemian apartment, Guitry used his collections of objects to create an atmosphere. Previously unpublished photographs of his study in the 1920s show it as a cabinet of curiosities: An ornamental marble column, architectural salvage, stands by the window. A French flag hangs high in a corner above a bookshelf crowded with leather

and gilt-bound volumes. The fireplace surround looks to date from the Renaissance, its elaborately carved wooden mantel worthy of a minor chateau. Above the mantel Guitry has propped an imposing panel painted in large, gilded kanji characters. There are tapestries, carvings, curios, and photographs. There are hydrangeas. The fringe that trims the lampshades would not look out of place on a stage curtain. The furniture is heavy and mostly covered in leather: Guitry's desk chair, with a high back and carved armrests, is almost a throne.[3] The decorating theme seems to be that more is more.

And then there are the paintings. They hang on the long wall facing the window salon-style, from the floor nearly to the ceiling. There are drawings and prints. There are small landscapes and a few figure drawings. There is a Renoir nude under a Toulouse-Lautrec showing a woman in her dressing room applying makeup. Above the Toulouse-Lautrec is a large painting, likely a landscape by Ker-Xavier Roussel, brother-in-law of Guitry's friend, the artist Edouard Vuillard. To the right of the Roussel is a painting of apple trees in bloom by Monet. To the left of the Roussel hangs *Flowers and Fruit*.[4]

In the photograph Guitry sits at his immense desk. Victor Hugo, in the shape of a bust by Rodin, watches over the actor as he writes. Wrapped in a velvet robe over a white shirt and wearing leather slippers, Guitry is entirely at home.[5] It is his room, his space. Here he writes his plays; here he learns his lines. He entertains his close friends—as well as those he wishes to impress. The writer René Bizet declared that "there is no warmer welcome than that of Sacha Guitry for a stranger." Visiting the great man "in his large studio where admirable Vuillards hang near velvety Monets," Bizet noted, was refreshing; he always left feeling better than when he arrived. Guitry would speak about "his paintings, his books . . . his autograph collection . . . his friends, and those he admires." He told funny stories seriously, and serious stories lightly.[6] He told his stories and charmed his guests, from 1923 until 1929, beneath the apples and roses of his Gauguin.

The 1920s were a lavish decade for Guitry. He jotted down expenses in a pocket notebook, today held in the French national library's theater department. Thus, we know that in April 1921, Guitry paid the art dealer Jos Hessel 4,000 francs for a painting by the Impressionist Alfred Sisley. On July 12, 1924, Guitry paid the elderly Monet 50,000 francs for a painting of apple trees in blossom, the same one that hung above his desk. Two years later, he added a painting by Maurice Utrillo to his collection (10,000 francs from, again, Jos Hessel). And in 1928, from the gallerist Etienne Bignou, he purchased a Cézanne watercolor (35,000 francs) and an oil painting by Matisse (also 35,000 francs).[7] He did not only buy art: Guitry bought furs and jewelry, rare books and autographs. He paid 100,000 francs for a necklace

Fig. 4.1. The salon of Sacha Guitry in the rue Alphonse de Neuville. *Source:* **Biblio-thèque nationale de France, Arts du spectacle, Fonds Guitry, 4-COL-41 / Photographies / boîte 652, "20 rue Alphonse de Neuville. Son bureau en 1923.**

from the jeweler Chaumet in 1924. In March 1926, he needed a chinchilla fur coat (44,500 francs) to keep out the damp. From the auctioneer Fernand Lair Dubreuil, Guitry bought 3,244 francs' worth of rare books just before Christmas 1927, and three weeks later he paid the auctioneer Henri Bau-doin, from whom he had purchased *Flowers and Fruit*, almost 5,000 francs for rare autographs.[8] He traveled regularly to take the cure at the expansive Royal Hotel in Evian; he toured his theatrical productions in the United States and England, as well as across France.

In 1929, Guitry decided to auction some of his collection. We can imagine the room thrown into disarray as he opened drawers and albums, choosing which works he loved less, or which would bring more. He culled drawings by Corot, Degas, Derain, and Dufy. He hesitated and then put in the pile his Laurencin watercolor of a young woman playing the guitar while wearing an elaborate plumed hat. Toulouse-Lautrec studies, Modigliani drawings, and eight assorted works on paper by Picasso went. A few Signac watercolors and one Vuillard drawing went into the stack. And then there were the pastels: a Cassatt of a little girl with her dog, some Degas dancers, a few Roussels. Guitry would send dozens of works on paper to the auction house.[9]

Guitry selected paintings for the sale: works by Corot, Dufy, van Don-
gen. Foujita and Friesz. Marchand and Marquet. Two by Berthe Morisot;
one, a scene of the port in Nice, is now in the collection of the Musée
Marmottan Monet.[10] Two Renoirs went, a nude and a landscape, and the
large Roussel that had hung between the Gauguin and Monet. All of those
came off the wall, making space for new purchases. The Gauguin went,
too.[11]

During the years that *Flowers and Fruit* lived with Guitry, museums began
to collect works by Gauguin. In 1921, the Brooklyn Museum of Art, the
Metropolitan Museum of Art, and the Worcester (MA) Art Museum had
brought Gauguins into their permanent collections. The Art Institute of
Chicago accepted the gift of four Gauguin works on paper from Emily Crane
Chadbourne in 1922. The Museum of Fine Arts in Strasbourg purchased
a watercolor of a landscape in Brittany in 1921, and in 1923 the Louvre
accepted the donation of two oil paintings: *Les Alyscamps*, a landscape
Gauguin painted outside Arles in 1888 alongside Vincent van Gogh,[12] and
his 1891 *Tahitian Women*, which showed two barefoot, modestly dressed
women seated on a beach, flowers tucked behind their ears.[13] The Art
Institute of Chicago had added four oil paintings between 1925 and 1927.[14]
The Louvre accepted Georges-Daniel de Monfreid's donation of two oils
in 1927;[15] the Ny Carlsberg Glyptotek in Copenhagen accessioned eleven
Gauguin paintings in 1927 alone.[16] Museums that may have been less willing
to put money into Gauguin's more expensive oil paintings were nevertheless
investing in his works on paper: the Brooklyn Museum of Art, the Metropoli-
tan Museum of Art, and the Baltimore Museum of Art all brought woodcuts
into their collections between 1924 and 1929.[17]

Collectors were buying up Gauguins as well. Samuel Courtauld, heir to
the largest silk manufacturing firm in Europe, took an interest in Gauguin's
work throughout the 1920s. In 1924, he bought Gauguin's *Tahitian Bath-
ers*, now part of the collection of the Barber Institute of Fine Arts, from
the dealer Ambroise Vollard.[18] Courtauld purchased Gauguin's dramatic
Tahitian nude *Nevermore* from the Goupil Gallery's London branch in early
1927.[19] He acquired *Te Rerioa*, another Tahitian scene, in 1929.[20] Both of
those works are now part of the collection of the Courtauld Institute in
London. The Bostonian John Taylor Spaulding was busy building his own
collection of Gauguins, most of which he donated to Boston's Museum of
Fine Arts. He purchased the 1882–1883 *Entrance to the Village of Osny* from
the New York branch of Durand-Ruel in 1921;[21] the following year, he went
back to Durand-Ruel to buy an 1894 still life from Pont-Aven, *Flowers and a
Bowl of Fruit on a Table*.

Guitry may have decided to put his Gauguin up for auction to see what it would bring in a world where Gauguin's work was increasingly well known. It could have made good business sense. Or maybe Sacha was matching his collection to his new house: his father Lucien had died in 1925, and Guitry had inherited the grand private home in the shadow of the Eiffel Tower. The house at 18, avenue Elisée-Réclus, had a cultivated air of aristocracy, with a wide sweep of staircase leading to a long oval room that would be Sacha's office and studio, salon and gallery.[22] Gone was the bohemian atmosphere of the apartment on the rue Albert de Neuville. This house, where Sacha would live for the rest of his life, would be the backdrop for his life as one of his country's most famous celebrities.

The Experts

The rue la Boétie is an ordinary Paris side street, full of small shops and offices. In 1929 there was a candy shop and a sports club, a bakery and a realtor. There were several dentists: Dr. Schwabacher at number 13, Dr. Schawinsky at number 23, and Drs. Bertrand (husband and wife) at number 29. There were law offices and engineering firms, banks and public relations companies. But the most common shop in the street was the gallery. There were all sorts. You could shop for antiques at M. James's place at number 28 and, if you didn't find quite the right bibelot, wander in to M. Ronsard's shop at number 14; if you still hadn't found quite what you had hoped for, there was M. Petit to consult at number 13 and, as a last resort, you could take a quick look into Mme. Gins's storefront at number 8. She specialized in objets d'art, and could almost certainly make you a good deal. Not interested in antiques? Carpets and made-to-order furniture were available from M. Bézier at number 17. M. Mitsouko sold Chinese and Japanese imports at number 5, and M. Raufast, number 18, sold old porcelain.[23]

There were also the galleries of over a dozen art dealers: the Wildenstein gallery was at number 57, Paul Guillaume at number 59, and Jos Hessel at number 26. Number 8 was the home of one of the centers of the market for modern art in the 1920s: the Galerie Etienne Bignou.[24] Its eponymous proprietor had agents and allies from Paris to Vienna, London to New York on the lookout for paintings to buy, sell, and trade. From the red damask-covered walls of his gallery, Bignou sold Seurats and Cézannes, Daumiers and Degases, Picassos and Matisses. Journalist Christian Zavros described him, in a 1927 profile in the art journal *Cahiers d'Art*, as always on the lookout for works that would gain in value over time: his goal was "to make his gallery the antechamber of museums."[25]

Fig. 4.2. Etienne Bignou (smiling at camera; left of woman in white gown) in the ocean-liner Île-de-France. December 16, 1933. Fonds Etienne Bignou (1891–1950), French art dealer. Silver gelatin print, ODO2006-10-1-14. Copy-photo: Patrice Schmidt. *Source:* © RMN-Grand Palais, Art Resource, NY

Born in France in 1891, Bignou had been educated in England where, he was proud to recount, he had been "the first French captain of an English football [soccer] team."[26] Bignou's first job had been selling fur coats to wealthy Londoners. He returned to France as a young man to apprentice with his stepfather, who owned an art gallery that dealt in old masters. Bignou inherited the gallery when his stepfather died and within a few years had shifted its stock to focus on modern art. He worked closely with the Glasgow dealer Alexander Reid and the Lefevre Gallery in London; with Reid and Lefevre, he organized shows throughout the 1920s of Impressionists, Post-Impressionists, and Modernists, from Pissarro to Gauguin to Laurencin.[27]

Bignou did more than buy and sell art. Beginning in 1924,[28] he served as an expert for the Hôtel Drouot, confirming the attribution of works to be auctioned and setting the amount of the opening bid.[29] Bignou provided his expertise for a collection of nineteenth-century French bronzes in that first auction. He appeared regularly as a buyer and bidder in the auction rooms over the next few years; in 1927 and 1928, Bignou served as expert at ten different auctions of modern paintings, working in each case with fellow

expert and his rue de la Boétie neighbor Jos Hessel and with the auctioneer Alphonse Bellier.[30] These sales included works by artists whose work was only gaining in value: Cassatt, Signac, van Dongen, Laurencin, Picasso, Dunoyer de Segonzac, Matisse. Etienne Bignou was part of every element of the art market except for making art himself. He worked directly with living artists such as Picasso (another neighbor on the rue de la Boétie); he worked as a scout for private collectors; he sold works through his gallery and through the galleries of his contacts; and he supervised sales at the Hôtel Drouot. When, in 1929, Sacha Guitry decided to sell some of his collection of modern paintings, he chose to work with Bignou and with Jos Hessel.

Hessel brought along his specific expertise in the work of Gauguin. Bignou had not often worked with Gauguins, but Jos Hessel had. Born in Brussels in 1859, Hessel had begun his career in Paris as a journalist and art critic before joining his cousins Josse and Gaston Bernheim in their Galerie Bernheim-Jeune. He opened his own gallery at 26, rue La Boétie, in 1915,[31] and leveraged his role as an expert at the Hôtel Drouot to acquire paintings from the secondary market and re-sell them. Closely allied to Barbazanges and Hodebert of the Galerie Barbazanges,[32] Hessel was part of a circle of gallerists that advanced the cause of contemporary art. His sales of nineteenth-century art financed his support for living artists. Hessel presented himself as more of a connoisseur than an art merchant, someone who could be considered reliable on matters of provenance and authenticity.[33] One of Hessel's closest associates was the artist Edouard Vuillard. The relationship between Hessel and Vuillard was both personal and professional. Vuillard and Lucie Hessel, the gallerist's wife, had an affair that lasted decades. Hessel acted as the artist's dealer and as his entrée into "Parisian haut-bourgeois society, where he became a highly sought-after portrait artist,"[34] the sort of artist hired by Sacha Guitry and his circle. Vuillard visited the Hessels every evening at six o'clock. It could well have been that the artist and dealer decided between them to pave the way for Hessel to manage the Guitry sale.

As far back as 1919 Hessel had been the expert for an auction that included the sale of a drawing by Gauguin.[35] In 1922, he had lent his knowledge to the sale of a Gauguin 1888 oil, now known as *Spring at Lézaven*.[36] The following year, he had been the expert in a sale that had included several Gauguins from his Breton years.[37] His familiarity with works by Gauguin only increased over the next six years. He was the expert in an auction with Fernand Lai, Dubreuil in the early spring of 1924 in which another dealer paid 15,300 francs for a Gauguin landscape. It was one of the top three prices in a sale that brought 209,255 francs total.[38] Beginning in

1925, Hessel worked with the *commissaire-priseur* Alphonse Bellier on sales of modern paintings;[39] beginning in 1927, Bignou joined them for a series of auctions. The three presented together an auction of modern paintings on December 12, 1927, that was standing room only and featured active bidding. "The highest price was for number 103," the Gazette de l'Hôtel Drouot reported the next day, "a pretty oil painting by Paul Gauguin called *L'Ondine*." The painting was imposing and perhaps even a little alarming: it depicted "a nude figure throwing herself into the sea," with "simplified lines and exaggerated colors."[40] The woman, seen from the back, has long red hair that has fallen forward over her left shoulder as she leans into the waves. The sea is a fierce, vivid green. It brought 46,100 francs—and it went to Jos Hessel.[41]

Hessel had sold *L'Ondine* before, in 1906, to the early Gauguin collector Gustave Fayet; we do not know for how much. When it came back to auction in 1927 Hessel saw a business opportunity. He bought it and turned it over once more—this time not to a private collector but to a gallery in London. The Leicester Gallery had been exhibiting Gauguin to its adventurous clientele since 1919. In 1928, the Leicester Gallery lent the painting to the Basel art museum and then to the well-known Galerie Thannhauser, in Berlin. In less than two years, the Gauguin traveled from Paris to London to Basel to Berlin. It is likely that Hessel maintained part ownership of the canvas on its travels in search of a collector. Since the 1800s, Paris had been, in the words of scholar Christel Force, "a center from which the art market radiated."[42] Hessel and Bignou were part of a network of dealers that stretched from their storefronts in the rue de la Boétie to around Europe and as far away as Buenos Aires and New York City. Hessel likely lent *L'Ondine* to his colleagues at the Leicester Gallery with the understanding that they would arrange to have the painting seen in places where it was likely to be purchased, and where critics would be likely to see it and write about it: places where its renown and financial value would increase. When a buyer tugged at the line, both the staff at the Leicester Gallery and Hessel would reel him in—and share the profits.

Early in 1929, Frank and Cornelia Ginn of Cleveland, Ohio, bought *L'Ondine*, which they called *In the Waves*; shortly after purchasing it, they lent it to the inaugural exhibition for the Museum of Modern Art in New York.[43] It remained in the Ginn family until, in 1978, Ginn's descendants gave the painting to the Cleveland Museum of Art, where it remains. "Paintings," Force notes, "are commodities for as long as they pass through the hands of dealers and collectors." They are objects to be bought and sold, not unlike teapots or chests of drawers. But the moment that a museum takes a

painting into its permanent collection, it becomes "invaluable . . . [its] validity being henceforth unquestionable and [its]value inestimable."[44] The object itself has not changed. Its classification shifted from being a commodity for sale in a place like the Hôtel Drouot where one could bid on a Gauguin in one room and then wander across the hall to buy a secondhand piano[45] to being set apart from the market, hallowed. Hessel and Bignou, and their network of connections—gallery owners, scouts, agents, gallery managers—kept this process of transformation in motion with swirls of telegrams and handshakes. They advised amateur collectors on which art was worth the francs or pounds or dollars. These gallerists, who were also experts, had a broader view of the market and of what was available, or likely to become available, than any individual with a bank account and an empty spot over the mantel. And so the art dealer Hessel's purchase of L'Ondine in December 1927, at an auction in which the expert Hessel set the prices, set in motion the painting's journey from Paris to Cleveland—and back again. In the fall and winter of 2017, it was part of an exhibition, Gauguin: Artist as Alchemist, that filled the exhibition halls of the Grand Palais.[46] Those crowds in their overcoats had not been born when Bignou and Hessel, in the winter of 1929, gathered to review and estimate the prices on their friend Sacha Guitry's collection. The auction date was set for April 27.

The Auction

The young man stopped to straighten his tie before he walked up the steps of the Hôtel Drouot that Saturday afternoon. Max Kaganovitch was on an errand at which he could not fail. There was a child at home to feed, a wife to please, and in-laws to impress. Kaganovitch's work this afternoon, if it succeeded, could help launch his career as an art dealer and gallerist. Forty years later, a respected figure in the Paris art world, he would recount how that career began. Born in Ukraine in 1891, Kaganovitch had made his way across Europe to Paris in 1924. Max, the youngest son in a progressive Jewish intellectual family, had trained in Moscow to become a sculptor.[47] He knew the artist Marc Chagall through one of his brothers; one of the stories he would tell when they were both deep into their successful careers was that he had staged an exhibition of Chagall's work in Lithuania while the two young men were trying to get to Paris. Kaganovitch, traveling under false papers, put together an impromptu exhibition in the city. "We sold nothing," he told a reporter for France-Soir in 1968. No one was buying art; if they had any money, they spent it on food. "We didn't even have enough change," he recollected, "to buy a café-crème."[48]

Fig. 4.3. Max Kaganovitch, about 1930. Photography, 3 x 3 cm. Gift of Yann and Florent, in memory of their mother Karin Kaganovitch, 2006. ODO 2007 3. Photo: Allison Bellido. *Source:* © RMN-Grand Palais, Art Resource, NY

We know that Kaganovitch arrived in Paris late in the summer of 1924. He promptly joined the *Union des Artistes Russes à Paris*.[49] Kaganovitch was active with the Union for a year or two; he helped design the decorations for the organization's annual costume ball the following May.[50] Soon, though, he stopped making art and began learning how to sell it. Kaganovitch would tell different tales about how and when he started buying and selling art. One story went like this: A potential client was interested in purchasing a modern painting, "a Renoir, a Modigliani, even a Van Gogh." Max, who lived with his young family on the Left Bank, ventured across the Seine to the rue de la Boétie. He slipped into a famous—and, in the story, unnamed—dealer's gallery to examine the stock. "The reception," he recalled forty years later, "was glacial." He fled back across the river and found his friends sitting over their drinks at the café de la Rotonde. Kaganovitch told his tale of woe. Likely after some laughter and teasing, one friend tapped his cigarette into the overflowing ashtray and leaned over. "Don't worry," he said. "I know this gentleman, and he's not easy. I'll tell him that you have a client, and we'll work it out. But please, I beg you, change your tie." The story goes that a few days later Max went back into the dread gallery. The gallerist approached him and asked what he was looking for. And Kaganovitch said: "That's not why I'm here. Today I came to show you my new tie!"[51] It worked; the difficult Frenchman was charmed. The difficult, and unnamed, gallerist was likely Etienne Bignou. Why? Bignou and Kaganovitch worked together throughout the 1930s. When Bignou owned the Galerie Georges Petit in the early 1930s, Kaganovitch regularly organized exhibitions there. In 1936, when Kaganovitch scraped together the funds to open his own gallery, Bignou wrote the catalog for one of the new gallerist's first exhibitions and even lent many works from his collection.[52]

That was all in the future on this April afternoon. On this day, Kaganovitch was going to bid on a painting. All evidence suggests that Kaganovitch was acting as an agent that afternoon for Bignou. His later connection with Bignou establishes the possibility of their relationship beginning around this time. Bignou worked with a wide network of agents who acted on his and his partners' behalf. The painting Kaganovitch was to bid on was number 99 in the sale: *Flowers and Fruit*.[53]

The auction began at two o'clock in the afternoon with the drawings. A Corot went for 6,000 francs; a Degas for 7,700; a Laurencin for 12,000. Bignou and Hessel were bidding from the floor, which was not uncommon. Experts who were also dealers or gallerists regularly bid on the objects that they had lately priced and cataloged. Bignou bought the Laurencin and, a few minutes later, three Modiglianis. Other art dealers were buying, too: van

Riel from Buenos Aires bought some Toulouse-Lautrec studies and a Rodin watercolor, and Léon Marseille, from the Left Bank, bought two paintings by Jean Marchand. And Hessel was busy adding Picasso, Degas, and Manet to his stock. The property developer Gaston Lévy spent 74,000 francs on Mary Cassatt's pastel of a young girl with her dog. Bidding against dealers Bignou and Bourgeat, Lévy triumphed. Gaston Lévy had his new Cassatt delivered to his apartment in the avenue de Friedland, an elegant street on the Left Bank that also sheltered hotels, banks, and real estate offices,[54] where it joined a collection of works by Paul Signac and Camille Pissarro, among others.[55] And how much had he spent? The Cassatt was his for 74,000 francs. Lévy could spend that and still manage the upkeep on his chateau without giving it a second thought. But it was a vast sum of money.

How vast? At the department store Samaritaine, on the rue de Rivoli, a silk day dress cost 85 francs. A made-to-measure suit, for those not yet ready to buy mass-produced clothing, cost around 345 francs. A portable phonograph would set you back 600 francs, but you could carry it with you when you went out to your weekend villa. An eight-room villa about 12 miles outside of Paris—close enough for weekend trips—offered a vegetable garden, a few barns and sheds, and all modern conveniences, including a telephone, for 300,000 francs. In town, you could rent an apartment not far from Drouot for 10,000 francs a month; if you were willing to cross the river, you could pay 6,000 francs for a flat that looked out over the lawns of the Champ de Mars.[56]

We do not know where Max Kaganovitch lived in 1929. When he married in 1927, he was living in the 11th arrondissement at 2, rue de la Grande Prieuré,[57] in a densely populated industrial district that had elected the socialist politician Léon Blum to the National Assembly for nearly a decade. The rue de la Grand Prieuré was home to people who made things: a locksmith, a printer, a tailor. At number 18 there was a manufacturer of rubber; at number 21, a maker of faucets. It was a working-class street: there were no banks, no realtors, and no fancy hotels. It was not a street where you might live if you had 42,700 francs to spend on a modern painting.

But that is what Max Kaganovitch did that afternoon at Drouot. The *Gazette de l'Hôtel Drouot* reported on the sale the following Tuesday, April 30. This sale, the editors effused, "had been a complete success, and the experts' asking prices had been exceeded, for some lots, by a significant amount."[58] In all, the sale had brought the striking sum of 700,000 francs. The Cassatt sale was the biggest: it had gone for 14,000 francs over asking price. Hessel paid a little more than twice the asking price of the Degas dancers pastel; the Japanese collector Baron Fukushima paid 59,100 francs for a tiny Corot oil. It was Kaganovitch's purchase, though, that inspired the

Gazette to provide a history lesson. "Another amateur, M. Kaganovitz" [*sic*] had paid 42,700 francs, for no. 99 in the sale, *Flowers and Fruit*, by Gauguin. The estimate for the painting had been 40,000 francs; bidding had raised the price. "M. Sacha Guitry paid only 14,000 francs for this painting in a sale carried out on April 14,1923, and then, the expert had only asked 4,000 francs," the *Gazette* noted breathlessly.[59] *Flowers and Fruit* had tripled in value in six years. This kind of appreciation in value was almost unheard of.

There are two interconnected points to make about this sale: one to do with the appreciation in the market value of Gauguins, and one to do with the inner workings of the market, with the mechanics of how paintings moved through the market. Ten years earlier, in 1919, agents from the Knoedler Gallery had purchased Gauguin's masterwork *Hail Mary* [*Ia Orana Maria*] at Drouot for 58,000 francs. The *Gazette* was astonished. The sale was "the event of the auction." Dealers and experts had tripped over each other bidding on it: Georges Bernheim, his cousin Bernheim-Jeune, their cousin Jos Hessel, the Scandinavian dealer Hansen, had all competed for the winning bid. It was a shocking amount, in 1919, for a modern painting to bring. The Gazette noted that the previous owner "had bought the painting for only 300 francs in 1894."[60] This sale led to more Gauguins coming into the market, which we will examine. What matters about it now is that the sale of *Hail Mary* [*Ia Orana Maria*] set a precedent for works by Gauguin to bring significant profits at auction—profits shared between their sellers, the experts, and the *commissaire-priseur*. In 1921, Gauguin's *Yellow Christ* [*Christ Jaune*] sold for 20,000 francs; in 1924 and 1925, two landscapes each brought a little more than 15,000. *Flowers and Fruit*, as we know, brought 14,000 in 1923. The 1927 auction of *In the Waves* [*L'Ondine*] brought 46,100 francs, and the following year a Breton village scene sold for 62,000.

All of which Bignou and Hessel knew in April 1929, and all of which contributed to the presence of Max Kaganovitch in the room that afternoon. The experts had set the price conservatively. The previous June the Berlin dealer Hugo Perls had bid up the Gauguin *Breton Village* [*Village en Bretagne*], and the result had been that the painting had left the Paris market, making profiting from its resale more complicated. Bignou and Hessel needed someone who could bid on *Flowers and Fruit* without attracting undue attention from other dealers. They wanted to be able to purchase the painting—of whose resale value they could be confident—for as low a price as they could. Enter Max Kaganovitch: young, determined, and eager. The bank account of this relatively recent arrival could not have furnished the significant sum required to purchase this Gauguin still life. Bignou and Hessel could make up the sum out of the notes they kept in their desk drawers, and provide

Kaganovitch with a commission that would help him pay the rent—and help him join the two seasoned gallerists in the Paris art world.

In 1919, the New York branch of Knoedler & Company had sold *Hail Mary [Ia Orana Maria]* to the American collector Adolph Lewisohn for the tidy price of $20,000, twice the Paris auction price.[61] The American art market had only grown stronger over the next decade. Bignou knew that there was a whole new continent of collectors and galleries—even museums—across the Atlantic. The New York art world was ripe for dealers who had the right connections. *Flowers and Fruit* was about to take a trip.

Notes

1. "Administration, Théâtre de La Madeleine, Théâtre de La Michodière: Répétitions Générales, Plan Des Places, Lists de Invités" (n.d.), Fonds Guitry, Fol-Col-41 (169), Bibliothèque nationale de France, Arts du spectacle.

2. "Administration, Théâtre de La Madeleine, Théâtre de La Michodière: Répétitions Générales, Plan Des Places, Lists de Invités."

3. "Interior, Rue Albert de Neuville," about 1925, Photographies: Demeures 18 avenue Elisée Reclus, Fonds Guitry.

4. "Interior, Rue Albert de Neuville."

5. "Interior, Rue Albert de Neuville."

6. René Bizet, "En Visite Chez Sacha Guitry," in *Sacha Guitry* (Paris: Editions de la revue Le Capitole, 1926), 46.

7. "Ce que j'ai payé par cheques," n.d., Fonds Guitry, 4-Col-41 (632), Bibliothèque nationale de France, Arts du spectacle. On Guitry's Monet, see Daniel Wildenstein, Monet: *Catalogue raisonné*, v. 4, p. 733, no. 1634, https://view.publitas.com/wildenstein-plattner-institute-ol46yv9z6qv6/c-r_claude_monet_volume_iv_wildenstein_institute/page/37.

8. BnF, Arts du spectacle, Fonds Guitry, 4-col-41 (boite 632), *Livre de comptes* 1924–1932.

9. Hôtel Drouot, *Catalogue des Tableaux Modernes, Pastels, Aquarelles, Gouaches, Dessins . . . Provenant des Collections de M. S. G. et de Différents Amateurs: Vente, Paris, Hôtel Drouot, Salle N° 6, le Samedi 27 Avril 1929* (Paris: Hôtel Drouot, 1929).

10. Berthe Morisot, "Le Port de Nice, 1882," Musée Marmottan Monet, n.d., https://www.marmottan.fr/notice/6010/.

11. Hôtel Drouot, *Catalogue des Tableaux Modernes, Pastels, Aquarelles, Gouaches, Dessins . . . Provenant des Collections de M. S. G. et de Différents Amateurs: Vente, Paris, Hôtel Drouot, Salle N° 6, le Samedi 27 Avril 1929.*

12. Paul Gauguin, "Les Alyscamps, 1888, RF 1938 47," POP: La plateforme ouverte du patrimoine, accessed May 10, 2023, https://www.pop.culture.gouv.fr/notice/joconde/000PE003848.

13. Paul Gauguin, "Femmes de Tahiti, Ou Sur La Plage, RF 2765," POP: La plateforme ouverte du patrimoine, Ministère de la Culture, n.d., https://www.pop.culture.gouv.fr/notice/joconde/000PE003844.

14. Paul Gauguin, "Woman in Front of a Still Life by Cezanne, 1890," Art Institute of Chicago, accessed May 10, 2023, https://www.artic.edu/artworks/16648/woman-in-front-of-a-still-life-by-cezanne.

15. Gauguin, "Les Alyscamps, 1888, RF 1938 47"; Paul Gauguin, "Le Cheval Blanc," POP: La plateforme ouverte du patrimoine, accessed May 10, 2023, https://www.pop.culture.gouv.fr/notice/joconde/000PE003839.

16. See, among others: Paul Gauguin, "Tahitian Woman with a Flower, 1891, MIN 1828," Kunstindeks Danmark & Weilbachs Kunstnerleksikon, accessed May 15, 2023, https://www.kulturarv.dk/kid/VisVaerk.do?vaerkId=104995; Paul Gauguin, "Two Children," Kunstindeks Danmark & Weilbachs Kunstnerleksikon, about 1889, https://www.kulturarv.dk/kid/VisVaerk.do?vaerkId=105000; Paul Gauguin, "Breton Girl," Kunstindeks Danmark & Weilbachs Kunstnerleksikon, 1889, https://www.kulturarv.dk/kid/VisVaerk.do?vaerkId=104994; Paul Gauguin, "Landscape from Tahiti with Four Figures," Kunstindeks Danmark & Weilbachs Kunstnerleksikon, 1892, https://www.kulturarv.dk/kid/VisVaerk.do?vaerkId=104996.

17. See, for example: Paul Gauguin, "Head Piece for 'Le Sourire,'" Brooklyn Museum, carved; printed 1921 1899, https://www.brooklynmuseum.org/opencollection/objects/23842; Paul Gauguin, "The Queen of Beauty—Langorus, 1898," Metropolitan Museum of Art, n.d., https://www.metmuseum.org/art/collection/search/337859; Paul Gauguin and Pola Gauguin, "Te Po (Eternal Night), Carved 1893–94; Printed 1921," Baltimore Museum of Art, n.d., https://collection.artbma.org/objects/33365/te-po-eternal-night?ctx=732f97ff5d5d2ccf37bc3168b9a379c93e656256&idx=0.

18. Georges Wildenstein, *Gauguin* (Paris: Les Beaux-Arts, 1964), 236–37, https://wpi.art/2019/01/14/gauguin/.

19. Wildenstein Plattner Institute, Inc. et al., eds., "Nevermore, 1897 (WPI Ref. No. PGYKHT)," in *Gauguin:* Catalogue raisonné *of the Paintings, 1891–1903*, accessed May 15, 2023, https://digitalprojects.wpi.art/artworks/gauguin/detail/71731-nevermore.

20. Wildenstein Plattner Institute, Inc. et al., eds., "Te Rerioa, 1897 (WPI Ref. No. PGMWBX)," accessed May 15, 2023, https://digitalprojects.wpi.art/artworks/gauguin/detail/71730-te-rerioa.

21. Paul Gauguin, "Entrance to the Village of Osny," MFA Boston, 83 1882, https://collections.mfa.org/objects/33274/entrance-to-the-village-of-osny.

22. Noëlle Giret and Noël Herpe, *Sacha Guitry: Une Vie d'Artiste* (Paris: Gallimard, 2007); Guitry, Sacha, *19 Avenue Elisée Reclus* (Paris: Raoul Solar, 1952).

23. *Annuaire du Commerce Didot-Bottin*, vol. 2, 2 vols. (Paris: Firmin-Didot frères, 1929), https://gallica.bnf.fr/ark:/12148/bd6t53480150/f1604.item.

24. *Annuaire du Commerce Didot-Bottin*.

25. Christian Zervos, "Nos Enquêtes: Entretien avec Etienne Bignou," *Feuilles Volantes, Supplément à la Revue "Cahiers d'Art,"* nos. 7–8 (1927): 1–2, https://gallica .bnf.fr/ark:/12148/bpt6k97952378.

26. Zervos, "Nos Enquêtes."

27. Christel H. Force, "Bignou: The Gallery as Antechamber of the Museum," in *Pioneers of the Global Art Market: Paris-Based Dealer Networks, 1850–1950* (London: Bloomsbury Visual Arts, 2022).

28. "Chronique des Ventes: Collection Henri Aubry," *Gazette de l'Hôtel Drouot,* April 8, 1924, bibliotheque-numerique.inha.fr/idviewer/59624/183.

29. Lukas Fuchsgruber, "The Hôtel Drouot as the Stock Exchange for Art: Financialization of Art Auctions in the Nineteenth Century," *Journal for Art Market Studies* 1, no. 1 (2017), https://doi.org/10.23690/jams.v1i1.5.

30. See, for example, "Ventes Prochaines: Collection d'un Amateur: 23 Tableaux Modernes," *Gazette de l'Hôtel Drouot,* December 3, 1927, bibliotheque-numerique .inha.fr/idviewer/59648/561; "Ventes Prochaines: Tableaux Modernes," *Gazette de l'Hôtel Drouot,* June 5, 1928, bibliotheque-numerique.inha.fr/idviewer/59656/277; "Ventes Prochaines," *Gazette de l'Hôtel Drouot,* February 18, 1928, bibliotheque -numerique.inha.fr/idviewer/59656/3.

31. Léa Saint-Raymond, Félicie Faizand de Maupeou, and Julien Cavero, "*Les rues des tableaux*: The Geography of the Parisian Art Market 1815–1955," *Artl@s Bulletin,* École normale supérieure / CNRS, 2016, 5 (1), pp.119–59, hal-02985690, p. 131.

32. See note 87 in Anne Distel, "Les amateurs de Renoir; le prince, le prêtre et le pâtissier," in *Renoir: [exposition], Hayward Gallery, Londres, 30 janvier–21 avril 1985, Galeries nationales du Grand Palais, Paris, 14 mai–2 septembre 1985, Museum of fine arts, Boston, 9 octobre 1985–5 janvier 1986* (Paris, 1985), 44, https://gallica.bnf .fr/ark:/12148/bpt6k1002224w/f58.item. See also the contract dated April 30, 1919, between Hodebert and Hessel, Barbazanges Archives, p. 235 note 49; Christel H. Force, *Pioneers of the Global Art Market: Paris-Based Dealer Networks, 1850–1950* (New York: Bloomsbury Visual Arts, 2020), 235.

33. Christel H. Force, ed., *Pioneers of the Global Art Market: Paris-Based Dealer Networks, 1850–1950* (Bloomsbury Visual Arts, 2020), 28, https://doi.org/10.5040/ 9781501342790.

34. Olivia Gruber Florek, review: "Edouard Vuillard: A Painter and his Muses," by Stephen Brown and Richard Brettell, in *Nineteenth-Century French Studies* 41, nos. 3/ 4 (Spring/Summer 2013): 351, https://www.jstor.org/stable/23538927.

35. "Revue des Ventes," *Gazette de l'Hôtel Drouot,* April 1, 1919, bibliotheque -numerique.inha.fr/idviewer/59645/121.

36. "Revue des Ventes," *Gazette de l'Hôtel Drouot,* March 17, 1921, bibliotheque -numerique.inha.fr/idviewer/59661/127.

37. "Revue des Ventes: Collection de M. B. . . .," *Gazette de l'Hôtel Drouot,* March 24, 1923, bibliotheque-numerique.inha.fr/idviewer/59610/151.

38. "Chronique des Ventes: Collection Henri Aubry."

39. "Ventes Prochaines: Tableaux Modernes," *Gazette de l'Hôtel Drouot*, April 18, 1925, bibliotheque-numerique.inha.fr/idviewer/59634/197.

40. Paul Gauguin, "In the Waves (Dans les Vagues), 1889," Cleveland Museum of Art, n.d.

41. "Chronique des Ventes," *Gazette de l'Hôtel Drouot*, December 13, 1927, bibliotheque-numerique.inha.fr/idviewer/59648/583.

42. Christel H. Force, "Introduction: Pioneers of the Global Art Market: Paris-Based Dealer Networks, 1850–1950," in *Pioneers of the Global Art Market: Paris-Based Dealer Networks, 1850–1950* (London: Bloomsbury Visual Arts, 2022), 1.

43. The Museum of Modern Art, *First Loan Exhibition, New York, November, 1929: Cézanne, Gauguin, Surat, van Gogh* (New York, 1929), https://www.moma.org/calendar/exhibitions/1767.

44. Force, "Introduction," 18.

45. "Chronique des Ventes."

46. Claire Bernardi and Ophélie Ferlier-Bouat, eds., *Gauguin l'alchimiste* (Paris: Réunion des musées nationaux-Grand Palais, 2017).

47. Gennady Estraikh, *Uncovering the Hidden: The Works and Life of Der Nister* (Oxford: Routledge, 2017), 10.

48. Jean-Paul Crespelle, "Les Tableaux Faits de Déchets Ne Se Vendent plus . . . Deux Marchands Rappellent Que la Peinture Existe Toujours," *France-Soir*, March 22, 1968.

49. Serge Fotinsky, "Union des Artistes Russes à Paris, le 16 Septembre 1924" (Letter, Paris, 4, rue Huyghens, 15e, September 16, 1924), Box 6, Biographie, Documents divers, Musée d'Orsay, Archives and Documentation, Fonds Max et Rosy Kaganovitch ODO 2007-3.

50. Union des artistes russes (Paris), Auteur du texte, *Bal de La Grande Ourse, Salle Bullier, [8 Mai 1925]: [Programme] / Organisé par l'Union Des Artistes Russes à Paris*, 1925, https://gallica.bnf.fr/ark:/12148/btv1b53112952v.

51. René Barotte, "Une Cravate Avait Fait la Fortune de Max Kaganovitch, *Le Journal des Arts*, 13 Mai 1964" (Paris, May 13, 1964), ODO 2007-3, Fonds Max et Rosy Kaganovitch. Musée d'Orsay, Archives and Documentation.

52. Chloé Dheilly, *L'Enigmatique, Max Kaganovitch* (Paris: Ecole de Louvre, 2019), 29.

53. Hôtel Drouot, *Catalogue des Tableaux Modernes, Pastels, Aquarelles, Gouaches, Dessins . . . Provenant des Collections de M. S. G. et de Différents Amateurs: Vente, Paris, Hôtel Drouot, Salle N° 6, le Samedi 27 Avril 1929*.

54. *Annuaire du Commerce Didot-Bottin.*

55. Sotheby's, "Artworks Restituted to the Heirs of Collector Gaston Lévy," Sotheby's, January 14, 2020, https://www.sothebys.com/en/press/three-works-restituted-to-the-heirs-of-art-collector-gaston-levy-to-make-their-auction-debuts.

56. "Petites Annonces," *Le Matin: Derniers Télégrammes de La Nuit*, April 27, 1929, https://gallica.bnf.fr/ark:/12148/bpt6k5765065.

57. "Kagamovitz and Wyspa, Acte de Mariage, No. 290," n.d.

58. "Chronique des Ventes: Tableaux Modernes. Collection Sacha Guitry et Autres," *Gazette de l'Hôtel Drouot*, April 30, 1929, bibliotheque-numerique.inha.fr/idviewer/59663/205.

59. "Chronique des Ventes: Tableaux Modernes. Collection Sacha Guitry et Autres."

60. M. Knoedler & Co., "Painting Stock Book 6: 12653–15139, December 1911–July 1920," Getty Research Institute Special Collections, accessed August 11, 2023, http://hdl.handle.net/10020/2012m54b6.

61. M. Knoedler & Co. Lewisohn's heirs would bequeath *Ia Orana Maria* to the Metropolitan Museum of Art in 1951. See: Force, *Pioneers of the Global Art Market*.

CHAPTER FIVE

~

Crossing the Atlantic

Robert and Eila Haggin McKee traveled to Europe every year. California natives transplanted to New York, the McKees lived off wealth inherited from Eila's family. The Haggins had gone West in 1849 and made several fortunes in real estate and mining; Eila was her parents' sole heir. Her grandparents and parents had collected nineteenth-century American and French academic art: Bierstadts, Gérômes, and a host of other conventional, high-priced artists popular in their day. Eila collected, too. Her taste tended toward the modern and contemporary. Her husband Bob was a casual painter himself, and helped his wife manage the family collection.

The McKees spent two months in London in the late summer of 1929, traveling first class on the White Star Line's *Berengaria*. Their suite at the Almonds Hotel in Mayfair was convenient to the National Gallery, the theater district, and art dealers' showrooms. A decade later Bob remembered strolling down New Bond Street exploring galleries when a painting caught his eye. "I never saw another still life by Gauguin," he wrote, "and told my wife she should go and see it." He was entranced by the painting's "colors and atmosphere"; he found it "exquisite."[1] Gauguin only occasionally painted still lifes: his most well-known works in the 1920s were Tahitian paintings like *Hail Mary* [*Ia Orana Maria*], which Adolph Lewisohn lent to five different temporary exhibitions in New York between 1920 and 1928,[2] and Breton-era works like his *Brittany Landscape*, which the McKees could have seen on loan at the Wildenstein Galleries in New York in 1928.[3] McKee would have had

Fig. 5.1. Robert and Eila Haggin McKee, Madrid, about 1930. Haggin Museum, Stockton, California

little opportunity to see a Gauguin still life until that day in London when, by chance, he found himself standing before *Flowers and Fruit.*

The McKees sailed for Genoa on October 10.[4] When they returned to New York on November 27,[5] they found the painting at the Reinhardt Galleries, at 730 Fifth Avenue. McKee explained that Eila had "not had time" to see the still life in London. Back home in New York, the couple likely went to see the loan exhibition at the new Museum of Modern Art, at 730 Fifth Avenue. *Cézanne, Gauguin, Seurat, Van Gogh* had opened on November 8 to crowds of visitors; the *New York Times* called it "the most comprehensive exhibition ever held in this country of work by four pioneers of modern art."[6] The McKees would not have wanted to miss this show—and during the same visit, on the ground floor of the same building, the couple could have popped into the Reinhardt Galleries to see an exhibition that included some of the same artists as the new museum upstairs. And it was there that McKee found the Gauguin still life that had so struck him a few months before. Eila

EXHIBITION OF

DRAWINGS, PAINTINGS AND WATER COLORS

BY

PICASSO, MATISSE, DERAIN, MODIGLIANI,
BRAQUE, DUFY, UTRILLO, VLAMINCK,
LAURENCIN, HENRI ROUSSEAU,
GAUGUIN, REDON AND OTHERS

REINHARDT GALLERIES
730 FIFTH AVENUE
NEW YORK
1929

Fig. 5.2. Exhibition of drawings, paintings and watercolors : by Picasso ... [et al.] :
October 12 through November 9th / Reinhardt Galleries. *Source:* Image copyright ©
The Metropolitan Museum of Art. Image source: Art Resource, NY

"bought it at Rhinehardts [sic] in New York"[7] for $5,000 on New Year's Eve, 1929.[8]

An intricate, slippery network of art dealers stretching from Paris to London to New York ferried this unusual Gauguin across the Channel, and then across the Atlantic, in 1929. The painting arrived in New York, to be offered for sale on the American market, because it participated in a web of relationships that began in the rue de la Boétie, continued to New Bond Street, and extended to Fifth Avenue. Eila McKee's purchase of *Flowers and Fruit* would be the first in a chain of events that would make the painting disappear from the international art world.

Mary Woodward Reinhardt and the Reinhardt Galleries

In 1924, Mary Woodward, Radcliffe class of 1923, moved to New York to begin her life in the art world.[9] Blue-eyed, with high cheekbones set off by fashionably bobbed brown hair,[10] Woodward had just returned from a year in Europe. One of her college professors, Paul Sachs, had given her letters of introduction to various art dealers in New York City. Sachs had been on the faculty in the Fine Arts Department at Harvard, Radcliffe's brother school, since 1917. During Woodward's time in Cambridge, Sachs had taught his "Fine Arts 15a: Museum Work and Museum Problems" course for the first time. He would continue teaching it until his retirement in 1948, and would train men and women who went on to lead museums around the country.[11] Sachs was connected not only in the museum world but in the art world: one of the letters of introduction he provided his student was to "the head of Knoedler's." Woodward would recall forty years later that through this connection to the august New York gallery, she "got an introduction to a man who was a partner in the Reinhardt Galleries, and this man wanted someone to run exhibitions for him, and I impressed him as being able properly to do this, and he introduced me to Paul Reinhardt."[12] Reinhardt hired her.

Paul Reinhardt was tall, blond, and blue-eyed.[13] Reinhardt's father Henry had begun as an art dealer in Milwaukee, then moved to Chicago, and then, finally, to New York, where he opened Henry Reinhardt & Son Gallery on Fifth Avenue in the early 1900s. Henry dealt in Old Masters: he bought and sold Rembrandts and van Dycks, Rubenses and Raphaels. He built the gallery into a thriving business, one whose exhibitions and sales the *New York Times* noted faithfully.[14] When Henry Reinhardt died in 1921, Paul took over. The gallery continued to thrive. Over the next several years, Reinhardt would sell a Holbein portrait to the collector and founder of the Libbey Glass Company in Toledo, Ohio[15]; he would sell other works to the Metropolitan Museum

of Art, the Boston Museum of Fine Arts, and Washington, DC's Corcoran Gallery.[16] In 1921 he had sold a Bellini *Virgin with Sleeping Child* to Isabella Stewart Gardner through her advisor Bernard Berenson.[17]

Reinhardt Galleries rarely exhibited modern and contemporary art before Mary Woodward joined the firm in 1924. Her arrival changed that. The first show she installed focused on a living artist who was "unknown and totally crazy and uninteresting"[18]: Marc Chagall. The exhibition had originated in Paris in December 1924 at the Galeries Barbazanges-Hodebert. Its young director, Georges Keller, and his assistant, Pierre Matisse, had organized Chagall's first retrospective, featuring works he had created between 1901 and 1921.[19] The Galerie Barbazanges-Hodebert exhibited a range of modern and living artists; sold regularly to collectors, including the American Albert Barnes; and worked closely with other Parisian dealers, including Jos Hessel, Etienne Bignou, and, on a smaller scale, Léon Marseille.[20] The Chagall show traveled to Cologne in 1925. And then Paul Reinhardt brought it to New York. It was the first exhibition of the artist's work in America.[21]

Once the three dozen paintings and seventy works on paper were uncrated, Mary Woodward arranged the January 1926 exhibition. The exhibition introduced Chagall's work to a reluctant public. The *New York Times* panned the show, noting that Chagall's "handicraft . . . is thick and clumsy . . . his patterns are barbaric and arresting."[22] "You couldn't sell any Chagall of any kind at any price," Mary Woodward remembered. "Large paintings were $600.00, and a watercolor was at a small price, $100.00 . . . and not one single thing was sold."[23] The following year, the gallery staged a one-man show of the work of the contemporary Spanish artist Ignacio Zuloaga that had the opposite result. The *Times* reported that "four pictures had been sold for a total of $100,000 before the private exhibition opened" to a waiting throng.[24] Twenty years later this was the exhibition that the *Times* mentioned in Paul Reinhardt's obituary: as "an unusually successful one-man show" visited by "70,000" persons.[25] Zuloaga himself was present for the exhibition and pronounced himself "much gratified at its success, which had exceeded his expectations."[26] Mary Woodward's exhibition was an enormous success—not only in selling the work of this living artist, but also in building the Gallery's network.

Reinhardt's European connections were critical. There was no international traveling exhibition service that sent around brochures and provided pre-written exhibition catalogs: gallerists made arrangements over drinks, or in their private offices, or by telegram—or all of the above. There was no fine art insurance until the 1950s[27] and, thus, no outside party requiring extensive documentation. When works of art traveled between galleries, they

traveled on the strength of the relationships between art dealers. Reinhardt knew Keller well enough to make a deal. Woodward and Reinhardt together impressed Zuloaga, who returned to Paris a few months later.[28] They were part of an international network.

Woodward brought her own set of connections. Through Paul Sachs, she gained access to the cosmopolitan world of the dealers in and around the rue de la Boétie in Paris. Sachs, in addition to being on the Harvard faculty, belonged to a family that owned one of the most successful stock brokerage firms in the country. He cultivated relationships among artists, dealers, and collectors. The staff at the venerable M. Knoedler & Co. were in regular contact. He knew Jacques Seligmann, a French dealer who had opened a New York branch in 1914. César de Hauke took over management of the Seligmann office in 1926; he, too, appears in Sachs's archive. Sachs and Paul Reinhardt knew each other.[29] Sachs knew the Wildensteins: in 1929, his brother Walter Sachs purchased Gauguin's *Still Life with Apples, a Pear, and a Ceramic Portrait Jug*,[30] from Wildenstein and Company. Sachs, as director of the Fogg Art Museum at Harvard, had featured the painting in an exhibition at Harvard in March 1929.[31] Mary Woodward was part of Sachs's art world network.

In May 1926, the gallery assistant married her boss.[32] Mary recollected that she was drawn to Paul Reinhardt "because he had a great feeling for pictures, and he was a very agreeable and pleasant man." But: "he drank too much. He didn't get drunk, but he was a heavy drinker." She only agreed to marry him after Reinhardt had given up drink for a year.[33] In 1934, his alcoholism, steadily worse after the crash of 1929, would contribute to the end of their marriage[34] and to the waning of the gallery. Reinhardt would retire from an active role in the gallery in 1936 at age forty-seven, handing its operations over to James St. Laurence O'Toole, who had worked with Paul and Mary as early as 1929.[35]

Before that, though, there were annual summers in Europe. "We used to go to Europe every summer and search" for undiscovered Old Masters, Mary Reinhardt recalled, and buy what they could risk of modern and contemporary artists. Mrs. Reinhardt remembered the market in those years:

I loved Impressionists but Impressionists began to have moderately big prices, although we sold a painting by Van Gogh to the Lewisohns for $35,000 called "*L'Arlésienne*." . . . No one had ever heard of such a fantastic price for a Van Gogh. . . . I was interested in Picasso and Matisse and Braque and Utrillo and Modigliani, and contemporary painters, because they seemed exciting and interesting to me. And we did buy them. I remember Dufys for $70 or $80. . . . The only thing to do was to keep all the pictures and never sell them, and if

you lived 30 years you made a fortune. But when you have to make money out of it every day, you have to have an awful lot of them and turn over a great many pictures in order to make any money . . . out of modern pictures.[36]

So that Mary could continue buying less expensive contemporary and modern pieces, the Reinhardts shopped as well for Old Masters. They visited country houses whose owners were selling off the family portraits; they visited auctions. And they "visited other dealers and looked for new stock for the gallery."[37] "The only way to make any real money" in those days was for a dealer "to make a discovery of a great old master in a sale or a private house."[38] That could pay for the trip and more.

With the riskier purchases, the Reinhardts regularly went in together with other dealers in their purchases: from Munich on August 29, 1929, Paul Reinhardt sent a telegram to the Seligmann Gallery's New York manager César de Hauke offering him a half share in one of van Gogh's drawings, which would appear as number 34 in their autumn 1929 exhibition.[39] The next summer, Mary Reinhardt telegrammed de Hauke:

If you have decided on exchange with [the art dealer Paul] Guillaume would be glad if you could have the picture sent to our apartment Paris as have client for Derain arriving Saturday.[40]

Arrangements like these between dealers helped them "increase their purchasing power, source a limited number of artworks, and share a narrow pool of clients."[41] The Reinhardts could bring home more art with less financial risk. By sharing some of the financial risk with de Hauke, they were able to share as well in his network of clients and collectors. This, in turn, would build their own reputation and reach.

The Reinhardts spent part of the summer after their wedding in Paris, returning to New York in early October 1926.[42] Paul and Mary were looking for paintings for the gallery's upcoming January 1927 loan exhibition, which would be called "From El Greco and Rembrandt to Cézanne and Matisse."[43] Likely on that trip they purchased Gauguin's The Large Tree [Te Raau Rahi]. The oil painting on fabric, created during the artist's first sojourn in Tahiti in 1891, shows a village scene. Four women sit or stand in the shade of large trees outside of a reed hut with a thatched roof. Another woman sits in the doorway of the house. The atmosphere is languid, heavy, even portentous. The women seem to be waiting for a breeze.

Gauguin specialists Richard Brettell and Elpida Vouitsis speculate that The Large Tree [Te Raau Rahi] may have come from the collection of

Gauguin's old friend George Daniel de Monfreid.[44] Gauguin stored a number of paintings, ceramics, and works on paper with Monfreid in 1895 when he took ship for Tahiti for the last time; during his final years in the South Seas, he had sent Monfreid still more. Monfreid, who was active in the avant-garde art scene, sold many of his Gauguins in the ensuing decades. He also lent his Gauguins to various exhibitions around Europe. The same year that the Reinhardts were on the prowl for pictures in Paris, the Paris–Latin American Association was planning a December 1926 retrospective exhibition of Gauguin's work. Monfreid served on the planning committee; so did the Reinhardts' friend Ignacio Zuloaga.[45] Perhaps Zuloaga introduced the Reinhardts to Monfreid. Or perhaps Georges Keller or Pierre Matisse made the connection.

However they came by it, the Reinhardts hung their new Gauguin in that show. The aim of the exhibition was, Reinhardt wrote in his introduction to the catalog, "to illustrate in a general way the history of painting from the beginning of the seventeenth century to the present day." His wife, who had majored in art history at Radcliffe, may have contributed to the catalog essay. Elisabeth Cary, writing in the *New York Times*, effused about the show:

> It is enlivening to find in this fair land an exhibition that can be called "important" in the classic, ponderous sense of the hateful word and also "interesting" in the cheerful, spontaneous idiom of the independent amateur. . . . In this exhibition there seem to be no false moves. Each master, each on the high plane of his period and country, is represented by the kind of thing he did best and in many instances by a piece of work embodying all his powers.[46]

To build the exhibition, the Reinhardts drew on their connections far and wide. Collectors from around the country lent pieces: Etta Cone, of Baltimore, lent a Matisse. New York's Adolph Lewisohn lent a van Gogh.[47] Museums lent pieces: the Toledo Museum of Art, a Turner; the Phillips Memorial Gallery in Washington, DC, a Courbet. Wildenstein and Company lent a Fragonard. The Reinhardts filled in gaps with paintings from their storeroom. Their Goya (*Portrait of a Lady*), Manet (*The Gypsy*), and their recently acquired Gauguin all appeared.[48] Paul and Mary Reinhardt were, in this exhibition, making claims about who belonged in the art historical canon. They were making claims about their knowledge and expertise in that canon. Perhaps most importantly for our purposes, they were laying bare their connections. This loan exhibition demonstrated the Reinhardts' relationships across the overlapping worlds of American collectors, museums, and art dealers in the United States. When the show ended, the Reinhardts passed

Gauguin's *The Large Tree* to the Leicester Galleries in London.[49] The Leicester Galleries were regular clients of César de Hauke and connected through him to the Seligmann family galleries in New York and Paris, as well as to Etienne Bignou and his far-flung network.[50] The Leicester Galleries sold the Gauguin to Mr. Frank Ginn, of Cleveland, in 1929. Ginn's family donated it to the Cleveland Museum of Art in 1976.[51]

A century later, the intricate connections and alliances that bound these art dealers are nearly invisible: invisible as they were, perhaps, intended to be. Art historian Christel Force has noted that "paintings are commodities," that is, objects to be bought and sold on the market, "for as long as they pass through the hands of dealers and collectors, but are regarded as invaluable once they enter the hallowed walls of museums."[52] For a work of art to be considered worthy of acquisition by a museum, its life as a commodity had to be veiled. It was in the interest of art dealers to place their inventory with collectors who would both pay top dollar—and whose ownership of an object would raise the market value of the artist's other work. Thus, selling to a renowned collector—as Reinhardt had to Isabella Stewart Gardner in the case of the Bellini Madonna—both brought income to the gallery and built its reputation. Selling van Gogh's *L'Arlésienne* to Adolph Lewisohn, as Mary Reinhardt recalled, demonstrated not only the value of that specific painting but increased the reputation of van Gogh as an artist collected by serious amateurs. The ultimate prize was placing a work that had come through one's gallery in a museum collection. Dealers like the Reinhardts "carefully placed works in the best collections so they would end up in museums, and sometimes placed them in museums themselves."[53] Once a work of art entered a museum collection, its history as a mere commodity was relegated to an acquisitions file.

Finding *Flowers and Fruit*

In June 1929, Paul and Mary Reinhardt sailed first class on the White Star Line's *Majestic* from New York to Southampton, England. By traveling first class Paul and Mary could rub elbows with current or would-be clients as well as with other dealers: in 1926, the newlyweds had made the return trip to New York with Félix Wildenstein, head of the stateside Wildenstein operation, and his family.[54] The loan of the Wildensteins' Fragonard for the Reinhardts' 1927 exhibition could well have been agreed upon during a stroll on the Promenade deck or a dip in the heated pool. The previous January, Paul had crossed to Southampton with the wealthy stockbroker Arthur Sachs, whose brother Paul had been Mary's professor.[55] In London, they checked

into the elegant Carlton Hotel.[56] This three-month trip would take them from London to Munich[57] to Paris,[58] and they would meet with collectors and dealers in each city.

Their purchases that summer would make up part of their fall exhibition. In the scant remaining archives, we see the Reinhardts buying works by Utrillo and Vlaminck, Derain and Redon; works by the same artists appear a few months later in the New York gallery. We know that in early September, César de Hauke planned to meet up with the Reinhardts, already in Paris and based in the rue Boissy d'Anglas, a short walk from the Seligmann, Bignou, and Galerie Georges Petit.[59] And we know that another painting, not mentioned in the archives, found its way to the Reinhardt Gallery's walls that October: a still life by Paul Gauguin that Paul and Mary called *Fruit and Flowers*[60] but that we know as *Flowers and Fruit*.

How did it get there? There are no receipts, no telegrams, no letters. But there is a trail. One of the galleries in New Bond Street, Mayfair, London, was Arthur Tooth & Sons. Established in 1842, the firm had expanded to New York and Paris in the early 1900s. In its early decades the gallery had focused on British painting with a sideline in Old Masters and modern work; in 1902, Tooth had sold Monet's *Rue de la Bavolle, Honfleur*, to the Durand-Ruel Gallery in Paris,[61] and a decade later, had sold a Hogarth print to Knoedler's.[62] Working relationships like these persisted and connected Tooth's to both Paris and New York dealers. In the mid-1920s, the gallery began to focus on modern and contemporary art. Dudley Tooth, the gallery's director from 1926, partnered with other galleries dealing in the same field, among them Reinhardt's. Among the artists that Dudley Tooth worked with were Derain and Dunoyer de Ségonzac, both of whom were represented in the Reinhardts' 1929 exhibition.[63] There is evidence that Paul and Mary Reinhardt were in touch with Dudley Tooth in the summer of 1929. There is an entry in the Arthur Tooth & Sons stock inventories, now held at the Getty Research Institute, on June 24, 1929, noting that Tooth sold the Reinhardt Galleries a half share of a portrait by Gilbert Stuart.[64] A few minutes before midnight on July 16, Paul dictated a telegram to the staff at the Carlton Hotel, to be sent to César de Hauke in Paris:

> Tried to buy Tooth Derain but it has just been sold privately will buy your Derain . . . answer Carlton Hotel Regards Reinhardt[65]

Paul and Mary would have seen Tooth's Derain at the Arthur Tooth & Sons Gallery at 155, New Bond Street.[66] The gracious premises featured arched windows in a Georgian building, with a wide gallery for potential clients to

view the stock and, doubtless, a warren of smaller rooms where dealer col-
leagues could examine and haggle. Later that summer, Robert McKee walked
down New Bond Street and stumbled across *Flowers and Fruit*; a few months
later, he found the painting with the Reinhardts. Was *Flowers and Fruit* in
Tooth's gallery when Paul Reinhardt was trying to buy a Derain? Did it catch
his eye, and did he jot down a note to learn more about it? But how had it
come to London? When last we saw *Flowers and Fruit*, Max Kaganovitch
had purchased it on behalf of the dealer Etienne Bignou. That was in April
1929. What connection could there be between Bignou, Kaganovitch, and
Mr. Tooth of London?

On May 29, 1929, the *commissaire-priseur* Bellier had presided over the
sale of the "collection of an English amateur." It had featured work by names
familiar to modern art dealers, names like Matisse, Marquet, Bonnard, and
Signac. The names of those who had come to bid, and who bid success-
fully, were also common at such auctions: Léon Marseille had bought three
paintings; Max Kaganovitch, a Degas pastel; and Etienne Bignou, a paint-
ing by Rouault.[67] A painting by Matisse had been one of the biggest sales
of the afternoon, and the winning bidder had been Tooth, of London.[68]
Dudley Tooth was in Paris, bidding on modern and contemporary art, in the
same auction hall as Etienne Bignou, a month after the sale of *Flowers and
Fruit*—and almost exactly six months before *Flowers and Fruit* would find a
home with Robert and Eila McKee. Bignou, ever on the lookout for placing
a painting in the way of a profit, may have drawn the tall Englishman aside
after the auction. Perhaps they went across the street for an aperitif; perhaps
Bignou suggested that Mr. Tooth might like to stop by his shop before cross-
ing back to London; perhaps there was something in his stock that might
interest one of the clients in New Bond Street. Would Mr. Tooth be inter-
ested in purchasing a share of a painting—perhaps this one, perhaps this
Gauguin that had recently brought such a handsome price? It had belonged
to Sacha Guitry; surely a man as cosmopolitan as Mr. Tooth was aware of
France's greatest living actor.

Perhaps that is how it happened. Or perhaps not: the records of Arthur
Tooth & Sons' sales of paintings in 1929 do not mention any Gauguin still
lifes. The records suggest that such a relationship was likely. Dudley Tooth
and his staff bought and sold their stock with the Reinhardts, César de
Hauke, Knoedler & Company, Alexander Reid & Lefèvre, and Jos Hessel,
all art dealers who were part of Bignou's web. Paolo Serafini and others have
observed that dealers worked together in order "to reduce business risk by
means of a constant and rapid turnover" of inventory, "as well as the con-
stant redistribution of works in search of their final buyers."[69] The intricacies

of the network were such that tracking one painting could require examining the stock books, inventories, ledgers, and photo albums that survive from each gallerist. Each dealer had a different method of keeping track, and absolute clarity was not always of primary concern. Complete records of any gallery have not survived. We are left to piece together details from what remains; what remains may be, as in the case of the papers of Arthur Tooth & Sons, thirty-six volumes. But no matter how many volumes remain, if some are missing, then the record is inevitably incomplete. What we know for sure is that de Hauke, Tooth, the Reinhardts, Hessel, and Bignou all worked together.

We do not have the bills of lading, but we know that *Flowers and Fruit* was in Paris in April 1929 and that sometime late in the summer of 1929, Robert McKee saw it in London. By November 1929 the painting had crossed the Atlantic and was installed in the Reinhardt Gallery. The exhibition included works by "Picasso, Matisse, Derain, Modigliani, Braque, Dufy, Utrillo, Vlaminck, Laurencin, Henri Rousseau, Gauguin, Redon and others."[70] *Brooklyn Daily Eagle* art critic Helen Appleton Read noted that the selection was "as exciting an array as has been assembled in this country for some seasons." She continued: "If the unsophisticated art lover would like to know what smart New Yorkers are buying, he need only visit this collection."[71] Lillian Semons, of the *Brooklyn Daily Times*, took up the chorus. Semons noted that "the major exhibition galleries of Manhattan have gone French in a great big way" in October 1929. De Hauke was exhibiting Modigliani and there were rumors flying about the first exhibition at the brand-new Museum of Modern Art, coming in November. At the Reinhardt Galleries, she wrote "the tricolor has been hoisted high," and even the artists unnamed in the exhibition's title "were hardly to be classed with 'also rans,'" including, as that category did, van Gogh, Degas, and Cézanne. "What we can do," she concluded, "is to urge you to see the Reinhardt exhibition and see it soon."[72]

Upstairs, Downstairs

The Reinhardts installed *Flowers and Fruit* with its title inverted: *Fruit and Flowers*. The reason is linked to a seminal event in the history of museums in America. The Reinhardt Gallery was at 730 Fifth Avenue, on the ground floor of the Heckscher Building, a grand 1921 skyscraper lavishly trimmed in gold. Two weeks after the Reinhardts opened their exhibition of Picasso, Matisse, and *Flowers and Fruit/Fruit and Flowers*, the Board of Directors of the new Museum of Modern Art signed a lease on a six-room suite of offices on

the twelfth floor. Paul Sachs had recommended his former student, twenty-seven-year-old Harvard Ph.D. candidate Alfred H. Barr Jr., for the position of director in August 1929. Barr would never write his dissertation. Instead, he would spend the rest of his life at the helm of what became one of the most important museums in the United States. The newly appointed director spent the next few months organizing the museum's first exhibition. Some on the Board had argued for an exhibition of American artists, but Barr and his staunch ally Abby Aldrich Rockefeller had carried the day. Aldrich Rockefeller wrote to Barr from her summer house in Maine on August 23:

> I feel that our first idea of a stunning exhibition of the French artists—Cezanne, Seurat, Gauguin, Daumier, Van Gogh—would still be my first choice. I feel this because I believe that the modern movement was started by these men and I believe it is chronologically appropriate.[73]

From the end of August to mid-November was not much time to organize a loan exhibition. The fledgling museum had no collection of its own; the philosophy of the Board was to organize a series of exhibitions of borrowed works while the organization got on its feet financially. Barr spent September and October of 1929 frantically finding paintings to borrow. In the archives of the Museum of Modern Art, pages from a pocket-sized notebook contain scribbled lists in Barr's hand of Gauguins that the museum might borrow, often along with a letter grade. From New York gallerist Paul Rosenberg, Gauguin's *Yellow Christ*. From John Spaulding in Boston, there was a *Still Life, Flowers*, which earned a B from Barr; also from Boston, the Shaw McKeans owned a *Portrait of Meier de Haan* that Barr awarded an A. The Ginns of Cleveland might lend their new acquisition, Gauguin's *The Large Tree [Te raau Rahi]*). The list goes on for fourteen pages. It includes fifty Gauguins (and one painting that Barr suspects is a van Gogh). Out of those fifty paintings, twenty were part of the exhibition. One of the fifty that Barr noted that did not make the show's final list was listed as *Flowers*, and was, Barr believed, part of a "private collection, Paris."[74]

Could that painting have been *Flowers and Fruit*? It's possible. Barr made his list while *Flowers and Fruit* was moving between dealers; as a solid researcher, he could have known that a Gauguin flowers painting had sold the previous April in Paris to . . . someone, was it a private collector? The notation is crossed out, suggesting that Barr decided not to pursue that loan.[75] Did he learn that the painting was no longer available? Did he hear from his Heckscher Building neighbors Paul and Mary Reinhardt that the Gauguin *Flowers* sold in April in Paris was now part of their inventory? The slip of

PAINTINGS

PABLO PICASSO (Born 1881)

1 The Harlequin
2 Portrait of a Lady
3 Woman and Cats

MARIE LAURENCIN (Born 1885)

4 The Dancer
5 Two Girls

FOUJITA (Contemporary)

6 The Cat
7 The Kitten

COUBINE (Born 1886)

8 Flowers

JULES PASCIN (Born 1885)

9 The Girl with Fruit
10 The Girl in Blue with Flowers

AMADEO MODIGLIANI
(1885-1920)

11 Portrait of Mme. Zborowski

ODILON REDON (1840-1916)

12 Dans les Reves

PAUL GAUGUIN (1848-1903)

13 Fruit and Flowers

ANDRÉ DERAIN (Born 1880)

14 Head of a Girl
15 Head of a Girl
16 Head of a Woman

GEORGES BRAQUE (Born 1882)

17 Still Life, 1929
18 Still Life
19 Still Life

HENRI-MATISSE (Born 1869)

20 The Ballet Dancer

HENRI-ROUSSEAU (1844-1910)

21 Rain in the Jungle

MAURICE DE VLAMINCK
(Born 1876)

22 Ships

MAURICE UTRILLO (Born 1883)

23 Theatre Montmartre
24 Rue Mont Cenis

Fig. 5.3. Exhibition of drawings, paintings and watercolors: by Picasso ... [et al.] : October 12 through November 9th / Reinhardt Galleries. *Source:* Image copyright © The Metropolitan Museum of Art. Image source: Art Resource, NY

paper that might answer the question is missing. What we do know is that *Flowers and Fruit* had the same address as twenty of Gauguin's most well-known works for a few months at the end of 1929.

John Spaulding of Boston lent his Gauguin still life, called *Flowers and Fruit* in Barr's catalog; now in the collection of the Boston Museum of Fine Arts, the painting shows a glass vase of pink and blue flowers beside a small Quimper ceramic bowl and a larger bowl filled with oranges and a lemon. The vase and bowls sit on a round table covered by a white cloth, in front of a fireplace whose mantel is decorated by a red cloth edged in pompoms. Spaulding had purchased the painting from the Durand-Ruel gallery in 1922; Durand-Ruel had acquired it from Gustave Loiseau to whom Gauguin had given it in 1894. When Spaulding purchased the painting, the gallerists had given him a copy of a letter from Loiseau describing his acquisition of it from the painter himself.[76] [fig. 5.5: MoMA Catalog] *Flowers and a Bowl of Fruit on a Table*, as it is known now, hung between Seurat's final study for *Sunday on La Grande-Jatte*, lent by Adolph Lewisohn, and one of Cézanne's portraits of his wife, lent by founding trustee Mary Quinn Sullivan.[77] Downstairs in the Reinhardt Galleries, the painting now known as *Flowers and Fruit* hung between a Redon and a Derain.[78] If Paul and Mary Reinhardt acquired any

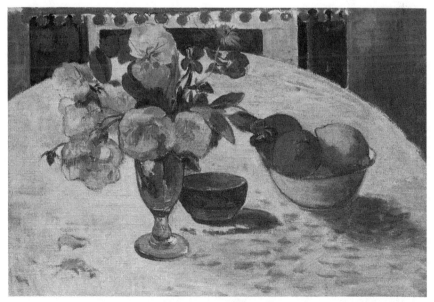

Fig. 5.4. Paul Gauguin, French, 1848-1903, *Flowers and a Bowl of Fruit on a Table*, 1894, Oil on canvas mounted on paperboard, 43.2 x 62.9 cm (17 x 24 3/4 in.), Museum of Fine Arts, Boston, Bequest of John T. Spaulding / 48.546. Photo Credit: Museum.

THE MUSEUM OF MODERN ART
FIRST LOAN EXHIBITION
NEW YORK
NOVEMBER
1 9 2 9

CÉZANNE
GAUGUIN
SEURAT
VAN GOGH

Fig. 5.5. Catalogue cover, "The Museum of Modern Art First Loan Exhibition, New York, November 1929: Cézanne, Gauguin, Seurat, van Gogh," by Alfred H. Barr, Jr., 1929. Offset, printed in black. 8 1/2 x 11" (21.6 x 27.94 cm). Alfred H. Barr, Jr. Books. The Museum of Modern Art Archives, New York. *Source:* Digital Image © The Museum of Modern Art/Licensed by SCALA / Art Resource, NY

additional documentation with the painting, it has not survived. We know only its history back to April 1923.

The two still lifes are not entirely dissimilar: the subjects are close enough for the paintings to share a title. The pink roses in each share a blousy quality; the objects are outlined in the same way, making them look colored-in. The still lifes have different settings and are made up of different objects: a vase that could be a large wineglass in the Spaulding painting, one pink cylindrical footed vase and one blue faceted hourglass vase in our painting. The surface is different, and so is the background: we are in an identifiable, specific space in Spaulding's still life, the Pension Gloanec in Pont-Aven, where Marie Gloanec decorated her mantelpiece with pompoms.[79] In *Flowers and Fruit*, we could be in any setting bourgeois enough to have patterned wallpaper, a not atypical choice for French interiors in the 1880s and 1890s, if we judge by the backgrounds in many paintings of the time.[80] It is difficult to resist the temptation to ask what would have happened to *Flowers and Fruit* had the Reinhardts decided to lend it to their upstairs neighbors for their opening exhibition. Would that exhibition have changed its fate? It is an ahistorical question, but a real question, nonetheless. It is a question that implicitly asks the difference between exhibition in a museum at the center of the art world and belonging to a museum at its extreme periphery.

Could Alfred H. Barr Jr. have declined to include *Flowers and Fruit* because he suspected its origin—because he suspected that it was not an authentic work by Paul Gauguin? Barr did not know the artist's work well enough to be able to form that opinion. He had done an MA and a BA in art history at Princeton, finishing in 1923. The following year, he had traveled to Europe for the first time; later that year, he began a doctorate in art history at Harvard. Barr interested himself in the European avant-garde movements.[81] He had not had time, or seen enough, by 1929 to have developed an eye for what was or was not authentic. Barr the graduate student felt confident in grading the works of artists that the museum might borrow. But nowhere in the surviving archives is there a suggestion that he was thinking about fakes or forgeries. Barr was networking with collectors, dealers, and museum staff whose judgment it did not occur to him to doubt.

The Reinhardts helped Barr and his small staff as they put together the Museum of Modern Art's loan exhibition. Barr and his team borrowed from over fifty different collectors, dealers, and museums from Cleveland to Zurich, Paris to Boston, New York to Berlin. Many dealers with whom we are familiar are there: both Bignou and Hessel are there, and so are Knoedler & Company and Wildenstein. The Ginns of Cleveland lent, and so did Samuel Courtauld of London, and Paul Sachs's brother Howard. In addition to the

lenders, Barr thanked several individuals and galleries for "their generous co-operation in assembling the exhibition."[82] The Reinhardts were on his list, as was César de Hauke. Paul Sachs, who had taught both Mary Woodward Reinhardt and Alfred Barr, appeared in the catalog both as a lender and as a member of the museum's Board of Trustees. Barr, too, was part of their art world network. Helping the new museum upstairs to succeed could only bring more traffic through their galleries.

Lillian Semons urged her *Brooklyn Daily Times* readers to visit the *First Loan Exhibition*. "Here," she wrote, "are the paintings that many of us have known through black and white reproductions, through hearsay and by their constant appearance in literary texts and critical writings as landmarks in art."[83] The works upstairs in the museum had been anointed as cultural exemplars, unique and priceless. But the works downstairs at the Reinhardt Galleries were still for sale. Paul and Mary Reinhardt were looking for buyers. Robert and Eila McKee were on their way back to New York. *Flowers and Fruit* was almost home.

Notes

1. "Annotated Letter, Earl Rowland to Robert T. McKee," March 15, 1939, McKee Papers, Haggin Museum Archives.

2. Wildenstein Plattner Institute, Inc., ed. Texts by Richard R. Brettell and Elpida Vouitsis. Research by Françoise Marnoni, Evgenia Kuzmina, and Jennifer Gimblett, "*Ia Orana Maria*, PG32XN," Gauguin: *Catalogue Raisonné* of the Paintings, 1891–1903. Edited and compiled by the Wildenstein Plattner Institute, Inc., 1891.

3. Paul Gauguin, "Brittany Landscape," National Gallery of Art, 1888, https://www.nga.gov/collection/art-object-page.46623.html.

4. "Outwards Passenger Lists," October 10, 1929, The National Archives; Kew, Surrey, England; BT27 Board of Trade: Commercial and Statistical Department and Successors: Outwards Passenger Lists; Reference Number: Series BT27-, Ancestry .com. UK and Ireland, Outwards Passenger Lists, 1890–1960 [database online].

5. "New York, U.S., Arriving Passenger and Crew Lists (including Castle Garden and Ellis Island), 1820–1957 . . ." (The National Archives and Records Administration, n.d.), Ancestry.com; New York, U.S., Arriving Passenger and Crew Lists (including Castle Garden and Ellis Island), 1820–1957 [database online].

6. "New Art Museum Visited by Scores," *New York Times*, November 9, 1929, https://nyti.ms/3qXd7IS.

7. "Annotated Letter, Earl Rowland to Robert T. McKee," March 15, 1939.

8. "Receipt, Clapp & Graham Company, Inc. to Mrs. Robert T. McKee," December 31, 1929, Haggin Museum Archives. $5,000 in 1929 is worth approximately $89,000 in 2023.

9. Mary Lasker, Reminiscences of Mary Lasker, 1982, 1962, 26, Oral History Archives at Columbia, Rare Book & Manuscript Library, Columbia University in the City of New York, http://www.columbia.edu/cu/lweb/digital/collections/nny/laskerm/introduction.html.

10. "Mary Rea Woodard, Passport Application," March 8, 1923, Roll 2194 - Certificates: 254350-254849, 08 Mar 1923–10 Mar 1923, Ancestry.com. U.S., Passport Applications, 1795–1925.

11. Karen Chernick, "Paul J. Sachs Trained a Generation of American Museum Leaders, Including Alfred Barr," Hyperallergic (blog), February 7, 2019, https://hyperallergic.com/483457/paul-j-sachs-trained-a-generation-of-american-museum-leaders-including-alfred-barr/; Hugh Eakin, Picasso's War: How Modern Art Came to America (New York: Crown, n.d.), 198–99.

12. Lasker, Reminiscences of Mary Lasker, 26.

13. "Paul Reinhardt, Emergency Passport Applications, 1924, Paris, France," n.d., Volume 186: Paris, France, U.S., Passport Applications, 1795–1925 [database online].

14. See, for example, "Minneapolis Gets a $200,000 Titian," New York Times, November 22, 1925, https://nyti.ms/47UejNO; "Buys Frans Hals and Rubens Works," New York Times, March 10, 1923, https://nyti.ms/45INnPc; "Paintings by George Inness," New York Times, January 11, 1917, https://nyti.ms/44tdzwh; "Aspiring Sculptors Show War in Clay," New York Times, April 27, 1915, https://nyti.ms/3Z5p388.

15. Hans (the younger) Holbein, "Portrait of a Lady, Probably a Member of the Cromwell Family," Toledo Museum of Art, accessed December 1, 2022, http://emuseum.toledomuseum.org:8080/objects/55183/.

16. "Paul Reinhardt, Dealer in Art, 56," New York Times, January 15, 1945, https://nyti.ms/3MxkOse.

17. Giovanni Bellini, "The Virgin with the Sleeping Child on a Parapet, P16s2," Isabella Stewart Gardner Museum, about 1470–1475, https://www.gardnermuseum.org/experience/collection/11794.

18. Lasker, Reminiscences of Mary Lasker, 26.

19. Christel H. Force, "Bignou: The Gallery as Antechamber of the Museum," in Pioneers of the Global Art Market: Paris-Based Dealer Networks, 1850–1950 (London: Bloomsbury Visual Arts, 2022), 206; Jackie Wullschläger, Chagall: A Biography, 1st ed. (New York: Alfred A. Knopf, 2008), 323, http://catdir.loc.gov/catdir/enhancements/fy0906/2008006162-s.html; Armand Dayot, ed., "Les Expositions: Expositions Visitées, Galerie Barbazanges-Hodebert," L'Art et Les Artistes 19, no. 50 (October 1, 1924): 142, https://gallica.bnf.fr/ark:/12148/bpt6k6154391x.

20. "Fonds Barbazanges-Hodebert Inventaire Analytique Détaillé," 2015, ODO 1996 1 à 1937, Musée d'Orsay—service de la documentation.

21. Reinhardt Galleries, ed., Marc Chagall Exhibition: The Reinhardt Galleries (New York, 1926).

22. "Quinn Show Opens at the Art Centre," *New York Times*, January 10, 1926, https://nyti.ms/3Eg6vZa.

23. Lasker, Reminiscences of Mary Lasker, 26.

24. "4 Zuloaga Works Sold for $100,000," *New York Times*, January 5, 1925, https://nyti.ms/3QOsLPE; "Throng to Zuloaga Show," *New York Times*, January 6, 1925, https://nyti.ms/3sJcG5z.

25. "Paul Reinhardt, Dealer in Art, 56."

26. "4 Zuloaga Works Sold for $100,000."

27. Marjorie Schwarzer, *Riches, Rivals, and Radicals: A History of Museums in the United States*, 3rd ed., American Alliance of Museums (Washington, DC: American Alliance of Museums Press, 2020), 120.

28. "Zuloaga Sailing, Extols American Women; 'Beautiful,' He Says, 'They Improve With Age,'" *New York Times*, April 26, 1925, https://nyti.ms/3r6j0DF.

29. "Papers of Paul J. Sachs," 2005, 1903, HC 3, Harvard Art Museums Archives.

30. Paul Gauguin, "1958.292: Still Life with Apples, a Pear, and a Ceramic Portrait Jug," Harvard Art Museums, 1889.

31. Gauguin, "1958.292: Still Life with Apples, a Pear, and a Ceramic Portrait Jug."

32. Dorothy Wilding, "A.D. Lasker Weds Mrs. Reinhardt," *New York Times*, June 22, 1940, https://nyti.ms/3kJi0lh.

33. Lasker, Reminiscences of Mary Lasker, 28.

34. Lasker, 34.

35. "James St. L. O'Toole—Reinhardt Galleries Scrapbook, 1936–1952," Archives Directory for the History of Collecting in America, The Frick Collection, n.d., https://research.frick.org/directory/viewItem/647#James.

36. Lasker, Reminiscences of Mary Lasker, 30.

37. Lasker, 33.

38. Lasker, 29.

39. Paul Reinhardt, "Telegram, August 29, 1929," n.d., Box 386, Folder 10: Henry Reinhardt & Son (Reinhardt Galleries), 1928–1930, Archives of American Art, Smithsonian Institution, Jacques Seligmann & Co. records, 1904–1978, bulk 1913–1974; Series: De Hauke & Co., Inc., Records.

40. Mary Reinhardt, "Telegram, August 18, 1930," n.d., Box 386, Folder 10: Henry Reinhardt & Son (Reinhardt Galleries), 1928–1930, Archives of American Art, Smithsonian Institution, Jacques Seligmann & Co. records, 1904–1978, bulk 1913–1974; Series: De Hauke & Co., Inc., Records.

41. Force, "Bignou: The Gallery as Antechamber of the Museum," 204.

42. "New York, U.S., Arriving Passenger and Crew Lists (including Castle Garden and Ellis Island), 1820–1957."

43. Henry Reinhardt & Sons, Inc., *Loan Exhibition of Paintings from El Greco and Rembrandt to Cezanne and Matisse in Aid of the Greenwich House Music School at the Reinhardt Galleries . . . January 15th to January 29th Inclusive, 1927* (New York, 1927).

44. *Te raau Rahi*, 1891 (WPI Reference no. PGkj37), Wildenstein Plattner Institute, Inc., ed. Texts by Richard R. Brettell and Elpida Vouitsis. Research by Françoise Marnoni, Evgenia Kuzmina, and Jennifer Gimblett, "Gauguin: *Catalogue raisonné* of the Paintings, 1891–1903," Gauguin: *Catalogue raisonné* of the Paintings, 1891–1903. Edited and compiled by the Wildenstein Plattner Institute, Inc., n.d., https://digital projects.wpi.art/artworks/gauguin/.

45. Association Paris–Amérique Latine, *Exposition Retrospective: Hommage au Génial Artiste Franco-Péruvien Gauguin* (Paris, 1926).

46. Elizabeth L. Cary, "Old and New Masterpieces of Painting," *New York Times*, January 16, 1927, https://nyti.ms/49P8UZn.

47. Vincent van Gogh, "L'Arlésienne: Madame Joseph-Michel Ginoux, 1888–89, 51.112.3," Metropolitan Museum of Art, accessed November 24, 2023, https://www .metmuseum.org/art/collection/search/436529.

48. Henry Reinhardt & Sons, Inc., *Loan Exhibition of Paintings*.

49. Wildenstein Plattner Institute, Inc., ed. Texts by Richard R. Brettell and Elpida Vouitsis. Research by Françoise Marnoni, Evgenia Kuzmina, and Jennifer Gimblett, "Gauguin: Catalogue Raisonné of the Paintings, 1891–1903."

50. Rachel Boate, "Jacques Seligmann & Cie," *The Modern Art Index Project, Leonard A. Lauder Research Center for Modern Art, The Metropolitan Museum of Art* (blog), August 2018, https://doi.org/10.57011/MBTP3835.

51. Paul Gauguin, "The Large Tree, 1891, 1975.263," The Cleveland Museum of Art, n.d., https://www.clevelandart.org/art/1975.263.

52. Christel H. Force, "Introduction: Pioneers of the Global Art Market: Paris-Based Dealer Networks, 1850–1950," in *Pioneers of the Global Art Market: Paris-Based Dealer Networks, 1850–1950* (London: Bloomsbury Visual Arts, 2022), 18.

53. Force, "Introduction," 19.

54. "New York, U.S., Arriving Passenger and Crew Lists (including Castle Garden and Ellis Island), 1820–1957 . . ."

55. "UK and Ireland, Incoming Passenger Lists, 1878–1960," January 4, 1929, Inwards Passenger Lists.; Class: BT26; Piece: 913; Item: 12, UK and Ireland, Incoming Passenger Lists, 1878–1960 [database online], The National Archives of the UK; Kew, Surrey, England; Board of Trade: Commercial and Statistical Department and successors.

56. The National Archives of the UK; Kew, Surrey, England; *Board of Trade: Commercial and Statistical Department and Successors: Inwards Passenger Lists*; Class: BT26; Piece: 913; and The National Archives of the UK; Kew, Surrey, England; *Board of Trade: Commercial and Statistical Department and Successors: Inwards Passenger Lists*; Class: BT26; Piece: 913; Item: 12.

57. Archives of American Art, Smithsonian Institution, Washington, D.C. Jacques Seligmann & Co. records, 1904–1978, build 1913–1974. Series 9: De Hauke & Co., Inc., Records. Box 386, Folder 10: Henry Reinhardt & Son (Reinhardt Galleries), 1928–1930. Collection: https://www.aaa.si.edu/collections/jacques -seligmann--co-records-9936.

58. New York, Passenger Lists, 1820–1957. Year: 1929; Arrival: New York, New York; Microfilm Serial: T715, 1897–1957; Microfilm Roll: Roll 4596; Line: 1; Page Number: 28.

59. "Box 386, Folder 10 | A Finding Aid to the Jacques Seligmann & Co. Records, 1904–1978, Bulk 1913–1974 | Digitized Collection | Archives of American Art, Smithsonian Institution," Text, accessed November 29, 2022, https://www .aaa.si.edu/collections/jacques-seligmann--co-records-9936/subseries-9-1-2/box-386 -folder-10.

60. Reinhardt Galleries (New York), ed., Exhibition of Drawings, Paintings and Watercolors: By Picasso . . . [et al.]: October 12 through November 9th (New York: The Gallery, 1929).

61. "Provenance of Paintings Record 11069: Monet, Claude, Rue de la Bavolle, Honfleur," n.d., https://www.openartdata.org/2022/05/tooth-in-provenance-getty -public.html.

62. "Provenance of Paintings Record 118: Hogarth, William, Miss Mary Edwards," n.d., https://www.openartdata.org/2022/05/tooth-in-provenance-getty-public.html.

63. Reinhardt Galleries (New York), Exhibition of Drawings, Paintings and Watercolors.

64. Arthur Tooth & Sons, "Box 27 (Vol. 31), Arthur Tooth & Sons Stock Inventories and Accounts," n.d., Accession no. 860679, The Getty Research Institute, http://hdl.handle.net/10020/cifa860679.

65. "Box 386, Folder 10 | A Finding Aid to the Jacques Seligmann & Co. Records, 1904–1978, Bulk 1913–1974 | Digitized Collection | Archives of American Art, Smithsonian Institution."

66. "Tooth Arthur & Sons Ltd. 155 New Bond St WI," in Post Office London Directory (London, 1925), Ancestry.com. London, England, City Directories, 1736– 1943 [database online].

67. "Revue des Ventes: Collection Jacques Zoubaloff," Gazette de l'Hôtel Drouot, June 1, 1929, 272, bibliotheque-numerique.inha.fr/idviewer/59663/269.

68. "Chronique des Ventes: Tableaux Modernes de La Collection d'un Amateur Anglais," Gazette de l'Hôtel Drouot, May 30, 1929, bibliotheque-numerique.inha.fr/ idviewer/59663/263.

69. Paolo Serafini, "Archives for the History of the French Art Market (1860– 1920): The Dealers' Network," Getty Research Journal 8, no. 1 (January 2016): 118, https://doi.org/10.1086/685918.

70. Reinhardt Galleries (New York), Exhibition of Drawings, Paintings and Watercolors.

71. Helen Appleton Read, "Who's Who in French Art, Shown at Reinhardt Opening," Brooklyn Daily Eagle, October 20, 1929.

72. Lillian Semons, "Carnegie Awards Announced; More French Moderns in N.Y.," Brooklyn Daily Times, October 20, 1929, https://www.newspapers.com/image/ 556440323.

73. "Abby Aldrich Rockefeller to Alfred H. Barr, Jr.," August 23, 1929, Alfred H. Barr, Jr. Papers, I.A. 3; mf 2164:214, Museum of Modern Art.

74. "Travel Notebook," n.d., I.A. 3; mf 3261: 708–721, Alfred H. Barr, Jr. Papers, Museum of Modern Art.

75. "Travel Notebook."

76. Paul Gauguin, "Flowers and a Bowl of Fruit on a Table, 1894," MFA Boston, 1894, https://collections.mfa.org/objects/33275/flowers-and-a-bowl-of-fruit-on-a-table.

77. Peter A. Juley, "Installation View of the Exhibition 'Cézanne, Gauguin, Seurat, Van Gogh,'" November 7, 1929, IN1.8, Photographic Archive. The Museum of Modern Art Archives., https://www.moma.org/calendar/exhibitions/1767?installation_image_index=7.

78. Reinhardt Galleries (New York), *Exhibition of Drawings, Paintings and Watercolors*.

79. Personal communication, Anne Bez, Musée de Pont-Aven, October 2022.

80. See, for example, Paul Gauguin, *Autoportrait (Les Misérables)*, 1888, Van Gogh Museum, and Paul Cézanne, *Still Life with Fruit Dish [Nature morte au compotier]*, 1879–1880, Museum of Modern Art.

81. "Biographical Note, Alfred H. Barr, Jr. Papers in the Museum of Modern Art Archives," The Museum of Modern Art, 2016.

82. The Museum of Modern Art, *First Loan Exhibition, New York, November, 1929: Cézanne, Gauguin, Seurat, van Gogh* (New York, 1929), https://www.moma.org/calendar/exhibitions/1767.

83. Lillian Semons, "The Museum of Modern Art, Its Advent and Its First Show," *Brooklyn Daily Times*, November 10, 1929.

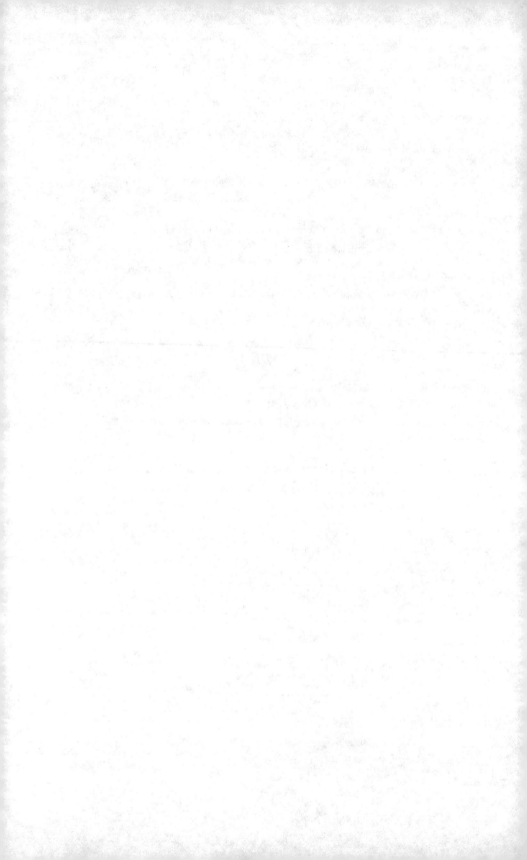

CHAPTER SIX

~

Disappearing

In the photograph, Eila Haggin is picnicking with friends in 1894 on a beach in Tahiti. Eila, aged twenty-one, sits on a woven straw mat with two Tahitian women. All three wear the high-necked, full-length loose cotton gowns introduced by Christian missionaries as appropriately modest dress for Tahitian women. A Tahitian man wearing long trousers, a long-sleeved shirt, and Western-style leather shoes sits with them on the woven mat. A servant stands at the edge of the group; in the background a pony grazes. A teakettle sits by one of the Tahitian women, a wine bottle in front of Eila. There are platters piled with grilled meat, a pineapple, coconuts. There are stemmed wineglasses. Eila, sitting cross-legged and holding a coconut, looks up at the camera with a smile that seems to share a secret.[1]

Eila Haggin McKee might have remembered that long-ago afternoon in 1929 when she visited the Museum of Modern Art's *First Loan Exhibition* and saw Gauguin's 1891 painting *Reverie*.[2] A Tahitian woman wearing a long, loose, high-necked gown leans back pensively in a rocking chair, her eyes cast down in thought and a handkerchief in her left hand. The mood of the portrait is melancholic, nostalgic.[3] *Reverie* was one of the stars of the exhibition. The *New York Times*'s art critic, Edward Alden Jewell, had called out this painting in his review of the exhibition. It was, he wrote, "simply gorgeous. . . . A glorious design, one of the best Gauguins this writer has seen."[4] Lillian Semons, writing in the *Brooklyn Daily Times*, noted that the Gauguins on view revealed the "immense vitality" of the artist. Their "striking design and . . . lush, rich color . . . [bore] evidence of a pagan riotousness."[5] Whether

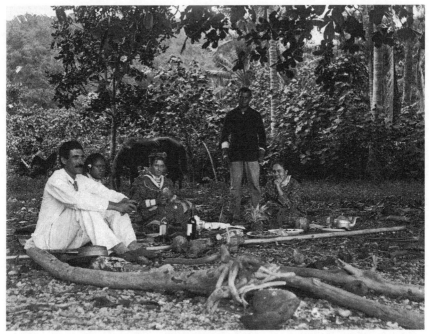

Fig. 6.1. Picnic with the Royal Family, January 1894 (Eila Haggin third from left) NM F 5975. *Source:* **Museum of Ethnography, Budapest**

Eila Haggin McKee recollected "pagan riotousness" from her apparently sedate formal picnic all those years ago, something about the Gauguins upstairs in the Heckscher Building must have spoken to her. When she went downstairs to the Reinhardt Galleries, she bought a Gauguin of her own.

Thirty-five years earlier, a lifetime ago, Eila had spent four months in Tahiti with her first husband, Rodolphe Festetics de Tolna, as part of a long cruise through the South Pacific. They had sailed into the port of Papeete just before dawn on January 10, 1894,[6] six months almost to the day after Paul Gauguin had sailed away for the first time.[7] The young couple spent that winter entertaining and being entertained by Tahitian high society, a mix of island royalty and expatriates from France, England, and America. Rodolphe recalled that they were quickly "inseparable" from the royal family. The late king's daughters taught Eila to weave straw hats. They gave informal dinner parties; they "organized teas in the garden, picnics, tours of villages, day trips to see famous sites in the mountains."[8] Eila wrote in her datebook that on January 26, 1894, they had picnicked with "Jack Brander, Manihinihi, and Matowira." Her husband photographed the occasion.

Fig. 6.2. Paul Gauguin (French, 1848-1903), Faaturuma (Melancholic), 1891. Oil on canvas. 37 x 26 7/8 inches (93.98 x 68.26 cm). Found in the collection of the Nelson-Atkins Museum of Art, Kansas City, Missouri. *Source:* Nelson-Atkins Museum of Art, Purchase: William Rockhill Nelson Trust. Photo Credit: HIP / Art Resource, NY

Did the middle-aged woman stand in front of Gauguin's *Reverie* and recall the photo of her younger self in a similar dress? Did she remember that afternoon in 1894, the rough bark of the coconut in her hands, the sound of the waves on the shore, the fuss around setting up the camera? Did the reasons for that small smile come back to her? No journal, no letters survive that could answer that question. But perhaps the answer is less important than the connection. She and Gauguin had heard the same sea break on the same shore.

Eila Haggin McKee bought *Flowers and Fruit* on December 31, 1929.[9] It was the last time the painting would be sold; joining Eila's collection brought the painting into the "antechamber of the museum" that Bignou had foretold, although the museum for which the painting would be destined was in a place and of a type that he could not have imagined. Eila McKee died in 1936. Three years later, Robert McKee moved out of their apartment at 136 East 79th Street and hired the firm of Samuel Marx, real estate appraisers, to inventory its contents.[10] It was *Flowers and Fruit*'s first step out of the rarefied world of art and wealth. The firm sent Isaac Sobel to manage the project. Sobel, a Russian immigrant and veteran of World War I, knew real estate, not fine art.[11] Sobel counted, measured, and described hundreds of objects for the inventory. Item 263 was an electric player piano with matching bench (item 264), valued at $250. Item 296 was a General Electric radio in a "walnut console cabinet," $25.00. Item 322 was a "small bronze horse on white marble base," valued at $2.00. And item 331:

Oil Painting
inscribed "en tolmi, Roy, PG",
Paul Gaugin [sic],
Still Life—Vases with Flowers and Fruit,
17½" x 21" in 4" gilt frame $1,000.[12]

Sobel knew real estate, not French: he misread the inscription and misspelled Gauguin's name. The painting, which had been measured, described, inventoried, and handled by some of the most well-connected art dealers in Paris, London, and New York, was migrating from one world to another. Sobel's misread of the inscription would become part of *Flowers and Fruit*'s cataloging information when it traveled by train from New York to Stockton, California, to join the Haggin Museum's collection.[13]

Pioneers

When *Flowers and Fruit* came to Stockton in 1939, it was the first painting by Paul Gauguin to join a public collection on the West Coast. It would remain one of only three paintings cataloged as Gauguins in California for the next thirty years.[14] California was a young state whose population was not preoccupied by modern art. It had become a state in 1850, two years after the first pioneers spotted gold at the bottom of a watercourse at Sutter's Mill.[15] In 1848, the year the Gold Rush began, Paul Gauguin was born in Paris into an intellectual and artistic setting. His father, Clovis, was a journalist; his mother, Aline Chazel, was the orphaned daughter of the feminist socialist Flora Tristan and a ward of the novelist George Sand. The family lived next door to the artist Eugène Delacroix.[16] Paris was already a center of the cultural world of western Europe when Stockton's first pioneers crossed the plains or sailed around the Horn in search of opportunity.

Founded in 1848 at the mouth of the San Joaquin River,[17] Stockton lies in the broad valley between the snow-capped peaks of the Sierra Nevada Range to the east and the rolling hills of the Diablo Range to the west. Forty-niners heading for the hills bought mining supplies there before heading up into the gold country. It was a town of saloons and boardinghouses where miners could outfit themselves with guns, wagons, flour, and produce. On July 3, 1865, when the first edition of Stockton's first newspaper was published, the lead article was about a local boy who had joined the army and was stationed in present-day Wyoming, where his division's mandate was "to whip the Indians . . . [and] kill Buffalo." Another article reported in detail on a fight with "six shooters" between two men in a nearby county. Robert Miller had bested Amaziah Scott by shooting him first in the right arm, then in the left thigh, and then in the right thigh. "Scott's recovery," the editor noted, "is considered doubtful." No one had been arrested.[18] One journalist would call Stockton the last stop from the developing San Francisco area before the frontier began.[19] It was a long way from the refined Paris of Delacroix and Sand.

From early on, residents of Stockton had a sense of place and a sense of history. They wanted to build a town. In 1868, city residents established the San Joaquin Society of California Pioneers. California became a state on September 9, 1850; to join the Society, men had to have been resident in the region before that date. The list of members numbered forty-five, and each of them provided the exact date of his arrival:[20] those who had arrived between 1847–1849 were accorded "first class" memberships, while those who arrived in 1850 joined as "second class" members. R. K. Reid had

arrived on September 16, 1849; Samuel Catts, on March 6, 1847.[21] The dates were two decades distant, but the men remembered them. Their history in California and in Stockton was a critical part of their identity. One of the purposes of the organization was "to collect and preserve information and facts connected with the early settlement of California, and especially of the Valley of the San Joaquin, and with the history thereof."[22] These early arrivals formed the Society, as they wrote in their articles of incorporation, to "perpetuate the memory of those whose sagacity, energy and enterprise induced them to settle in this country, and to become the founders of a new State." The Society was founded to last for fifty years.[23]

Seventy-five years later, the 1868 Pioneers' descendants organized the San Joaquin Pioneer and Historical Society with the goal of founding a local museum to tell the story of the town and its surrounding area.[24] The Society would

> revere, honor, and perpetuate the memory of the pioneers and early settlers of California, and especially of San Joaquin County; . . . study the history of California, and especially of San Joaquin county . . . encourage and develop educational facilities for the study of California History; . . . secure documents and articles of historical interest . . . establish and maintain a museum . . . develop the love of community, county, State and nation in the State of California, and especially among the youth thereof.[25]

The society's goal was to preserve the "relics of the old days" so that their "memory would endure."[26] The museum would use artifacts to preserve and recount an idealized local history of pioneers who came in covered wagons, "slow wheels making history in the trail of desert dust." When the museum opened in 1931, its staff assembled a "Handbook to the Contents" of the museum. They included a poem by local Stockton resident Harry T. Fee that idealized the pioneers and the settlement of the area:

> I can see the covered wagon,
> I can see its precious freight,
> I can see the spirit in it,
> Now the glory of a State . . .
> On the Scroll of Fate 'tis written
> In Times' Archives it appears
> This lowly covered wagon,
> And these noble pioneers.[27]

The San Joaquin Pioneer Historical Museum was going to present a specific, local story of heroic elders and their taming of the West.

But raising money for the endeavor was a slow process. The Pioneers had about $20,000 in their account; building and furnishing a museum would take much more. In November 1928 the women's committee of the Society held "a mammoth card party . . . at the civic memorial auditorium, the proceeds to go into the society's museum fund." "In a community where glamorous tradition plays such an important part," a museum was "a real necessity."[28] There was a palpable sense of urgency as history slipped away. At a meeting on March 21, 1929, Miss Emily Dodge, one of the San Joaquin Pioneer and Historical Society's directors, pointed out that "the most valuable local book collection of Californiana" had recently been sold to a collector in Los Angeles. Two of the town's original photography studios had closed and thrown away their archives, and there had been "instances . . . where covered wagons were chopped up for kindling wood by recent owners who placed no value upon them." Irving Martin, president of the local newspaper, called on the community to "rally to the cause" and contribute to the museum fund. "Unless some wealthy person or group gives a substantial sum sufficient to start the museum," he wrote, even more "priceless souvenirs" would be lost.[29]

Almost three thousand miles away, in a penthouse apartment at 136 East 79th Street in Manhattan, the McKees heard Martin's summons. Bob McKee had grown up in Stockton and still had ties there. The timing of the Pioneers' fundraising turned out to be propitious. Eila's father, Louis Terah Haggin, had died on March 7, 1929, leaving Eila and Bob with a mansion to empty. They had to find a place for sofas, tapestries, carpets, tables, mirrors, lamps, porcelain, and paintings collected by two generations. In April 1929, the McKees made the Society an offer. Mrs. McKee would donate, with conditions, the sum of $30,000 to be used to purchase land for a gallery to be named for her father. The gallery building, McKee stipulated, would be "of red brick, limestone trimmed . . . the design to be plain, simple, but suited to your surroundings and climate." With the money, Eila Haggin McKee would also donate "from thirty to sixty paintings in the original gold frames in which they were purchased from the best dealers in Paris and New York within the last sixty years. . . . The pictures after being hung . . . must stay in that room for all time, and not be removed or replaced by others, if the fashion or taste of your members change."[30]

McKee presented the Society with a solution to their fundraising problem that presented another problem. There would be seed money to buy land and begin construction: problem solved. The new problem? In the finished

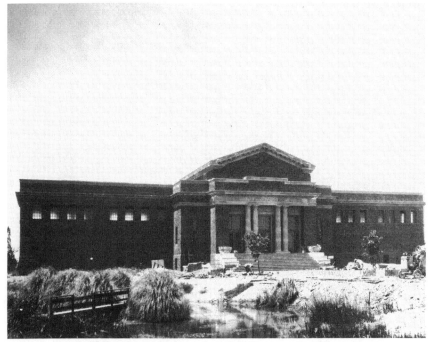

Fig. 6.3. Haggin Museum, 1931. *Source:* Haggin Museum, Stockton, California

building there would have to be installed a ready-made collection of fine art whose connection to California was tenuous, and to San Joaquin County, nonexistent. The thirty-one incorporators of the Society could have their museum, but they would have to compromise on its focus. Where their original intent had been to create a museum of history for civic education, they were now presented with the option of taking the money to build a museum—but of having that museum contain a collection its founders did not seek. The San Joaquin Pioneer and Historical Society chose to take the money and the collection and solve the problem of the museum's purpose later. The problem did not go away.

The Board of Directors of the San Joaquin Society voted to send a letter of thanks and set to work to bring the McKees' offer to fruition. "Not in recent years has Stockton had as welcome a piece of news," wrote the editors of the *Stockton Record*. They noted that many who had made their fortunes in California had taken their money back East. "It is gratifying to learn . . . of public-spirited individuals . . . who are loyal to the scenes of their youth and are anxious to translate their loyalty into a material gift that will be enjoyed by Californians through generations to come." The gift would form "a

valuable cultural and educational asset for the people" of Stockton. The new building could also be "a repository for pioneer mementoes."[31] The original vision of the museum was intact, with fine art grafted onto it. Leaders envisioned the museum as a center of the community, a place for education and elucidation that would elevate Stockton's cultural reputation. In February 1930, the McKees supervised the packing of twenty-seven cases of paintings to be shipped from New York to Stockton, where they would be stored in Dawson's Fireproof Storage Company until such time as the museum galleries were ready for installation. There were 133 paintings in all, more than twice what McKee had suggested in his April 1929 offer.[32] These paintings would make the gallery one of the largest art museums in California.

Between Civilization and the Frontier

The Haggin Museum's first director, Harry Noyes Pratt, was born in Wisconsin and settled in California with his family as a young man. He completed high school and then went to work; by 1931, the year the Pioneer Society hired him, he had been a bank cashier, journalist, art critic, and poet. L. A. Mills, the Pioneer Society's secretary, noted that not only was Pratt "a known organizer of ability" who did "not overlook the value of publicity"; he also had a "private collection of relics and interesting photographs of the ghost towns of California." His starting annual salary would be $2,000.[33] He moved to Stockton in early June and the museum opened a few days later. It already held the collections of "photographs, maps, [and] prints" accumulated by the Pioneer Society over decades. The volunteer firefighters had donated "several important pieces of early apparatus"; the county sheriff's office had contributed "a fascinating collection of weapons connected with criminal activities." And then there were "textiles, porcelains, household utensils, and documents which vividly portray the days of the great migration into the San Joaquin valley." "Already," wrote Pratt, "the walls and cases are filled to overflowing."[34]

Pratt devoted himself to building community interest in the museum. He made the rounds of community organizations, boosting the museum and looking for donations of objects and cash. In February 1932, he was the dinner speaker for the Business and Professional Women's Club; his lecture about the museum was part of a program that also included a performance by the Legion Auxiliary Glee Club and an interlude performed by a local ballet school.[35] He also wrote a regular column for the *Stockton Record* called "At the Gallery-Museum." In January 1933, he was pleased to announce that Mrs. E. L. Gibbens, of the Society of Pioneers, had donated a griddle, vintage

washing machine, and branding iron that had been used by a pioneer fam-
ily in the early 1860s.[36] Charles M. Aaron had donated a "double-barreled,
muzzle-loading gun" that he had been given "as a boy in Montana in 1866."[37]
The museum continued to collect artifacts from local families; in 1935, local
resident Mrs. J. A. Meade donated an "old-fashioned centerpiece of wool
flowers."[38] Even more objects to fill the walls and cases.

Community members were in and out of the museum regularly. In late
May 1934, students and alumni from Stockton High School performed
chamber music in the museum's main hall, an event that "the directors and
curator of the Haggin Memorial Gallery" hoped could happen "at least once
a month."[39] There were exhibitions of contemporary California artists such
as the photographer Edward Weston; annual shows of the local Photography
Club; and an annual exhibition of the work of local high school art students.
There were bridge parties[40] and club meetings.[41] Surviving records suggest
that the young museum was a center of community activities for those who
felt, or aspired to feel, connected to the pioneer past.

The art collection was both large and, at least in the community's eyes,
an afterthought. When the museum published its first handbook, Director
Pratt listed 182 paintings on view that the McKees had donated. There
were sixteen landscape paintings by Albert Bierstadt; a painting by Wil-
liam Bouguereau of nymphs bathing in the forest; four works by Jean-Léon
Gérôme; three by George Inness. The collection reflected the fashions of
the decades when Eila Haggin McKee's parents and grandparents had made
their fortunes. The art was conservative, academic in nature: landscapes and
genre paintings.[42] Seeing Mrs. Gibbens's heirloom griddle near Bouguereau's
nymphs may have highlighted the differences between Stockton's local cul-
ture and the high-culture paintings that were helping to pay the bills. The
Stockton of pioneer days had been, as the secretary of the local tourist and
travel association noted, "the point where civilization left off and where
the frontier began." These paintings were relics of that world that started at
the end of the wharves on the San Joaquin River. Their presence implied a
connection between the California market town and European capitals that
may have been a point of civic pride, but it must also have caused cognitive
dissonance. What would a person who had lived his life in Stockton have
made of Bouguereau's frolicking nymphs? What of Gérôme's streets of Cairo
with their turbaned guards? The landscapes, the Bierstadts and Innesses,
were likely easier to relate to: dramatic Western vistas were familiar. But
what to make of these relics of French culture and the French art world?
One response could have been to bring a curator, perhaps one of Paul Sachs's

students from Harvard, to look after the art collection, to research, lecture, and publish about it. That position was never created.

Even in the year of its opening, the museum struggled for funds. The Pioneer Society sent out a call for new members on December 9, 1931, six months after the museum's opening. L. A. Mills, now its general chairman, emphasized that the "Museum-Galleries" were important to the community, and that "funds on hand" were inadequate. He attached a budget that showed about $12,000 for staff salaries, utilities, office supplies, and general operation and maintenance, plus an additional $3,000 for exhibition "cases and racks" and additional exhibits. The city had appropriated $3,000 for the following year—and that left $12,000 to be made up in donations from Stockton's residents. An annual membership could be had for $5.00; a life membership, for $250.[43] In November 1935, the Pioneer Society sponsored a show they called "Heirlooms on Parade," a display of "beautiful mementos of early California and early America" put on to raise funds for "the purchase of some of the needed additional equipment for display of museum material."[44] The museum was able to keep the doors open, but the budget was always tight.

Visiting Art Works

When the museum's second director, Frances Garden Noble, organized a one-man show of California arts and crafts printmaker William S. Rice's works in 1936, it was with the understanding that the works would be for sale, which was the museum's common practice with living artists. Noble had come to Stockton from Mills College, in Oakland, first as temporary and then as permanent director of the Haggin.[45] She cautioned Rice not to send "heavy framed paintings" for the one-man show that the museum would shortly host. "We have very little money" to cover the cost of shipping, she explained. And while he was packing up his prints, work in color would be more popular than work in black and white. Did he have anything in color that he could include? Noble encouraged the artist to adjust any expectations he might have had about potential sales:

> Stockton is no more of an artist's town than it ever was as far as I can ascertain. There is very little buying of original art works and not even very much visiting of art works on display.[46]

Noble's sigh is nearly audible. Stockton was still, in her view, a frontier town, not interested in art or artists. She stayed for thirteen months before

marrying and moving back to San Francisco.[47] The community valued hav-
ing a museum, but was ambivalent about the art collection.

But both Pratt and Noble arranged for temporary exhibitions. An exhi-
bition of work by "Women Painters of the West" ran in January 1932;
the Stockton State Hospital sent over a show of ceramics later that year.
California artist Palmer Schoppe had a show there in 1934.[48] Sometimes
exhibitions came from farther away. In September 1931, the McKees decided
that the Haggin would benefit from hosting an exhibition of works from the
Reinhardt Galleries. The couple spent a morning at the gallery choosing
almost two dozen works from its inventory that they would pay to ship to
Stockton for a monthlong exhibition. The list included works by modern
and contemporary artists from Courbet to Redon, Derain to Picasso. Fred
Landeck, then manager of the Reinhardt Galleries, assured the McKees that
"this exhibition will be a credit to your institution."[49] When Landeck sent
the paintings to Stockton in January 1932, he noted that the Galleries would
give the museum a 10 percent commission on any works that were sold from
the exhibition. Landeck hoped that Director Pratt would "get the coopera-
tion of all of your larger cities nearby" in publicizing the exhibition—which
was "worthy of any of the finest and biggest museums in the country." The
New York art dealer wanted to be sure that the Stockton museum director
knew how grateful he ought to be for this collection of important paintings.
Whether Landeck knew which larger cities were near Stockton is unclear; it
is likely that California geography was just as mysterious to him as Manhat-
tan geography was to Harry Noyes Pratt. Landeck also suggested how the
paintings should be installed, assuming, perhaps, that Pratt was not familiar
with the artists and their styles:

> We would suggest that you hang the Monet, Sisley, Renoir, André and Maufra
> in one group and the Matisse, Rafaelli, Picasso, Friesz and Derain in the next
> group. The other pictures can be hung at random as offshoots from the latter
> group.

He also helpfully attached a three-page essay explaining Impressionism in
case it should be required.[50]

The paintings that Reinhardt Galleries sent were by important artists,
but they were not important paintings. Many had been part of the gallery's
inventory for a while, and had not yet sold. The previous June, Reinhardt
Galleries had exhibited Matisse, Renoir, Vlaminck, and Laurencin, among
others. *Times* Art critic Edward Alden Jewell had written of the show that

it was worth seeing, though there are pictures whose chief bid for attention resides in the fact that, because they are far from topnotch, they serve the more vividly to remind us of the worthier labors that have brought to their authors wide, often even world-wide, renown.[51]

The paintings that Landeck sent to the Haggin probably included ones from this exhibition. Harry Noyes Pratt alerted Stockton in his January 30, 1932, column that the exhibition was on its way: "February Display One to Stimulate Controversy," read the column's headline. Pratt lifted liberally from Landeck's mini lecture on Impressionism to introduce the coming exhibition. This would be a show "of the radical school," and it would be "shown no place else in the West."[52] That Stockton would host the exhibition was thanks to the McKees' relationship with the Reinhardt Galleries. Would Pratt have organized the exhibition on his own? Evidence suggests that his only contacts in New York were the McKees; correspondence between Pratt and Landeck is formal and businesslike. Landeck writes to Pratt with the tone of a man of culture speaking to his inferior.

What did Stockton think of the exhibition? Pratt published his regular Monday column the day after the exhibition opened. "Stockton noses," he wrote, "turn up to the same angle as do those of New York; Stockton lips curl to the same expression of derision." A few visitors could see past the "garish color, the distorted drawing" of "Matisse and his school." "Will we eventually come to accept these modernists?" he asked. "I wonder."[53] Visitors to the museum could see the display for twenty-five cents. A few short weeks later when the show was about to close, Pratt reflected that more out-of-town visitors had come to see "the unusual Reinhardt Gallery show" than locals. Groups had come from Sacramento and Berkeley, but it seemed that locals had not been impressed. "It may be," he opined, "that Stockton's culture will appreciate these canvases more if a journey across the continent is necessary."[54] Fancy art from New York City was not enough to impress the museum's usual visitors. They were, perhaps, more interested in seeing their grandparents' pioneer artifacts.

In the same month as the Reinhardt exhibition, local resident Miss Ella Henderson donated an antique gazing ball to the museum, in honor of the McKees. It came with a long provenance: "tradition had it" that Lafayette had once owned it, and that it had gone from him to the family of President Franklin Pierce. From the president it had gone to Senator Hannibal Hamlin of Maine, who had left it to Mrs. Amanda Pierce Henderson. And Mrs. Henderson had brought it with her to California in 1861.[55] The globe was connected to a wider, larger history—but what mattered for Stockton,

what made it interesting, was that it was evidence of Stockton's connection, through the pioneer generation, to that broader story. That, unlike the avant-garde paintings that the McKees chose and Landeck sent, was relevant to Stockton residents' experience.

Eila did not send her Gauguin along with the paintings from Reinhardts. It hung over the mantel in one of the drawing rooms in the McKees' Manhattan apartment. There is no evidence that she ever lent it to an exhibition. Her health was poor. In a June 1932 letter to L. A. Mills, Bob worried about his wife's health. She had traveled to Tucson to take the cure but had "returned . . . much worse . . . she looked worn and old." The couple were considering spending the next winter in Tucson for Eila's health. They would have to give up their opera tickets; Eila had had season tickets to the Metropolitan Opera since before they were married. "I dread it," wrote her husband.[56] The regular trips abroad that she and Bob had taken stopped in the early 1930s as her energy faded.[57] She died in 1936. The McKees never visited the museum they had done so much to bring into existence.

Disappearing

In January 1939, the McKees' Gauguin went into a crate with three other oil paintings and a pastel and was shipped to the Louis Terah Haggin Memorial Art Gallery. Traveling with it were several of what we can assume had been others of Eila's favorite works: a Laurencin, a Chase, and a Renoir.[58] They were all sent off to join the Haggin family collection. It was the last stage of *Flowers and Fruit*'s journey out of the art market.

On Tuesday, April 18, 1939, editor Irving Martin Jr. titled his column in the *Stockton Record* "The Museum's Gauguin." *Flowers and Fruit* had arrived recently at the Haggin and was still on view with the Laurencin, Chase, and Renoir "in a special setting in the main hall of the museum." "Just these four pictures," he wrote, "are sufficient to stamp any gallery a place of national importance." But Martin was besotted with the Gauguin. *Flowers and Fruit*, which illustrated the column, was, he wrote, "typical of [Gauguin's] technique and color, signed and fully authenticated, highly stylized and yet more restrained than many of his works." Martin did not explain what he meant by "fully authenticated"; at that time, to the best of anyone's knowledge, it was. And Martin noted that the painting was signed, but overlooked the inscription. Perhaps he was not confident in what it said.

Martin wondered where it could have been painted. Was it from Tahiti? If it was from Tahiti, was it evidence of the artist's nostalgia for a country of roses and apples instead of frangipani and mangoes? "Or perhaps," he

continued, "the picture was painted in Arles, when Gauguin was living with Vincent Van Gogh." Martin was taken with the mystery of how the still life fit into Gauguin's body of work. "We hope," he wrote, "that at some time the museum will find time to dig back into the detailed life of Gauguin and find just when and where he painted this small, fine typical still life of a few apples, two vases, some pink roses and a single nasturtium. Its story will be interesting."[59]

The museum staff did not have that kind of time or expertise. There were regularly changing exhibitions; there were school field trips; there were chamber music concerts. No one had ties to the New York or Paris art world. Earl Rowland, the museum's director from 1937 to 1963, was an artist and teacher, not an art historian. He did not research the collection. If he had had time or inclination to dig into the history of the museum's Gauguin, he might not have known even where to begin: the tools of the provenance researcher are obscure, the trade secrets closely held. There is no record of Rowland having ever applied for a passport. His world was California. Berkeley-educated New Yorker Jerome Jenkins took over the post in 1963 and announced his intention of focusing not on the art collection but instead on Stockton's pioneer history.[60] The art galleries were re-installed a few times, adding accessioned furniture and decorative arts or taking it away, depending on the museum staff's interest and needs for the space. They served as a backdrop for the museum's civic mission of telling the story of Stockton and San Joaquin County.

Flowers and Fruit was installed, in 1939, in a new room given to the museum by Bob McKee. He gave it in memory of Eila Haggin McKee and her "kind, generous, and cosmopolitan life." The room was filled with furniture, decorative art, and paintings from the McKees' household, 129 objects in all. McKee wrote brief catalog descriptions for the brochure that the museum produced. There was a "very old Italian leather chair with original iron. Such chairs are found in many of the old palaces." There were three pieces of "old Louis XVI brocade." There was a "Mahogany Empire stand (exceptional), purchased from Hotel Drouot, great Parisian antique house." Each object was numbered, and number 12, according to McKee's notes, was a "Still Life by Paul Gauguin, given by Gauguin to a friend; the signature include[d] dedication to the friend. Acquired from a Bond Street Gallery in London."[61] McKee's pride in his association with these objects may have meant that he exaggerated here and there for effect; here and there, too, he misremembered. He wanted to be certain that there was a monument in his hometown that showed how important and connected he and his wife had been out in

the world beyond Stockton. They had lived among objects created by genius and owned by the great and good.

The museum's Gauguin remained in the New Room for over twenty years. It did not make up part of any traveling exhibitions; the Haggin collection never went on tour. Nor was it lent to other museums. The museum did not publish a catalog of its art collection; there was no one on staff who had the expertise to write one, and no money to pay them. If any of those things had happened, *Flowers and Fruit* would have been recalled, recognized, outside of Stockton. Earl Rowland directed the museum until 1963. The next director, Jerome Jenkin, arrived later that year. He had trained as a historian and his goal was "to help correct any 'distorted point of view' of local history" by telling the stories of "the Chinese, Mexicans, Basques, and others" in the region.[62] Jenkin cared about telling the stories of ordinary people. In his introductory interview in the *Stockton Evening and Sunday Record*, he did not mention the Haggin's art collection.

The Haggin's directors moved within a tight network of Stockton community leaders. In the dozens of articles that appear in the local press about these directors—the luncheons where they were guest speakers, the city council meetings at which they presented—there is no article that records them traveling East to attend meetings with their museum director counterparts or to purchase works at auction. There is no record of their working with art dealers or art historians to learn more about the museum's collection. Their work was about the community, and about keeping the museum central to it. It was not about digging into dusty archives or expanding the museum's influence beyond the Stockton city limits. What was important in the Stockton context was the civic pride that came from a connection to the world of high culture. And even that was secondary to the museum's role as a history museum, as a place that told the story of the pioneer generations of the San Joaquin Valley.

Still Life

The June 15, 1957, late city edition of the *New York Times* led with news on the latest civil rights bill in Congress, an update on Senator Lyndon Johnson's marshaling of a foreign aid bill through the Senate, and—the biggest headline, in the upper right corner—the news that the Soviet Union had agreed to an "international control system" that would "assure observance of an agreement to suspend nuclear tests." Between that article and the news about the $3.6 billion foreign aid package, there was another. The dateline was Paris, June 14. The headline: "Painting by Gauguin

Sells for $255,000." "A Gauguin painting was sold here today," the lead went, "for what may be the highest price paid for a modern work of art." The painting was a still life of flowers and fruit, painted in the Marquesas Islands in 1901–1902. It passed from the estate of one wealthy collector to another at an auction organized by the Galerie Charpentier. "Brisk bidding had been foreseen," the article continued, "but the results exceeded the wildest expectations." When this still life was bid up to 100,000,000 francs, "the entire audience rose and burst into applause." The hall was full of celebrities and leaders of the art world, from the Louvre's chief curator to the celebrity classical pianist Arthur Rubinstein. "Some persons got so enthusiastic that they raised their hands without any real intention of bidding," and at times the auctioneer lost his place in recording the bids and had to stop to recapitulate.[63]

The Gauguin's $255,000 sale price was enough to merit a prominent story—albeit nearly a month later—in the *Stockton Evening and Sunday Record*. "City Possesses Rare Gauguin," read the headline, "Museum Plans Special Show."

> The recent sale in Paris of a painting by the French artist Paul Gauguin for $300,000 has caused the San Joaquin Pioneer Museum and Haggin Art Galleries to spotlight a Gauguin in its possession.
>
> A special showing is planned in August of the Gauguin in the Victory Park museum, believed by local museum officials to be a companion picture to the painting which brought the premium price of $300,000 in an auction June 13.[64]

Museum director Earl Rowland explained to the *Record* that the auction in Paris "unquestionably enhanced the value" of *Flowers and Fruit*, "making it perhaps the most costly painting in the museum's collection."[65] In Stockton in 1957, a new three-bedroom, two-bathroom house cost $14,850.[66] George Vaughn Motors, the local Chrysler dealer, was offering Plymouth Suburban station wagons, "the largest wagon on the road today," at prices starting at $2,295. An upright refrigerator—offering 18 cubic feet of storage—was on sale for $299.95.[67] The sale of a painting for hundreds of thousands of dollars must have seemed to happen in another world.

Rowland and his colleagues brought their prize Gauguin into the front hall of the museum on August 15. Museum visitors could visit it and marvel that such a valuable work of art, by a world-renowned artist, was part of their neighborhood. The *Record* noted that the painting would remain on special display "indefinitely, and then would be replaced in its usual position in the

Eila Haggin McKee Memorial Room."[68] There are no records of how many came to see *Flowers and Fruit* while it was on special view.

Still Life with Grapefruits, the painting that inspired the *Times*'s article and the Haggin's special exhibit, is now part of a collection in Athens, Greece.[69] It depicts a pale blue porcelain bowl filled with greenish-yellow grapefruit, sitting next to a blue vase filled with oleander blossoms and a sprig of fiery red peppers on a rumpled white tablecloth. The ensemble rests on a trunk whose fastenings lead the eye into the painting. A smaller bowl contains more flowers and peppers. The background is a deep yellow wallpaper or, perhaps, tapestry. Gauguin painted it in 1901 or 1902, in the Marquesas, and may have sent it back to Paris to his dealer Ambroise Vollard in 1902.[70]

Like *Flowers and Fruit*, this painting echoes the Cézanne still lifes that Gauguin so admired. Each piece of fruit is outlined and carefully highlighted so that we see the afternoon sunlight hitting them just so. The grapefruits are smooth, round, regular, instead of the bumpy and misshapen apples of *Flowers and Fruit*. Instead of roses in the vase, we have oleander; instead of a single nasturtium blossom in the foreground, a tropical lily. Gauguin has paid attention to the folds and wrinkles of the tablecloth in *Still Life with Grapefruits*, showing us the blue and green shadows that the objects cast on it and suggesting that there may have been a faint rose-colored pattern on the cloth. There is no tablecloth in *Flowers and Fruit*, no trunk, no shiny red peppers, but the paintings are more alike in both subject and style than they are different.

Still Life with Grapefruits, like *Flowers and Fruit*, had belonged to an American heiress, Margaret Thompson Biddle, who had died in Paris in 1956. She was born in Montana, the daughter of William Boyce Thompson, who made a fortune in copper mining. The *Times* reported that, when he died in 1930, Thompson left his wife and daughter an estate worth $85,000,000.[71] Margaret, like Eila, had used her inheritance to collect art and fine things, and to travel the world. But there the paintings' biographies diverge. *Still Life with Grapefruits* had never traveled far from the center of the art world. Vollard had held it for about ten years after he unpacked one of Gauguin's last shipments. From him, the painting found its way to the Galerie Eugène Druet in Paris. Druet sold it in 1913 to German-Jewish industrialist and collector Dr. Max Meirowsky. Meirowsky fled Germany in 1938 and died in Switzerland in 1949. What became of his collection after he left Germany is uncertain; one of Meirowsky's van Goghs has been the subject of a successful restitution suit brought by his heirs.[72] *Grapefruits* had been lent by a private collector to Geneva's Museum of Art and History before the Wildenstein firm purchased

it in March 1952; Mrs. Biddle had purchased it from the New York branch of Wildenstein & Co., Inc., later that year.[73]

Still Life with Grapefruits had a résumé of exhibitions. Druet had sent the painting to be exhibited in St. Petersburg, Russia, in 1912. It was part of exhibitions at Geneva's Museum of Art and History in 1948 and 1951. The Galerie Charpentier, who managed the Biddle sale, included it in an exhibition they called *Cent Chefs-d'oeuvre de l'Art Français* in 1957; two years later, *Still Life with Grapefruits*'s new owner lent it to the Gauguin retrospective hosted by the Art Institute of Chicago and the Metropolitan Museum of Art. This was the largest Gauguin show in the United States up until that time. Two years in preparation,[74] this retrospective brought "70 paintings, 44 drawings and watercolors, 74 prints, and 11 sculptures" together and provided, the two museums' directors wrote in their exhibition catalog introduction, "an exceptional opportunity . . . to study the qualities in [Gauguin's] work which have led to a steadily growing public interest."[75] Theodore Rousseau Jr., the Met's curator of paintings, writing in the catalog, placed Gauguin in the modern canon: "every progressive painter of the last half century at some time in his career has been moved by the continuing power of Gauguin."[76]

That place had been earned in part because leaders of the art market, like Vollard and Wildenstein, had promoted Gauguin's work. They had sought out collectors for it; they had worked to place it in museum collections; they had organized and contributed their own inventory to exhibitions. They had kept careful track of who owned which works. *Still Life with Grapefruits*'s complicated history has been carefully documented in large part because it passed through the Wildenstein galleries during the years in which Georges Wildenstein and Raymond Cogniat were researching their Gauguin *catalogue raisonné*. They knew, in 1964, that the painting was in the collection of Greek shipping magnate Basil Goulandris, who had purchased it in 1957 at the Biddle sale; they knew where it had been on exhibition since.[77]

They had much less information about *Flowers and Fruit*. Wildenstein and Raymond Cogniat worked for decades to assemble their Gauguin *catalogue raisonné*. They drew on the Wildenstein company's copious, unrivaled archives: the auction catalogs they had picked up at Drouot, their exchanges and conversations with auctioneers and experts, the museum exhibition catalogs they were sent each time they lent material from their storerooms for exhibitions, and the letters and telegrams that they exchanged with collectors and dealers, and their own stockbooks and ledgers of purchases and sales.[78] There was no slip of paper, no telegram or ledger entry, that mentioned the Reinhardts' 1929 sale of *Flowers and Fruit* to Eila Haggin McKee. And neither Wildenstein nor Cogniat nor any of their colleagues

had seen Irving Thayer's 1939 tribute to "the Museum's Gauguin" on the editorial page of the *Stockton Record*.[79] They likely did not know that Stockton existed, any more than people in Stockton knew that the Wildenstein Gallery existed.

The art world had lost sight of the painting that had traveled from Paris to London to New York and come to rest in Stockton. In the entry for *Flowers and Fruit* in their 1964 catalog, Wildenstein and Cogniat trace the painting's provenance from Louis Roy to Sacha Guitry to Max Kaganovitch to the Reinhardt Galleries. After that, for the Wildenstein firm and for the broader art world, its location was a mystery. The French word used in the catalog when a painting's location was unknown was *disparu*, disappeared. Georges Wildenstein wrote, in his preface to the catalog, "The notation *disparu* indicates a work of which we have lost the trace but which we know about from a previous reproduction."[80] When Etienne Bignou brought *Flowers and Fruit* to auction in Paris in 1929, he included a photograph of the painting in the auction catalog.[81] The Wildenstein archives had a copy of that catalog; in the 1964 *catalogue raisonné*, they included Bignou's catalog photograph.[82] But Wildenstein and his colleagues did not see the painting again.

"History," scholar Jill Lepore has written, "is the study of what remains." What remains has withstood fires and floods, willful negligence and hapless disregard. Sometimes our historical remains have been carefully kept, cataloged, put on shelves or, lately, digitized, and saved for the next generation. But whole swaths of history have been lost, or mislaid, or fallen from notice. The historical record, Lepore continues, is "maddeningly uneven, asymmetrical, and unfair."[83]

The archives of what we now know as the Wildenstein Plattner Institute constitute one version—a thorough version—of the historical past. Yet even it is not a complete version; there are no complete versions of the past. The story of *Flowers and Fruit*, still missing important chapters, is yet more complete than it was. Significant research and study have created new knowledge. We know, now, more about the connections between Louis Roy and Paul Gauguin. We know more about Roy, his preoccupations and paintings. We know more about the dealers who bought and sold *Flowers and Fruit* during the 1920s, and the collectors who proudly hung it on their walls. The story is more balanced than it was. We still do not know who painted it. But we know that it has a history of its own, a history that connects Le Pouldu with Stockton, Sacha Guitry with Eila Haggin McKee, Etienne Bignou with Earl Rowland. *Flowers and Fruit*'s history teaches us that the world is both larger and smaller than we may have imagined. It teaches us, and it also

invites new questions. What happens when a Gauguin disappears from the horizon of the art market? Is it still a Gauguin, or does it become something else: a fake or a forgery, or does it remain a mystery?

Notes

1. Rodolphe Festetics de Tolna, *Chez les Cannibales: Huit Ans de Croisière dans l'Océan Pacifique à Bord du Yacht "Le Tolna"* (Paris: Plon, Nourrit et Cie, 1903), 75, https://gallica.bnf.fr/ark:/12148/bpt6k6549123n.

2. Edward Alden Jewell, "The New Museum of Modern Art Opens," *New York Times*, November 10, 1929. The current title of the painting, now in the collection of the Nelson-Atkins Museum of Art, is *Faaturuma [Melancholic]*. See https://art.nelson-atkins.org/objects/18445/faaturuma-melancholic?ctx=d553c357-57f5-4f71-86eb-ec539b444cbb&idx=6.

3. Cornelia Homburg et al., eds., *Gauguin: Portraits* (Ottawa, Ontario, and London: National Gallery of Canada; National Gallery, 2019), 140.

4. Edward Alden Jewell, "The New Museum of Modern Art Opens," *New York Times*, November 10, 1929, https://nyti.ms/3pPjmh6.

5. Lillian Semons, "The Museum of Modern Art, Its Advent and Its First Show," *Brooklyn Daily Times*, November 10, 1929.

6. de Tolna, *Chez Les Cannibales*, 68–69.

7. David Sweetman, *Paul Gauguin: A Life* (New York: Simon & Schuster, 1995), 350.

8. de Tolna, *Chez Les Cannibales*, 68–69.

9. "Receipt, Clapp & Graham Company, Inc. to Mrs. Robert T. McKee," December 31, 1929, Haggin Museum Archives.

10. "Haggin Family Papers" (Haggin Museum, Stockton, CA, n.d.).

11. "Isaac Sobel, New York, U.S., State and Federal Naturalization Records, 1794–1943," n.d., The National Archives in Washington, DC; Washington, DC; NAI Title: Index to Petitions for Naturalizations Filed in Federal, State, and Local Courts in New York City, 1792–1906; NAI Number: 5700802; Record Group Title: Records of District Courts of the United States, 1685–2009; Record Group Number: Rg 21; "Isaac Sobel," *New York Times*, November 4, 1961, https://nyti.ms/49bG7hs.

12. "Haggin Family Papers."

13. "Collections File, Flowers and Fruit, 1939.34.3," n.d., Haggin Museum Collection.

14. Gauguin's *The Red Cow* joined the collection of the Los Angeles County Museum of Art in 1948; his *Fruit Dish on a Garden Chair* joined LACMA's collection in 1954. See https://collections.lacma.org/node/231172 and https://collections.lacma.org/node/229569. The Fine Arts Museums of San Francisco acquired *Breton Girl* in 1969 as a work by Gauguin; it has since been disattributed. See https://www.famsf.org/artworks/breton-girl.

15. Kevin Starr, *California: A History* (New York: Random House, 2005), 78.

16. Sweetman, *Paul Gauguin: A Life*, 20.

17. Starr, *California: A History*, 76.

18. "Letter from a Stockton Boy," *Stockton Daily Evening Herald*, July 3, 1865, Newspapers.com, https://www.newspapers.com/image/488607682/.

19. William Metzger, "Stockton Ideal Headquarters for Tourists Visiting California," *Stockton Daily Evening Record*, February 21, 1933, Newspapers.com, https://www.newspapers.com/image/843482813/.

20. "Pioneers' Meeting," *Stockton Daily Evening Herald*, December 8, 1868, Newspapers.com, https://www.newspapers.com/image/488426801/.

21. "List of Pioneers," *Stockton Daily Evening Herald*, December 10, 1868, Newspapers.com, https://www.newspapers.com/image/488427353/.

22. "Agreement, 26th Day of March, 1930," n.d., Early Museum Documents, Haggin Museum Archives.

23. San Joaquin Society of California Pioneers, "Record Book," 1868, LB67-3199, Haggin Museum Archives.

24. "New Historical Societies Form," *Santa Cruz Evening News*, February 16, 1928, California Digital Newspaper Collection, https://cdnc.ucr.edu/?a=d&d=SCEN19280216.1.10&srpos=2&e=01-01-1928-01-01-1939-192-en--20--1--txt-txIN-%22san+joaquin+pioneer%22-------.

25. "San Joaquin Pioneer and Historical Society Files Articles of Incorporation," *Stockton Evening and Sunday Record*, February 15, 1928, https://www.newspapers.com/image/843378777/?terms=%22san%20joaquin%20pioneer%20and%20historical%20society%22&match=1.

26. Harry Noyes Pratt and Marion Washington, "A Handbook to the Contents of the Louis Terah Haggin Memorial Galleries and San Joaquin Pioneer Historical Museum," August 1931, Exhibition Catalogues & Programs, Haggin Museum Archives.

27. Pratt and Washington, "A Handbook," 12.

28. "Another Museum Problem," *San Bernadino Sun*, November 21, 1928, California Digital Newspaper Collection, https://cdnc.ucr.edu/?a=d&d=SBS19281121.1.20&e=-------en--20--1--txt-txIN--------.

29. "Before the Time Has Passed," *Stockton Evening and Sunday Record*, March 21, 1929, Newspapers.com, https://www.newspapers.com/image/843392114/.

30. "Stockton to Have $30,000 Museum," *Stockton Evening and Sunday Record*, April 17, 1929, Newspapers.com, https://www.newspapers.com/image/843380675/.

31. "Stockton Evening and Sunday Record 17 Apr 1929, Page 24," Newspapers.com, accessed January 23, 2023, https://www.newspapers.com/image/843380867/.

32. "Inventory of Paintings for the Account of Estate of Louis T. Haggin," February 28, 1930, Collections Files, Haggin Museum Archives.

33. "Museum Here to Be Opened Sunday, Jun 14," *Stockton Evening and Sunday Record*, May 20, 1931, Newspapers.com, https://www.newspapers.com/image/843513958/.

34. Pratt and Washington, "A Handbook," 8.

35. "Harry Noyes Pratt Dinner Speaker for Bus. and Pro. Club," *Stockton Evening and Sunday Record*, February 13, 1932, Newspapers.com, https://www.newspapers.com/image/843438926/.

36. Harry Noyes Pratt, "At the Gallery-Museum," *Stockton Evening and Sunday Record*, January 7, 1933, Newspapers.com, https://www.newspapers.com/image/843513677/.

37. Solly Strutter, "Art & Other Things," *Stockton Independent*, February 21, 1934, Newspapes.com, https://www.newspapers.com/image/608138715/.

38. Dorothy Hayne, "At the Gallery Museum," *Stockton Daily Evening Record*, December 21, 1935, Newspapers.com, https://www.newspapers.com/image/843302428/.

39. "Haggin Gallery Affords Ideal Setting for String Quartet Concert Tomorrow," *Stockton Evening and Sunday Record*, May 26, 1934, Newspapers.com, https://www.newspapers.com/image/843422593/.

40. Hayne, "At the Gallery Museum."

41. "Mrs. R.J. Custer, Lodi, to Head San Joaquin Federated Clubs," *Stockton Evening and Sunday Record*, May 1, 1935, Newspapers.com, https://www.newspapers.com/image/843429736/.

42. Pratt and Washington, "A Handbook," 13–30.

43. L. A. Mills, "Selective Membership Campaign, San Joaquin Pioneer and Historical Society," December 9, 1931, Haggin Museum Archives.

44. L. A. Mills, "Heirlooms Parade," *Stockton Evening and Sunday Record*, November 7, 1935, Newspapers.com, https://www.newspapers.com/image/843435442/.

45. Dorothy Hayne, "At the Gallery Museum with Dorothy Hayne," *Stockton Daily Evening Record*, May 9, 1936, Newspapers.com, https://www.newspapers.com/image/843441694.

46. "Frances Garden Noble to William S. Rice," September 19, 1936, Haggin Museum Archives.

47. "Gardens of Fort Provide Setting for Nuptials," *Stockton Evening and Sunday Record*, July 3, 1937.

48. "Exhibitions, 1930s," n.d., Haggin Museum Archives.

49. "Fred A. Landeck to Mrs. Robert Tittle McKee," September 14, 1931, Exhibition from Reinhardt Galleries, New York, February 4, 1932–March 1, 1932, Haggin Museum Archives.

50. "Fred A. Landeck to Henry Noyes Pratt, January 21, 1932," n.d., Haggin Museum Archives.

51. Edward Alden Jewell, "The New York Prospect Surveyed," *New York Times*, June 7, 1931, https://nyti.ms/40iiLmg.

52. Harry Noyes Pratt, "At the Gallery-Museum," *Stockton Evening and Sunday Record*, January 16, 1932, Newspapers.com, https://www.newspapers.com/image/843436209.

53. Harry Noyes Pratt, "February Display One to Stimulate Controversy," *Stockton Evening and Sunday Record*, January 30, 1932, Newspapers.com, https://www.newspapers.com/image/843439138/.

54. Harry Noyes Pratt, "Last Week to View Reinhardt Exhibit," *Stockton Evening and Sunday Record*, February 20, 1932, Newspapers.com, https://www.newspapers.com/image/843440430/.

55. Harry Noyes Pratt, "Reinhardt Collection Is Source of Interest," *Stockton Evening and Sunday Record*, February 6, 1932, Newspapers.com, https://www.newspapers.com/image/843440603/.

56. "Robert Tittle McKee to L.A. Mills," June 4, 1932, Haggin Museum Archives.

57. "Haggin Family Papers."

58. "Handbook of the New Room, 'La Vie En La Grande Ténue,'" 1939, Haggin Museum Archives.

59. Irving Martin Jr., "The Museum's Gauguin," *Stockton Daily Evening Record*, April 18, 1939, Newspapers.com, https://www.newspapers.com/image/843746688.

60. "Stockton Evening and Sunday Record 20 May 1963, Page 26," Newspapers.com, accessed January 26, 2023, https://www.newspapers.com/image/845200410/.

61. "Handbook of the New Room."

62. "New Museum Director Plans 'Flesh and Blood' Area History," *Stockton Evening and Sunday Record*, May 20, 1963, Newspapers.com, https://www.newspapers.com/image/845200410/.

63. "Painting by Gauguin Sells for $255,000," *New York Times*, June 15, 1957, Late City Edition edition, https://nyti.ms/40CHcL6.

64. "City Possesses Rare Gauguin: Museum Plans Special Show," *Stockton Evening and Sunday Record*, July 12, 1957, Newspapers.com, https://www.newspapers.com/image/844824628/.

65. "City Possesses Rare Gauguin: Museum Plans Special Show."

66. "Sierra Meadows," *Stockton Evening and Sunday Record*, June 16, 1957.

67. "$500 in Cash for YOU," *Stockton Evening and Sunday Record*, July 12, 1957, Newspapers.com, https://www.newspapers.com/image/844824506.

68. "Gauguin Painting on Display Sunday," *Stockton Daily Evening Record*, August 15, 1957, Newspapers.com, https://www.newspapers.com/image/844815424.

69. Paul Gauguin (formerly attributed), "Nature Morte Aux Pamplemousses, 1901 or 1902," Basil & Elise Goulandris Foundation, n.d., https://goulandris.gr/en/artwork/gauguin-paul-still-life-with-grapefruits.

70. Wildenstein Plattner Institute, Inc., ed. Texts by Richard R. Brettell and Elpida Vouitsis. Research by Françoise Marnoni, Evgenia Kuzmina, and Jennifer Gimblett, "Nature Morte Sur Une Malle, 1901, PGQWJV," n.d.

71. "Margaret Biddle Is Dead in Paris," *New York Times*, June 9, 1956, https://nyti.ms/47Dp5XX.

72. Michelle Young, "After Disappearing for Decades, a van Gogh Watercolor Sold Under Duress and Then Stolen by Nazis May Fetch $30M," *Hyperallergic*,

November 10, 2021, https://hyperallergic.com/691726/a-van-gogh-watercolor-sold-under-duress-and-then-stolen-by-nazis-may-fetch-30m/.

73. Wildenstein Plattner Institute, Inc., ed. Texts by Richard R. Brettell and Elpida Vouitsis. Research by Françoise Marnoni, Evgenia Kuzmina, and Jennifer Gimblett, "Nature Morte Sur Une Malle, 1901, PGQWJV."

74. Howard Devree, "Art: Career of Gauguin," *New York Times*, April 23, 1959.

75. The Art Institute of Chicago, The Metropolitan Museum of Art, *Gauguin Paintings, Drawings, Prints, Sculpture* (Chicago: Lakeside Press, 1959), 7.

76. The Art Institute of Chicago, The Metropolitan Museum of Art, 25.

77. Georges Wildenstein, *Gauguin* (Paris: Les Beaux-Arts, 1964), 268.

78. Philip Hook, *Rogues' Gallery: The Rise (and Occasional Fall) of Art Dealers, the Hidden Players in the History of Art* (New York: The Experiment, 2017), 101–2.

79. Martin Jr., "The Museum's Gauguin."

80. Georges Wildenstein, *Gauguin*, np.

81. Hôtel Drouot, *Catalogue des Tableaux Modernes, Pastels, Aquarelles, Gouaches, Dessins, par J. Bernard . . . Provenant des Collections de M. S. G. et de Différents Amateurs: Vente, Paris, Hôtel Drouot, Salle N° 6, le Samedi 27 Avril 1929 / Me F. Lair-Dubreuil, Commissaire-Priseur; M. Jos. Hessel, M. Étienne Bignou, Experts* (Paris: Hôtel Drouot, 1929).

82. Wildenstein, *Gauguin*.

83. Jill Lepore, *These Truths: A History of the United States* (New York: W. W. Norton & Co., 2018), 4.

~

Epilogue

In 2023, a century after its first appearance in the historical record, *Flowers and Fruit* went on another journey. It traveled west once again: across California's San Joaquin Valley, through the mountain pass at Altamont and through the flatlands until, at last, it crossed the San Francisco Bay. The August heat gave way to cool fog rolling in over the hills. Row houses and the chimes of cable cars replaced Stockton's low-slung bungalows and wide boulevards. The painting had never been to San Francisco; workers in the city's art museums did not even know of its existence. Gauguins were scarce in Northern California. There was one authenticated painting by Gauguin in the Bay Area, in the collection of the University of California at Berkeley.[1] In San Francisco museums, there was one oil painting formerly attributed to him.[2] When *Flowers and Fruit* arrived in town on that Thursday afternoon, it traveled in secret.

The painting had connections to San Francisco. This was the city of Eila Haggin's birth, the city in which her family's collections began. It was the city her grandfather Butterworth had come to in 1863 from New York to seek his fortune, the city where he wrote home in delight about the figs: they "were large and the best I ever saw, you never tasted such nice ripe blue figs, they are delicious with cream."[3] During the time that she owned *Flowers and Fruit* Eila never visited San Francisco, but the painting lived in her household with countless family mementoes. There was the tile with her father's monogram in silver; family portraits of her grandparents and great-grandparents; a drawing given to her mother by the artist Elihu Vedder in 1888. There

were packing trunks and andirons, faience urns and Staffordshire pottery dogs: the evidence of family life over decades and across continents.[4] Some of the objects, some of the art, had traveled with Eila's forebears from the East Coast to the West in the 1850s and back to the East in the 1890s, when they settled in New York. *Flowers and Fruit* had never been to San Francisco before, but it had been part of a San Francisco collection.

The painting's destination in 2023 was a conservation studio. At the edge of the city, up a narrow flight of stairs, *Flowers and Fruit*—swaddled for travel—entered a new stage of its life: technical analysis. This was the one step we had not yet taken. Derek Fincham, who writes about art law, identifies the three main tools the art market uses to assign authenticity: provenance, connoisseurship, and scientific analysis.[5] Provenance tells us where a work of art came from. Connoisseurship tells us what a painting looks like. Scientific analysis tells us how a painting was made. It could provide the missing key to the painting's story.

Provenance

This book has been a historical study of the provenance of *Flowers and Fruit*. The provenance listed in a museum's catalog, or in a *catalogue raisonné*, is typically limited to a few lines, "a string of names, places, and dates . . . without elaboration."[6] But these unadorned lists are "saturated with information and significance." They demonstrate "attitudes, events, politics, and social relations that would otherwise go unnoticed."[7] The 1964 Wildenstein provenance for *Flowers and Fruit* does not mention that Sacha Guitry knew Henri Baudoin; it does not explain that Max Kaganovitch was a connection of Etienne Bignou's. The significance of each sale and purchase, the social relations they represent, is buried in the commas and semicolons of the listing. Had the Wildenstein list begun with, instead of the terse and vague "Collection Roy," an explanation of how the painting had come to be part of Roy's collection, how that information was manifested, and when the object had entered the art market, this would be a very different study.

Instead of an austere list of owners, I have endeavored to provide a sense of who those owners were and the worlds they lived in; in building these worlds I have sought to deepen our understanding of the object's meaning over time. I have tracked the painting across time and space, across networks and on its journey in and out of authenticity. I have opened boxes covered in decades of archival dust, unwrapped bundles of documents that threatened to disintegrate from age. I have used my scholarly expertise to uncover as much as I could about the history of the painting. While my research has revealed

an extraordinary amount about the painting's life—who sold it, bought it, sold it again, and how it entered the Haggin's collection—it has not revealed definitively who made the painting, and when.

An ideal provenance will describe an uninterrupted chain of ownership from the moment that the artist signed a canvas until the present day. Many works by Gauguin have such a provenance. In 1889, for example, while Gauguin was in Pont-Aven, a local woman, Angélique Satre, agreed to sit for her portrait. It was a commission that would bring in much-needed funds for the artist. But when Gauguin presented the portrait to Madame Satre, she was horrified and refused to buy it. Two years later, in 1891, Gauguin put it up for auction and the artist Edgar Degas bought it. *La Belle Angèle* remained in Degas's collection until 1918, when it went into his studio sale. The dealer Ambroise Vollard bought it and, in 1927, donated it to the Louvre. Today it is on view in Room 38 of the Musée d'Orsay, and you can take home a print of it for €22.[8] From the moment that Gauguin signed the painting, collectors and dealers, donors and curators have known where it was.

A provenance may not always be what it appears: art crime expert Noah Charney has written about "provenance traps"[9] in which the history of an object, as well as sometimes the object itself, is invented. In 1997, the Art Institute of Chicago purchased a sculpture of a faun attributed to Gauguin. Curators hailed it as one of the museum's most important acquisitions of the last twenty years and effused about significance. *The Faun* had appeared at auction at Sotheby's in 1994, consigned by someone named Madame Roscoe. Included in the object's description was a note stating that the statue would be included in the next Gauguin *catalogue raisonné*. The owners of a London gallery bought the statue and, several years later, a prominent curator from the Art Institute came to lunch. He saw the statue and knew immediately that he wanted it for the Art Institute's collection. The museum purchased the statue for over $513,000. The sculpture appeared to be a long-lost Gauguin that had been included in a 1917 exhibition catalog. Madame Roscoe had included in the sculpture's documentation a copy of a 1917 receipt from the gallery for the sale of the statue to Gauguin's Pont-Aven colleague, the Irish artist Roderick O'Conor. Roscoe claimed to be a descendant of O'Conor and to have inherited it.[10]

The Art Institute of Chicago featured *The Faun* in several publications and exhibitions. It was an important new discovery and a significant addition to the museum's collection. But there were clouds on the horizon. In 2007, Scotland Yard brought charges against Shaun Greenhalgh and his elderly parents George and Olive for producing and selling over 120 fake works of art since 1990. Greenhalgh forged everything from Egyptian sculptures to

Expressionist paintings. The family's trick was to page through old, obscure auction catalogs and identify lots that had vague descriptions and whose current whereabouts were unknown. Then, Greenhalgh would create the work, his parents would create the provenance documentation, and either the aged and harmless-seeming Olive or George would offer the object for sale as a family heirloom which they, regrettably, were forced to sell to make ends meet.[11] When she placed *The Faun* at Sotheby's in 1997, Olive Green-halgh used her maiden name, Roscoe. Shaun Greenhalgh was sentenced to four years and eight months in prison in November 2007, and his parents to suspended sentences because of their ill health. Journalists from *The Art Newspaper* saw that one of the items on the family's list of forgeries was a statue by Gauguin called *The Faun*. It only took them a few days to trace the statue to Chicago.[12] When informed, museum staff removed the statue from exhibition. The object's forged provenance had been instrumental in persuading experts of its authenticity. The Greenhalghs had capitalized on what scholars and experts do not know about Gauguin's work in sculpture and had created an object that filled a gap. The 1917 exhibition had fea-tured a sculpture of a faun; the whereabouts of that object was unknown; the Greenhalghs produced it.[13]

Flowers and Fruit fills no known gap in Gauguin's body of work; instead, it suggests that there may be unknown fissures in our knowledge of his career. No documentation exists to connect Gauguin to the painting: no partial sketch of a vase or apple, no letter referencing it, no line in an inventory. But that absence does not necessarily imply inauthenticity. Historian Tiya Miles has observed that archives "only include records that survived acci-dent, were viewed as important in their time or in some subsequent period, and were deemed worthy of preservation."[14] Even the most thorough archive is necessarily incomplete, and no amount of research can capture the fullness of human experience. A gap in provenance may mean that a painting was forged. Or it may mean that evidence is missing.

A few months ago, I found new evidence in the painting itself. *Flowers and Fruit*'s inscription to Louis Roy suggests that the artist may have owned it at one time. The inscription makes it likely, but it does not make it inevitable. There is another piece of evidence hidden in the painting, though. In the upper right corner of the canvas backing there are two barely visible faded stamps. One is a circle about an inch and a half in diameter; all that remains of the circle is its outline and some interior markings that are indistinct even under magnification. Investigations of this stamp have been inconclusive; it seems possible that it could be a customs stamp. The other stamp is an irregular circle surrounded by an oval of linear marks.

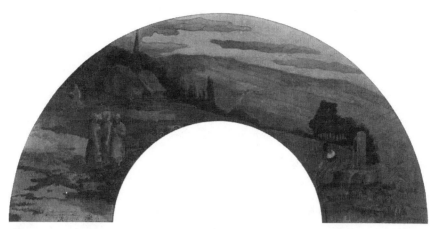

Fig. E.1. Louis Roy, *Breton peasant by a fountain,* **1901.** *Source:* ©Ader

In March 2023, an object came up at the Hôtel Drouot that introduced surprising information. The auction was of a group of "old and modern drawings," and it included a 1901 watercolor in the shape of a handheld fan by Louis Roy.[15] Many of Roy's contemporaries painted handheld fans: the shape provided a design challenge, required few supplies and little space to make, and could be sold or reprinted more cheaply than a canvas painting. This was

Fig. E.2. *Flowers and Fruit,* verso, detail. Source: ACdR Conservation

a watercolor landscape scene that featured a church, a water pump, and a few figures. In the lower left corner, next to Roy's signature, there is a stamp. Less than an inch in length and circumference, the unfaded oval image depicts a berry surrounded by a garland of oval leaves. Additional research in auction websites revealed that, by 1897, Roy had begun marking some of his works on paper with a stamp.[16] The small stamp on the back of *Flowers and Fruit* matches Louis Roy's stamp in size, shape, and form. It is strong evidence that Louis Roy handled the painting.

Marking works with a studio stamp was a common practice among Roy's fellow artists: Schuffenecker had been using a distinctive stamp of a lotus entwined with his initials on his works on paper since 1890.[17] Both Bernard and Seguin had stamps.[18] Artists typically included the stamp on the front of the artwork near, or in place of, their signature. That is how Roy used his stamp on the few examples of fans that have become known. Collectors have, for centuries, marked objects in their collection: whether monogramming a silver service or affixing a coat of arms over the door of a royal residence, markings are meant to be "visible and indelible."[19] By affixing his stamp to the back of *Flowers and Fruit*, Louis Roy was leaving a record, if we could decipher it, of his ownership of the painting. The faded stamp is a new link in the chain of the object's provenance.

Connoisseurship

When the Wildenstein Plattner Institute's Gauguin committee examined *Flowers and Fruit* in 2018, they looked at it through the lens of their decades of study of Gauguin's work. Connoisseurship tells us what a painting looks like in relationship with other paintings by the artist. No Gauguin expert had laid eyes on the painting since it left France in 1929. Georges Wildenstein, author of the 1964 Gauguin *catalogue raisonné*, had relied on the image and provenance listed in the 1929 auction catalog of works from Sacha Guitry's collection. Using that information and his knowledge of Gauguin's style, he had dated *Flowers and Fruit* to 1889.[20] When Georges described it as lost, no one from the Haggin spoke up: the museum's director at the time was interested in local history, not the latest news from the Paris art world. In 2002, Georges' son Daniel had published the next version of the Gauguin catalog, which revised his father's and followed the artist's career from 1873–1888.[21] Sylvie Crussard was one of the primary contributors to this edition; she had worked on Gauguin at the Wildenstein Institute since the late 1970s, beginning with studying the artist's drawings.[22] She had acquired her connoisseurship by years of immersion in Gauguin's works, by internalizing the forms and

structures of his paintings. It was Crussard, along with other colleagues, who had had enough misgivings about *Flowers and Fruit*'s authorship to opt, in 2018, not to include it in the forthcoming catalog of Gauguin's 1889–1891 works.

Crussard and connoisseurs like her have spent decades learning to recognize an artist's style. It is a process not unlike learning to recognize an individual's handwriting. Just as each of us has our own signature way of writing the first letter of our name, perhaps, or of dropping the loop of a lowercase *g* below the baseline, an artist has a signature way of applying paint to canvas. An apple painted by Cézanne will not look like an apple painted by Renoir, just as two scholars with the same first name will write their names differently. Artists may copy elements of another's style—an apple by Gauguin may incorporate characteristics of an apple by Cézanne—but the artist will do so in his own style. In an oral history, Crussard describes this as a "sensitive aspect," a sense of things about the artist and his work that is, at times, beyond words.[23] This sense of things, "of the small differences, details and micro-variations,"[24] that reveal "the creative process of the artist's mind"[25] develops only over time and repeated exposure. It is ineffable. A painting looks right, or it doesn't. Daniel Wildenstein described how he applied his connoisseurship when authenticating a painting: "Most of the time, I'm 100 percent sure. If I am 95 percent sure, I say yes, but there is a possibility of error. At 90 percent, I say no."[26]

Connoisseurship is an important tool in the authentication process. In May 2000, both Christie's and Sotheby's published their spring auction catalogs and discovered that both were offering the same painting for sale: Paul Gauguin's *Vase de Fleurs [Lilas]*. The painting at Christie's had come from a Tokyo gallery; Sotheby's had purchased theirs from a dealer named Ely Zakhai. One was a deliberate forgery, but which? Sylvie Crussard examined both paintings and pronounced the Christie's Gauguin a forgery. A forger may seek to copy an artist's style, and may succeed, but a connoisseur will be able to recognize something not quite right. A connoisseur will be able to compare the style of one artwork with others in the artist's body of work. There might be clues in "brushwork, quality of line and color, composition of the painting, and . . . the historical and relative chronology of the artist's own development." Any inscription or signature on the painting would, likewise, have to be "harmonious with the composition" of the artwork, and of others like it.[27] Crussard spotted the difference between the original and the forgery. Further investigation revealed that the Tokyo gallery's forgery had originally come from Zakhai: the New York dealer had bought lesser-known paintings by Gauguin and his contemporaries and hired artists to

copy them—down to the markings on the back of the originals. He then sold the forgeries to unsuspecting clients. When the client tired of the painting and sold it to the next buyer, putting a layer of provenance between the dealer and his forgery, Zakhai would then sell his original.[28] Over time, he could sell one authentic Gauguin and one forged Gauguin for the price of two authentic paintings. Crussard's examination was the first thread that led to the unraveling of Zakhai's scheme, which ended with a prison term and a fine of $12.5 million.[29] The fine is a useful reminder of the financial stakes of authentication; Crussard's involvement in the case is a marker of the centrality of the role of the connoisseur in the art market. Connoisseurship at its finest can demonstrate "sound and unprejudiced judgment, based on comparison and experience."[30]

There is another dimension to connoisseurship, beyond the visual examination, and that is the object's, and the connoisseur's, network. As chapter 4 explored, the art world runs on networks of relationships between dealers and artists, collectors and curators. Connoisseurs—who may also be dealers and collectors, as in the case of Daniel Wildenstein—are part of that network. So are many museums. The Haggin Museum and the Wildenstein Institute have never shared an overlapping network with common points of reference. The Haggin staff no more subscribed to *La Gazette Drouot* than the Wildenstein Institute had the *Stockton Daily Evening Record* delivered. When the Wildenstein Gauguin experts examined *Flowers and Fruit*, they examined it without the benefit of a shared history with the painting's custodians since 1939. This could have contributed to their less than 90 percent confidence that *Flowers and Fruit* was authentic and the decision to leave it out of the forthcoming *catalogue raisonné*.

Scientific Analysis

Scientific analysis is a third piece of the authentication process. Technical studies of paintings can tell us how a painting was made. They can help the custodians of artworks preserve them for the future by revealing the painting's current condition: whether the paint is detaching from the canvas, the amount of dirt on the painting's surface, the tension between the canvas and the stretcher. And scientific studies can also expose the physical history of a painting: the type of canvas that supports the painting; the ground, or base layer, that prepares the canvas for the painting, similar to a primer coat; the layers of paint and varnish. Information about the artist's creative process may lie "micrometers below a painting's surface." Below the surface may be visible "underdrawings, underpaintings, and adjustments made in

the course of painting."[31] The ways that an artist builds up his painting are as idiosyncratic as a signature. In the last decades, scientists have developed new tools and techniques that have expanded the information that analysis can provide.

Flowers and Fruit's appointment with the conservator was for an extensive checkup. First, the specialists would assess its condition, examining the signature and inscription, "specific brushstrokes, noting previous conservation efforts, and any damage, dirt, or aging of the surfaces." In this stage, they would remove the painting from its frame and document the condition of the front and back of the canvas and of the frame. Next, they would document the painting and canvas with hundreds of photographic images. The images would record their examination of the painting and canvas under various types of lighting and degrees of magnification. They would take cross-section pigment and fiber samples and secrete them in brown glass vials, for possible examination by other researchers.[32] All of this would take months.

There have been instances when examination and imaging revealed information that changed the perceived authenticity of a painting. In March 2019, experts at the Van Gogh Museum authenticated a still life previously attributed to van Gogh in the collection of the Wadsworth Atheneum in Hartford, Connecticut. After scholars had questioned its authenticity, the painting had been taken off view. The staff at the Van Gogh Museum examined *Still Life with Poppies*'s "canvas, ground layer, pigments and style" and concluded that it was by Vincent after all. They found corroborating evidence in an autumn 1886 letter that van Gogh had written describing how he was re-using canvases to save money, and had spent the summer painting "a series of color studies" including red poppies. Technical imaging revealed a previous painting under the finished *Poppies*, a profile portrait of a man.[33]

Technical analysis has also revealed forgeries. The Knoedler Gallery had been in business in New York since 1846, catering to clients that included J. P. Morgan and the Metropolitan Museum of Art, and showing artists from John Singer Sargent to Jackson Pollock. In 2011, the gallery closed after it was revealed that Knoedler "had been selling forged artworks for years."[34] The suit that brought about the gallery's closing concerned a painting purportedly by the abstract expressionist Jackson Pollock which, under analysis, was revealed to include a type of yellow paint that was not on the market until 1970, fourteen years after the artist's death.[35] It was the work of Pei-Shen Qian, an immigrant living in Queens. The Pollock was not the only fake Qian produced. Knoedler's director, Ann Freedman, had acquired many works from another dealer, Glafira Rosales, who presented herself as working for an anonymous collector. Freedman acquired works attributed to

a number of American contemporary artists through Rosales; many of them later turned out to be forgeries done by Qian.[36] Rosales's partners would supply Qian with old paint and decades-old canvases they found in flea markets. Some canvases they stained with tea bags, others they left outside in the elements, to make them look older.[37] While others in the art world later claimed that they had been suspicious of Knoedler's inventory of contemporary American art all along, the information that ultimately caused the venerable gallery to close came from technical analysis of the forged Pollock.

And so, *Flowers and Fruit* went under the microscope.

The question was, as it has been: Is *Flowers and Fruit* an authentic work by Paul Gauguin, or a forgery? Why does it matter?

The question matters because of what its answer can mean. If the answer is that the painting is the work of Paul Gauguin—if he stretched the canvas, mixed his paints, chose the roses and the apples, the vases and the lone nasturtium blossom, and, when he was finished, inscribed it to Louis Roy—then we know something more about both artists. Studying the painting in that case is an opportunity to learn more about Gauguin's method and work habits, and about the network of artists, patrons, dealers, and enablers with which he surrounded himself. It might change what we understand about the way that Gauguin's style developed, and about how and where he spent his time. It might even put Louis Roy's name higher up on the list of those who orbited Gauguin. Scholar of cultural heritage law Patty Gerstenblith writes about why authenticity, why knowing who made the painting, matters:

> Only by examining and viewing authentic art works and cultural objects can we truly understand the perspective of the original creator of the work and the historical and cultural context in which the work was created. Only in this way can knowledge of ourselves, our past and different places and people be expanded and better understood.[38]

We want to understand because understanding who made the painting will help us understand more both about the world of Gauguin, Roy, Marseille, Guitry, and all the others whose names have been connected to *Flowers and Fruit*, and because it will help us understand more about our own world, about the networks in which we live out our lives. The question of authenticity is also a question of affiliation and membership: if *Flowers and Fruit* could be determined to be authentic, then all those whose lives it had traveled through would now be part of a history that included Gauguin's life and work as well as his posthumous influence on modern art. It would expand the

circle of membership in the art world's elite echelons to include a regional history museum in central California as much as the hallowed halls of the Musée d'Orsay.

If the answer is that *Flowers and Fruit* is a forgery, that, too, would provide us with important information. Philosopher Denis Dutton has defined a forgery as "a work of art whose history of production is misrepresented by someone (not necessarily the artist) to an audience (possibly to a potential buyer of the work), normally for financial gain."[39] If initial technical analysis presented evidence that *Flowers and Fruit* was a forgery, scholars would need to re-examine other ostensible Gauguins that appeared on the art market for the first time in the early 1920s. They would re-evaluate the expertise accredited to dealers like Etienne Bignou and collectors like Sacha Guitry. That re-evaluation could ripple around the world, from California to Denmark and New York to France. Discovering that the painting was a forgery would reinforce the cultural distance between Stockton and Paris, between those inside the network of the elite art world and those outside.

What did the conservator find?

She found that the painting had been loose in its wooden frame, and that the frame had rubbed off bits of paint along the edges where it had been in contact with the canvas. She found that the canvas had been re-stretched: someone tacked the canvas onto a stretcher, and then at some point, likely in the early twentieth century, someone else had untacked it and tacked it onto another stretcher. The evidence? Rusty nail holes and the shadow of discoloration where a crossbar had connected the two long edges of the stretcher. She found that the "original flax linen canvas" was brittle with age. The canvas was woven on a hand loom, not on a machine, and the fibers that make up the canvas were spun by hand. The irregularities that appear in the canvas under magnification are consistent with those found in canvases used in France in the late nineteenth century.[40]

She found that the paint had been applied in thin layers, and that there were places where "the canvas weave was nearly bare and visible."[41] She found that the artist who made the painting had applied a "thin gesso ground" before beginning to paint, and that the brushstrokes all appeared to have been applied by the same person: there is "no evidence of any prior restoration, repairs, or alteration to the original composition; no overpainting, re-touching, or inpainting is visible or identifiable."[42] The inscription and signature appear to have been applied when the rest of the canvas was still wet, and are painted on using the dark blue that appears in other areas of the painting. At some point, likely in the 1980s, someone applied a thick coat

of varnish to the painting in an attempt to preserve it. The painting was not cleaned before varnishing, and specks of dirt—the detritus of a century—are visible under the varnish under magnification. "It was our finding," she wrote, "that the painting is in original condition, with no later alterations" other than the varnish layer. The conservator's technical analysis did not conclude that *Flowers and Fruit* is a work by Paul Gauguin. Nor did the testing reveal the apparent hand of a forger. The conservator's technical observations that the painting was created by one artist invite other conclusions, conclusions which, by the terms of the workings of the art world, can only become valid through additional study.

Today, *Flowers and Fruit* continues to exist in limbo. It is at once rooted in its historical connections and adrift from its origins. The question of its authenticity has not abated but has become, instead, richer and more complex. Is it or isn't it a work by Gauguin? Additional analysis will reveal more evidence. More conservators will study it; more tests will be done; there will be more conversations. The next chapter of *Flowers and Fruit*'s life is just beginning. But what we know already is this: *Flowers and Fruit* is part of our common heritage, for Stocktonians as well as Parisians, for the connoisseurs who have examined it and the museum registrars who have cataloged it. It is a portal that invites us to ponder the ways that the identity of objects changes across time and space, and a doorway that provides a glimpse into new ways of classifying and authenticating art. It is an object that summons us to think about connections and ruptures. A century after its first appearance on the art market, *Flowers and Fruit*'s story continues.

Notes

1. Paul Gauguin, "Still Life with Quimper Pitcher (Nature Morte à la Cruche de Quimper), 1889, 1990.11," BAMPFA, accessed November 30, 2023, https://colAlection.bampfa.berkeley.edu/catalog/467711a3-4557-4740-86fc-cfadf5cc1cb1.
2. Paul Gauguin, "Breton Girl, 19th–20th c., 69.30.79," Fine Arts Museums of San Francisco, accessed November 30, 2023, https://www.famsf.org/artworks/breton-girl.
3. "Samuel Butterworth to Blanche Butterworth," September 26, 1863, Haggin Family Papers, Haggin Museum Archives.
4. "Inventory of Goods Removed from 136 East 79th Street, New York, N.Y., for the Account of Alexander & Green . . .," January 12, 1939, Haggin Museum Archives.
5. Derek Fincham, "Case Study 2: The Knoedler Art Forgery Network," in *The Palgrave Handbook on Art Crime* (London: Palgrave Macmillan, 2019), 345, https://rdcu.be/dhDLZ.

6. Christel H. Force, "Intellectual Property and Ownership History," in *Collecting and Provenance: A Multidisciplinary Approach* (Lanham, MD: Rowman & Littlefield, 2019), 29.

7. Gail Feigenbaum, "Manifest Provenance," in *Provenance: An Alternate History of Art*, ed. Gail Feigenbaum and Inge Reist (Los Angeles: Getty Research Institute, 2012), 7.

8. Paul Gauguin, "La Belle Angèle, 1889, RF 2617," Musée d'Orsay, accessed December 3, 2023, https://www.musee-orsay.fr/fr/oeuvres/la-belle-angele-286#art work-history.

9. Noah Charney, *The Art of Forgery: The Minds, Motives and Methods of Master Forgers* (London: Phaidon Press, Ltd., 2015), 18.

10. Martin Bailey, "Art Institute of Chicago Gauguin Sculpture Is Fake," *The Art Newspaper*, January 1, 2008, https://www.theartnewspaper.com/2008/01/01/art -institute-of-chicago-gauguin-sculpture-is-fake.

11. Charney, *The Art of Forgery*, 108–12.

12. Bailey, "Art Institute of Chicago Gauguin Sculpture Is Fake."

13. Christian Bessy and Francis Chateauraynaud, "Being Attentive to Things: Pragmatic Approaches to Authenticity," *Experts et Faussaires* 2 (2015): 7.

14. Tiya Miles, *All That She Carried: The Journey of Ashley's Sack, a Black Family Keepsake*, 1st ed. (New York: Random House, 2021), 27.

15. "Lot 135, Louis Roy (1862–1907), Paysage Breton à La Fontaine, 1901," *La Gazette Drouot*, March 30, 2023, https://www.gazette-drouot.com/lots/20905109 -louis-roy-1862-1907--paysage.

16. "Lot 802, Louis George Eléonor Roy, Landscape with Roses (Design for a Fan), Old Master and 19th Century Paintings," February 1, 2013, https://www .sothebys.com/en/auctions/ecatalogue/2013/old-master-and-19th-century-paintings -n08953/lot.802.html; "Lot No. 173, Louis Roy (1862–1907), Fillettes aux Oies, Aquarelle . . .," La Gazette Drouot, October 25, 2020, https://www.gazette-drouot .com/lots/13375085-louis-roy-1862-1907-fillettes---.

17. Jill-Elyse Grossvogel, *Claude-Emile Schuffenecker Catalogue Raisonné 1* (San Francisco, CA: Alan Wolfsy Arts, 2000).

18. "Lot 818: Emile Bernard (1868–1941), Bretonne Étendant le Linge, Planche Issue de Bretonnerie, La Collection Sam Josefowitz: Dessins et Gravures de l'Ecole de Pont-Aven Online," Christie's, October 12, 2023; "Lot 905: Armand Seguin (1869–1904), Décoration de Bretagne, La Collection Sam Josefowitz: Dessins et Gravures de l'Ecole de Pont-Aven Online," Christie's, October 12, 2023, https:// onlineonly.christies.com/s/la-collection-sam-josefowitz-dessins-et-gravures-de-lecole -de-pont/overview/3482?sc_lang=en.

19. Feigenbaum, "Manifest Provenance," 8.

20. Georges Wildenstein, *Gauguin* (Paris: Les Beaux-Arts, 1964), 146, https://wpi .art/2019/01/14/gauguin/.

21. Daniel Wildenstein, *Gauguin: A Savage in the Making: Catalogue raisonné of the Paintings, 1873–1888*, 2 vols. (Milan and Paris: Skira; Wildenstein Institute, 2002), https://wpi.art/2019/01/07/gauguin-a-savage-in-the-making/.

22. Sylvie Crussard, Elizabeth Gorayeb, Jennifer Gimblett, Oral History with Sylvie Crussard, September 16, 2020, 8–12, https://wpi.art/2020/12/11/17106/.

23. Crussard, Gorayeb, Gimblett, Oral History,15.

24. Bessy and Chateauraynaud, "Being Attentive to Things," 34.

25. Jehane Ragai, *The Scientist and the Forger: Insights into the Scientific Detection of Forgery in Paintings* (London and Hackensack, NJ: Imperial College Press, 2015), 8.

26. Philip Hook, *Rogues' Gallery: The Rise (and Occasional Fall) of Art Dealers, the Hidden Players in the History of Art* (New York: The Experiment, 2017), 113.

27. Ragai, *The Scientist and the Forger*, 20.

28. G. E. Newman and Paul Bloom, "Art and Authenticity: The Importance of Originals in Judgments of Value," *Journal of Experimental Psychology: General* 141, no. 3 (November 14, 2011): 1, https://doi.org/10.1037/a0026035.

29. Ragai, *The Scientist and the Forger*, 20.

30. O. Kurz, *Fakes* (New York: Dover Publications, Inc., 1968), 23.

31. S. Legrand, F. Vanmeert, G. Van de Snickt et al., "Examination of Historical Paintings by State-of-the-Art Hyperspectral Imaging Methods: From Scanning Infra-Red Spectroscopy to Computed X-Ray Laminography," *Heritage Science* 2, no. 13 (2014): 1, https://doi.org/10.1186/2050-7445-2-13.

32. Elise Yvonne Rousseau, Director and Principal Conservator, "Summary Report for Conservation Condition Assessment and Analysis" (ACdR Conservation LLC, November 18, 2023).

33. Martin Bailey, "Fake No More: Poppy Painting in US Museum Is by Van Gogh—and Has a Surprise under the Surface," *The Art Newspaper*, March 22, 2019, https://www.theartnewspaper.com/2019/03/22/fake-no-more-poppy-painting-in-us-museum-is-by-van-goghand-has-a-surprise-under-the-surface.

34. Fincham, "Case Study 2: The Knoedler Art Forgery Network," 344.

35. Fincham, 344–45.

36. Fincham, 349.

37. Jon Swaine, "Artist at Center of Multimillion Dollar Forgery Scandal Turns Up in China," *The Guardian*, April 22, 2014, https://www.theguardian.com/artand-design/2014/apr/22/forged-art-scandal-new-york-artist-china-spain.

38. Patty Gerstenblith, "Getting Real: Cultural, Aesthetic, and Legal Perspectives on the Meaning of Authenticity of Art Works," *Columbia Journal of Law & the Arts* 35, no. 3 (2012): 325, https://heinonline.org/HOL/P?h=hein.journals/cjla35&i=337.

39. Denis Dutton, "Chapter 14: Authenticity in Art," in *The Oxford Handbook of Aesthetics*, Oxford Handbook (Oxford Academic, 2009), 258–74, https://doi.org/10.1093/oxfordhb/9780199279456.003.0014.

40. Rousseau, Director and Principal Conservator, "Summary Report for Conservation Condition Assessment and Analysis," 2–3.

41. Rousseau, Director and Principal Conservator, 2.

42. Rousseau, 3.

~

Acknowledgments

My grandfather loved Paris. When I was fifteen, he took me to see the Impressionists at the Jeu de Paume and showed me a world that, over forty years later, brought me here. My mother made that trip happen: I am thankful every day for her vision, which gave me an outsized sense of possibility.

This book began in the office I shared at the University of San Francisco with the amazing Marjorie Schwarzer. Her conversation and encouragement helped send me down this rabbit hole. At the Haggin Museum, Tod Ruhstaller was patient and game, and Susan Obert a wonderful and supportive partner. At Johns Hopkins, the fabulous Phyllis Hecht suggested that my research project could become a blog as we stood in front of the Gauguins at the National Gallery of Art in Washington, DC, and then supported me as it became a book. Sarah Chicone's unwavering encouragement, confidence, and sense of humor fortified me. All those who followed my research on my blog, *The Disappearing Gauguin*, convinced me that the story of this mystery painting was worth telling. My students at both Johns Hopkins and the University of San Francisco made me a clearer thinker; I am grateful to all of them, particularly Nicole Meldahl and Sabrina Oliveros, who have gone on to become valued colleagues and friends whose counsel I trust.

I am indebted to museum, library, and archives staff in France and the United States who digitized archival records, newspapers, books, journals, and so much more. I could not have done this research in a world without digital assets. Many colleagues have been generous with their time and resources. Particular thanks go to the staff at the Arts du spectacle department

of the Bibliothèque nationale de France; the Berkeley Art Museum and Pacific Film Archive; the Fine Arts Museums of San Francisco; the Getty Research Institute; the Haggin Museum; the Institut national de l'histoire d'art; the Maison-Musée Gauguin in Le Pouldu; the Watson Library, European Paintings, and Modern and Contemporary Paintings departments at the Metropolitan Museum of Art; the archives and documentation center of the Musée d'Orsay; the archives of the Musée de Pont-Aven; the collections department of the Musée des Beaux-Arts, Brest; the Museum of Ethnography in Budapest; the archives of the Museum of Modern Art; and the archives and Print Study Room at the National Gallery of Art. Thank you to those who expressed interest and provided assistance: Emily Beeny, Anne Bez, André Cariou, Elise Effman Clifford, Lisa Cooperman, Sylvie Crussard, Judit Csorba, Andrea Dompe, Joyce Faust, Alice Fornari, Corinne Gibello, Anthony Graham, Gloria Groom, Isabella Holland, Marie-Josephe Lesieur, Alejandro Leal-Pulido, Isabella Lores-Chavez, Maud Naour, Line Clausen Pedersen, Catherine Puget, Saoussan Sabeh, Belinda Thomson, and Amanda Zimmerman.

I visited many museums and sites to construct the world of *Flowers and Fruit*. I explored Pont-Aven and its environs; my afternoons in Le Pouldu and Kerfany-les-Pins gave me insights no amount of reading could have. I spent hours with the collections at the Musée de Pont-Aven, the Brest Musée des Beaux-Arts, and the Quimper Musée des Beaux-Arts. Seeing the Max and Rosy Kaganovitch Collection at the Musée d'Orsay piqued my curiosity about art dealers and art collectors. I learned to imagine artists' working spaces by visiting the Musée Montmartre's reinstallation of Suzanne Valadon's studio and apartment. Examining works on paper in the Louvre's Cabinet des Dessins was immeasurably useful, as were the hours I spent retracing the steps of art dealers and artists through Paris. Time looking at paintings at the National Gallery of Art and the Museum of Modern Art, at the Norton Simon and at the Getty, helped me learn what questions to ask.

Late in the process, conservator Elise Rousseau and her team uncovered critical data, which has pointed the way to the next stage of *Flowers and Fruit*'s journey and my own. I am grateful for her skills and insights, and I look forward to what's next.

Charles Harmon and his colleagues at Rowman & Littlefield have been marvelous in their support and generosity from the first email I sent. Many thanks to all who read the manuscript, particularly Sean Blinn. The work is better because of the time you spent. Thank you.

My daughters and their partners, my bonus daughter and godchildren, and my family and friends have supported me each in their own vital way. Laura

Smyth has been my creative partner every day of this process. The book would not exist without her.

Last and most, my husband Cory Modlin has listened, read, questioned, believed, and accompanied me at every step. I am grateful beyond measure for our life together.

~

Selected Bibliography

I have included here only the published secondary source materials that have been most important in my research. The notes reference primary source materials—archival documentation, exhibition reviews, newspaper articles—and citation information for works of art taken from online museum collection catalogs. All translations are my own unless otherwise noted.

Anishanslin, Zara. *Portrait of a Woman in Silk*. New Haven and London: Yale University Press, 2016.

Bailey, Martin. "Art Institute of Chicago Gauguin Sculpture Is Fake." *The Art Newspaper*, January 1, 2008. https://www.theartnewspaper.com/2008/01/01/art-institute-of-chicago-gauguin-sculpture-is-fake.

———. "Fake No More: Poppy Painting in US Museum Is by Van Gogh—and Has a Surprise under the Surface." *The Art Newspaper*, March 22, 2019. https://www.theartnewspaper.com/2019/03/22/fake-no-more-poppy-painting-in-us-museum-is-by-van-goghand-has-a-surprise-under-the-surface.

Baldasarre, Maria Isabel. "Buenos Aires: An Art Metropolis in the Late Nineteenth Century." *Nineteenth-Century Art Worldwide* 16, no. 1 (n.d.): 1–53. https://doi.org/10.29411/ncaw.2017.16.1.2.

Bernardi, Claire, and Ophélie Ferlier-Bouat, eds. *Gauguin L'Alchimiste*. Paris: Réunion des musées nationaux, 2017.

Bessy, Christian, and Francis Chateauraynaud. "Being Attentive to Things: Pragmatic Approaches to Authenticity." *Experts et Faussaires* 2 (2015).

Boyle-Turner, Caroline, Samuel Josefowitz, and Rijksmuseum Vincent van Gogh. *The Prints of the Pont-Aven School: Gauguin & His Circle in Brittany*. New York: Abbeville Press, 1986.

Brettell, Richard R. *The Art of Paul Gauguin.* Washington, DC: National Gallery of Art, 1988.

Bruneau, Anne-Pascale. "Aux Sources du Post-Impressionisme: Les Expositions de 1910 et 1912 aux Grafton Galleries de Londres." *Revue de l'art* 113, no. 3 (1996): 7–18.

Bullen, J. B. "Great British Gauguin: His Reception in London in 1910–11." *Apollo* 500 (October 2003): 3–12.

Cahen, Joël J., and André Cariou, eds. *Meijer de Haan, Le Maître Caché.* Paris: Hazan, 2009.

Cahn, Isabelle. "An Echoing Silence: The Critical Reception of Gauguin in France, 1903–49." *Van Gogh Museum Journal* 2003, 25–39. Accessed May 11, 2023. https://www.dbnl.org/tekst/_van012200301_01/_van012200301_01_0004.php.

Cariou, André. *Filiger: Correspondances et Sources Anciennes.* Paris: Locus-Solus, 2019.

———. *Gauguin et l'École de Pont-Aven.* Rennes: Editions Ouest-France, 2001.

Charles, Mallaurie. "Marie Henry (1859–1945): Une Bretonne en quête d'émancipation." Angers: Université Angers, 2020.

Charney, Noah. *The Art of Forgery: The Minds, Motives and Methods of Master Forgers.* London: Phaidon Press, Ltd., 2015.

Chernick, Karen. "Paul J. Sachs Trained a Generation of American Museum Leaders, Including Alfred Barr." *Hyperallergic* (blog), February 7, 2019. https://hyperallergic.com/483457/paul-j-sachs-trained-a-generation-of-american-museum-leaders-including-alfred-barr/.

Crussard, Sylvie. Oral History with Sylvie Crussard. Interview by Elizabeth Gorayeb, September 16, 2020. https://wpi.art/2020/12/11/17106/.

Cusinberche, Jean-Marie. *Gauguin et ses Amis Peintres: La Collection Marie Henry, "Buvette de La Plage," Le Pouldu, en Bretagne.* Yokohama: Le journal Mainichi, 1992.

Daniel, Jean-Pierre. *Le Destin Fabuleux de Sacha Guitry.* Asnières-sur-Seine: Marque-pages, 2007.

Danielsson, Bengt. *Gauguin in the South Seas.* Translated by Reginald Spink. Garden City, NY: Doubleday, 1966.

Datta, Venita. *Birth of a National Icon: The Literary Avant-Garde and the Origins of the Intellectual in France.* Albany: State University of New York Press, 1999.

Dellheim, Charles. *Belonging and Betrayal: How Jews Made the Art World Modern.* Waltham, MA: Brandeis University Press, 2021.

Dheilly, Chloé. "L'Enigmatique, Max Kaganovitch." Ecole de Louvre, 2019.

Distel, Anne. "Les Amateurs de Renoir: Le Prince, Le Prêtre et Le Pâtissier." In *Renoir: [Exposition], Hayward Gallery, Londres, 30 Janvier–21 Avril 1985, Galeries Nationales du Grand Palais, Paris, 14 Mai–2 Septembre 1985, Museum of Fine Arts, Boston, 9 Octobre 1985–5 Janvier 1986.* Paris: Réunion des musées nationaux, 1985. https://gallica.bnf.fr/ark:/12148/bpt6k1002224w/f58.item#.

Druick, Douglas W. "Vollard and Gauguin: Fictions and Facts." In *Cézanne to Picasso: Ambroise Vollard, Patron of the Avant-Garde*, 60–81. New York: Metropolitan Museum of Art, 2006.

Dumas, Ann. "Ambroise Vollard, Patron of the Avant-Garde." In *Cézanne to Picasso: Ambroise Vollard, Patron of the Avant-Garde*, 2–27. New York: Metropolitan Museum of Art, 2006.

———, ed. *The Private Collection of Edgar Degas*. New York: Metropolitan Museum of Art, 1997.

Dutton, Denis. "Chapter 14: Authenticity in Art." In *The Oxford Handbook of Aesthetics*, 258–74. Oxford Handbook. Oxford: Oxford Academic, 2009. https://doi.org/10.1093/oxfordhb/9780199279456.003.0014.

Eakin, Hugh. *Picasso's War: How Modern Art Came to America*. New York: Crown, 2022.

Estraikh, Gennady. *Uncovering the Hidden: The Works and Life of Der Nister*. Oxford and New York: Routledge, 2017.

Feigenbaum, Gail. "Manifest Provenance." In *Provenance: An Alternate History of Art*, edited by Inge Reist and Gail Feigenbaum, 6–28. Los Angeles: Getty Research Institute, 2012.

Fernier, Robert. *La Vie et l'Oeuvre de Gustave Courbet: Catalogue raisonné*. Vol. 1: *1819–1865 Peintures*. 2 vols. Paris: Fondation Wildenstein, 1977.

Field, Richard S. "Gauguin's Noa Noa Suite." *The Burlington Magazine* 110, no. 786 (1968): 500–511. http://www.jstor.org/stable/875731.

Fincham, Derek. "Case Study 2: The Knoedler Art Forgery Network." In *The Palgrave Handbook on Art Crime*. London: Palgrave Macmillan, 2019. https://rdcu.be/dhDLZ.

Findlay, Michael. "The Catalogue Raisonné." In *The Expert versus the Object: Judging Fakes and False Attributions in the Visual Arts*, 55-62. Oxford: Oxford University Press, 2004.

Florek, Olivia Gruber. "Review: Edouard Vuillard: A Painter and His Muses, 1890–1940 by Stephen Brown, Richard Brettell." *Nineteenth-Century French Studies* 41, nos. 3/4 (2013): 350–52. https://www.jstor.org/stable/23538927.

Force, Christel. "Intellectual Property and Ownership History." In *Collecting and Provenance: A Multidisciplinary Approach*, 17–36. Lanham, MD: Rowman & Littlefield, 2019.

———, ed. *Pioneers of the Global Art Market: Paris-Based Dealer Networks, 1850–1950*. London and New York: Bloomsbury Visual Arts, 2020. https://doi.org/10.5040/9781501342790.

Fuchsgruber, Lukas. "The Hôtel Drouot as the Stock Exchange for Art: Financialization of Art Auctions in the Nineteenth Century." *Journal for Art Market Studies* 1, no. 1 (2017). https://doi.org/10.23690/jams.v1i1.5.

Gauguin, Paul, and Maurice Malingue. *Lettres de Gauguin à sa Femme et à ses Amis*. Paris: B. Grasset, 1946.

Gauguin, Paul, and Belinda Thomson. *Gauguin by Himself*. First edition. Boston: Little, Brown, 1993.

Gerstenblith, Patty. "Getting Real: Cultural, Aesthetic, and Legal Perspectives on the Meaning of Authenticity of Art Works." *Columbia Journal of Law & the Arts* 35, no. 3 (2012): 321–56. https://heinonline.org/HOL/P?h=hein.journals/cjla35&i=337.

Giret, Noëlle, and Noël Herpe. *Sacha Guitry: Une Vie d'Artiste*. Paris: Gallimard, 2007.

Glassie, Henry. "The 2011 Charles Homer Haskins Prize Lecture: A Life of Learning." In *ACLS Occasional Paper*, 68:x, 2011.

Gofman, Ida. "'Golden Fleece' 1906–1909. At the Roots of the Russian Avant-Garde." *Tretyakov Gallery Magazine* 1, no. 18 (2008). https://www.tretyakov-gallerymagazine.com/articles/1-2008-18/golden-fleece-1906-1909-roots-russian-avant-garde.

Gordon, Donald E. *Modern Art Exhibitions: 1900–1916; Selected Catalogue Documentation*. Vol. 2. 2 vols. Materialien zur Kunst des Neunzehnten Jahrhunderts. München: Prestel, 1974.

Grossvogel, Jill, and Claude Emile Schuffenecker. *Claude-Emile Schuffenecker, 1851–1934: [Exhibition] University Art Gallery, State University of New York at Binghamton and Hammer Galleries*. Binghamton: University Art Gallery, 1980.

Grossvogel, Jill-Elyse. *Claude-Emile Schuffenecker Catalogue raisonné 1*. San Francisco, CA: Alan Wolfsy Arts, 2000.

Guitry, Sacha. *19 Avenue Elisée Reclus*. Paris: Raoul Solar, 1952.

Homburg, Cornelia, ed. *Gauguin: Portraits*. Ottawa, Ontario, and London: National Gallery of Canada; National Gallery, 2019.

Hook, Philip. *Rogues' Gallery: The Rise (and Occasional Fall) of Art Dealers, the Hidden Players in the History of Art*. New York: The Experiment, 2017.

Institut Français de St Pétersbourg. "Exhibition 100 Years of French Painting (1812–1912): Выставка Сто Лет Французской Живописи (1812–1912)." Database of Modern Exhibitions (DoME) | European Paintings and Drawings 1905–1915. Accessed November 18, 2023. https://exhibitions.univie.ac.at/exhibition/411.

Jansen, Leo, Hans Luijten, and Nienke Bakker, eds. *Vincent van Gogh: The Letters*. Amsterdam and The Hague: Van Gogh Museum & Huygens ING, 2021. https://vangoghletters.org.

Jaworska, Wladyslawa. *Gauguin and the Pont-Aven School*. Greenwich, CT: New York Graphic Society, 1972.

Kropmanns, Peter. "The Gauguin Exhibition in Weimar in 1905." *Burlington Magazine* 141, no. 1150 (1999): 24–31.

Kurz, O. *Fakes*. New York: Dover Publications, Inc., 1968.

Lambirth, Andre. *Sir Matthew Smith 2015 by Browse & Darby Ltd - Issuu*. London: Browse & Darby, 2015. https://issuu.com/joshdarby/docs/catalogue_-_matthew_smith.

Lasker, Mary. Reminiscences of Mary Lasker. Oral History Archives at Columbia, Rare Book & Manuscript Library, Columbia University in the City of New York. http://www.columbia.edu/cu/lweb/digital/collections/nny/laskerm/introduction .html.

Lees, Sarah. Nineteenth-Century European Paintings at the Sterling and Francine Clark Art Institute. Williamstown, MA: Sterling and Francine Clark Art Institute, 2013.

Legrand, S., G. Vanmeert, and G. Van de Snickt. "Examination of Historical Paintings by State-of-the-Art Hyperspectral Imaging Methods: From Scanning Infra-Red Spectroscopy to Computed X-Ray Laminography." Heritage Science 2, no. 13 (2014). https://doi.org/10.1186/2050-7445-2-13.

Lemonedes, Heather, and Paul Gauguin. Paul Gauguin: The Breakthrough into Modernity. Ostfildern: Cleveland Museum of Art; Van Gogh Museum; Hatje Cantz Verlag, 2009.

Lepore, Jill. Book of Ages: The Life and Opinions of Jane Franklin. First edition. New York: Alfred A. Knopf, 2013.

McCormick, Donald. Pedlar of Death: The Life of Sir Basil Zaharoff. New York: Holt, Rinehart and Winston, n.d.

Miles, Tiya. All That She Carried: The Journey of Ashley's Sack, a Black Family Keepsake. First edition. New York: Random House, 2021.

Mongan, Elizabeth, Eberhard Kornfeld, and Harold Joachim. Paul Gauguin: Catalogue raisonné of His Prints. Bern: Galerie Kornfeld, 1988.

Moret, Henry, and Musée des Beaux-Arts Quimper. Henry Moret: Un Paysagiste de l'Ecole de Pont-Aven. Quimper: Musée des beaux-arts, 1998.

Museum of Art (blog), August 2018. https://doi.org/10.57011/MBTP3835.

Nelson, Robert. "The Art Collecting of Emily Crane Chadbourne and the Absence of Byzantine Art in Chicago." In To Inspire and Instruct: A History of Medieval Art in Midwestern Museums, 131–48. Newcastle upon Tyne: Cambridge Scholars Publishing, 2008.

Newman, G. E., and Paul Bloom. "Art and Authenticity: The Importance of Originals in Judgments of Value." Journal of Experimental Psychology: General 141, no. 3 (November 14, 2011): 558–69. https://doi.org/10.1037/a0026035.

Ponthus, Anne-Françoise. "La Galerie Georges Petit." La Société Nouvelle (blog). Accessed April 27, 2023. http://www.lasocietenouvelle.fr/galerie-georges-petit .html.

Prelinger, Elizabeth. "The 'Noa Noa Suite.'" In Paul Gauguin: The Prints, 59–85. Kunsthaus Zürich: Prestel, 2012.

Quemin, A., and Moulin. "La certification de la valeur de l'art: Experts et expertises." Annales: histoire, sciences sociales 48, no. 6 (December 1993): 1421–25. https://www .jstor.org/stable/27584571.

Quemin, Alain. Les Commissaires-Priseurs: La Mutation d'une Profession. Paris: Anthropos, 1997.

Ragai, Jehane. The Scientist and the Forger: Insights into the Scientific Detection of Forgery in Paintings. London and Hackensack, NJ: Imperial College Press, 2015.

Reff, Theodore, ed. *Post-Impressionist Group Exhibitions*. Vol. 28. Modern Art in Paris, 1855–1900: Two-Hundred Catalogues of the Major Exhibitions Reproduced in Facsimile in Forty-Seven Volumes. New York: Garland Publishing, Inc., 1982.

Rouart, Denis, and Daniel Wildenstein. *Edouard Manet: Catalogue raisonné*. Vol. 1. 2 vols. Lausanne: La Bibliothèque des Arts, 1975.

Rouge-Ducos, Isabelle. *Le Crieur et Le Marteau: Histoire des Commissaires-Priseurs de Paris (1801–1945)*. Paris: Belin, 2013.

Saint-Raymond, Léa, Félicie Faizand de Maupeou, and Julien Cavero. "Les Rues des Tableaux: The Geography of the Parisian Art Market 1815–1955." *Artl@s Bulletin* 5, no. 1 (2016): 119–59.

Saint-Raymond, Léa, and Agnès Penot. "Paul Gauguin: Businessman or Starving Artist?" In *Gauguin: A Spiritual Journey*. New York: Prestel, 2019.

Sanchez, Pierre, and Dominique Lobstein, eds. *Les Expositions de la Galerie Le Barc de Boutteville (1891–1899) et du Salon des Cent (1894–1903): Répertoire des Artistes et de Leurs Œuvres*. Dijon: L'Echelle de Jacob, 2012.

Sanders, Patricia B. *The Haggin Collection*. Stockton, CA: The Haggin Museum, 1991.

Schuffenecker, Claude Emile, and Jill Grossvogel. *Emile Schuffenecker: 1851–1934*. Pont-Aven: Saint-Germain-en-Laye: Musée de Pont-Aven; Musée Maurice Denis "Le Prieuré," 1996.

Schwarzer, Marjorie. *Riches, Rivals, and Radicals: A History of Museums in the United States*. Third edition. American Alliance of Museums. Washington, DC: American Alliance of Museums Press, 2020.

Serafini, Paolo. "Archives for the History of the French Art Market (1860–1920): The Dealers' Network." *Getty Research Journal* 8, no. 1 (January 2016): 109–34. https://doi.org/10.1086/685918.

Shakeri, Aria. "Albert Sézary: The Man, the Cell, and the Syndrome." *JAMA Dermatology* 154, no. 4 (2018): 496–97.

Shields, Caroline D. "Objects of Memory: Paul Gauguin and Still Life Painting, 1880–1901." Ph.D. diss, University of Maryland, 2017.

Société Paul Cezanne, ed. *The Paintings, Watercolors and Drawings of Paul Cezanne: An Online* Catalogue raisonné, 2023. https://www.cezannecatalogue.com/catalogue/.

Spencer, Ronald. "Authentication in Court: Factors Considered and Standards Proposed." In *The Expert versus the Object: Judging Fakes and False Attributions in the Visual Arts*, 189–215. Oxford: Oxford University Press, 2004.

Spurling, Hilary. *Matisse the Master: A Life of Henri Matisse, the Conquest of Color, 1909–1954*. New York: Alfred A. Knopf, 2005.

Starr, Kevin. *California: A History*. New York: Random House, 2005.

Steffen, Charles. "The Man Behind the Eponym Dermatology in Historical Perspective: Albert Sézary and the Sézary Syndrome." *American Journal of Dermatopathology* 28, no. 4 (August 2006): 357–67.

Stein, Susan Alyson. "From the Beginning: Collecting and Exhibiting Gauguin in New York." In *The Lure of the Exotic: Gauguin in New York Collections*. New York: Metropolitan Museum of Art, 2002.

Swaine, Jon. "Artist at Center of Multimillion Dollar Forgery Scandal Turns Up in China." *The Guardian*, April 22, 2014. https://www.theguardian.com/artand-design/2014/apr/22/forged-art-scandal-new-york-artist-china-spain.

Sweetman, David. *Paul Gauguin: A Life*. New York: Simon & Schuster, 1995.

Tancock, John. "Issues of Authenticity in the Auction House." In *The Expert versus the Object: Judging Fakes and False Attributions in the Visual Arts*, 45–53. Oxford: Oxford University Press, 2004.

Taretreau-Zeller. "Mirbeau Face à Gauguin: Un Exemple de la Nécessité d'Admirer." *Cahiers Octave Mirbeau*, no. 8 (2001).

The Art Institute of Chicago, The Metropolitan Museum of Art. *Gauguin Paintings, Drawings, Prints, Sculpture*. Chicago: Lakeside Press, 1959.

Thomson, Belinda, Tamar Garb, Philippe Dagen, Paul Gauguin, Tate Modern (Gallery), and National Gallery of Art (U.S.), eds. *Gauguin: Maker of Myth*. Princeton, NJ: Princeton University Press, 2010.

Walter, Elisabeth. "'Le Seigneur Roy': Louis Roy, 1862–1907." *Bulletin des Amis du Musée de Rennes* 2 (1978): 61–78.

Wildenstein, Daniel. *Gauguin: A Savage in the Making*: Catalogue raisonné *of the Paintings, 1873–1888*. 2 vols. Milan and Paris: Skira; Wildenstein Institute, 2002. https://wpi.art/2019/01/07/gauguin-a-savage-in-the-making/.

———. *Monet: Catalogue raisonné*. Vol. 4: *Nos. 1596–1983 et les Grandes Décorations*. Paris: Taschen, 1996.

Wildenstein, Georges. *Gauguin*. Paris: Les Beaux-Arts, 1964. https://wpi.art/2019/01/14/gauguin/.

Wildenstein Plattner Institute, Richard R. Brettell, Elpida Vouitsis, Françoise Marnoni, Evgenia Kuzmina, and Jennifer Gimblett, eds. *Gauguin*: Catalogue raisonné *of the Paintings 1891–1903*. New York: Wildenstein Plattner Institute, 2023. https://digitalprojects.wpi.art/gauguin/about.

Wullschläger, Jackie. *Chagall: A Biography*. First edition. New York: Alfred A. Knopf, 2008. http://catdir.loc.gov/catdir/enhancements/fy0906/2008006162-s.html.

Young, Michelle. "After Disappearing for Decades, a van Gogh Watercolor Sold Under Duress and Then Stolen by Nazis May Fetch $30M." *Hyperallergic* (blog), November 10, 2021. https://hyperallergic.com/691726/a-van-gogh-watercolor-sold-under-duress-and-then-stolen-by-nazis-may-fetch-30m/.

Index

~

Page references for images are italicized.

189

~

About the Author

Stephanie A. Brown is assistant program director for Johns Hopkins University's MA in museum studies. She discovered *Flowers and Fruit*, a still life formerly attributed to Paul Gauguin, in a museum in California's Central Valley in 2016. Intrigued, she began to research the painting's history and ask questions about its provenance. Dr. Brown earned her BA from Williams College and her Ph.D. in French history from Stanford University. She lives in the San Francisco Bay Area with her husband and dogs.